Photography a...

exposures

EXPOSURES is a series of books on photography designed to explore the rich history of the medium from thematic perspectives. Each title presents a striking collection of approximately 80 images and an engaging, accessible text that offers intriguing insights into a specific theme or subject.

Series editors: Mark Haworth-Booth and Peter Hamilton

Also published

Photography and Spirit John Harvey
Photography and Australia Helen Ennis
Photography and Cinema David Campany
Photography and Literature François Brunet
Photography and Flight Denis Cosgrove and William L. Fox
Photography and Africa Erin Haney
Photography and Italy Maria Antonella Pelizzari
Photography and Death Audrey Linkman
Photography and Science Kelley Wilder
Photography and the USA Mick Gidley
Photography and Egypt Maria Golia
Photography and Anthropology Chris Pinney
Photography and Japan Karen Fraser

Photography and Ireland

Justin Carville

reaktion books

For Karen, Dillon and Zach

Published by Reaktion Books Ltd
33 Great Sutton Street
London EC1V ODX
www.reaktionbooks.co.uk

First published 2011

Printed and bound in China

British Library Cataloguing in Publication Data
Carville, Justin.
 Photography and Ireland. – (Exposures)
 1. Photography – Ireland – History.
 2. Photographs as information resources – Ireland – History
 3. Historiography and photography – Ireland.
 I. Title
 II. Series
 770.9'415-dc22

ISBN 978 1 86189 871 5

Contents

Introduction: Geographical Imaginings 7

one A Short History of Irish Photography 18

two That Vast and Absorbing Subject 60

three One of the World's Puzzles 90

four Conflicting Images 127

five The City in Ruins 160

Epilogue 184

References 191
Select Bibliography 207
Acknowledgements 209
Photo Acknowledgements 210
Index 211

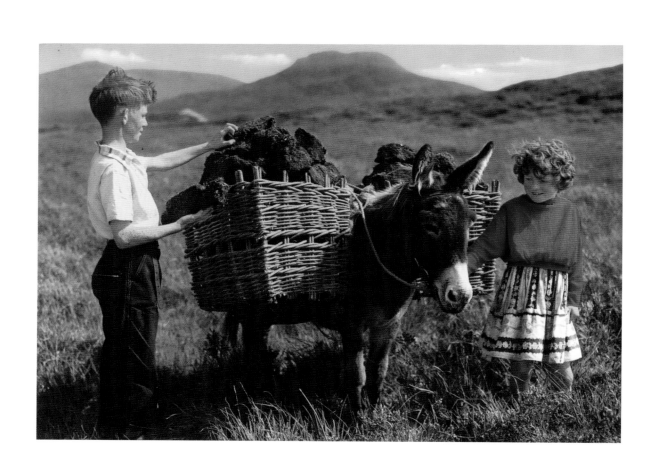

Introduction:
Geographical Imaginings

It has often been claimed that if Ireland had never existed, it would have had to have been invented.[1] That the island of Ireland does exist as a geographic place, however, has not prevented generations of photographers from framing their pictorial representations of the island to form the imaginary image that existed for them in their mind's eye before they experienced it in reality. As a colony and a nation, it has existed simultaneously both as a real and imagined geographical space onto which tourists, anthropologists and antiquarians have all projected their racial and cultural fantasies of Ireland and the Irish through photography. Readers of this book will no doubt be familiar with the photographic manifestations of these colonial and tourist fantasies. They are usually of two distinct genres of photography that are at the two poles of Ireland's photographic culture. At one end are to be found the tourist picturesque views of colour-saturated landscapes, replete with rolling hills of lush vegetation dotted with thatched cottages, and occasionally red-haired children. At the opposite end are the grainy, monochromatic hues of the photojournalistic depictions of urban streets strewn with the detritus of sectarian conflict. These polarized representations are often identified as affirmation of the distinctiveness of Ireland's visual culture. The paradox, however, is that this unique and authentic visual culture has been established through the patterned, repetitive similarity of each photographic image of Ireland that conforms to these stereotypical pictorial representations.

In 170 years of photography's presence in Irish society these dual photographic fantasies have circulated in various forms: from nineteenth-century daguerreotypes and calotypes to Cibachrome and silver gelatin

1 John Hinde, *Collecting Turf from the Bog, Connemara, Co. Galway, Ireland*, c. 1954, colour postcard.

prints; stereoscopic cards and *cartes-de-visite* to tourist postcards and souvenirs; the photographic document to photo-reportage in magazines and newspapers. It is unlikely, however, that readers would be familiar with any more than a handful of names of historical or contemporary Irish photographers. It is even more unlikely that they would be aware of Ireland's long and sometimes complex photographic history. It is a history that spans the technological development of photography such as the invention in 1894 by the physicist, geologist and engineer John Joly of the first single-plate colour photographic process.[2] It is also a history that incorporates emerging debates within photographic culture internationally about disentangling the aesthetics of photography from its technological characteristics. The dramatist and writer George Bernard Shaw, himself a prolific photographer, wrote several essays and reviews professing the lofty aesthetic aims of groups such as the Linked Ring, with whose members, such as Frederick H. Evans, he regularly corresponded.[3] Outside of Ireland there has been scant attention given to this history, and internationally there has been little commercial or cultural interest in Irish photography beyond picturesque views of the Irish landscape and the representation of the Troubles.[4] Even within Ireland the history of Irish photography has largely been of interest only to a small community of photographers, curators and collectors.[5] This book, then, is about the cultural history of photography in Ireland that is located in between the picturesque views and photojournalistic representations of conflict that appear to dominate perceptions of the history of Irish photography.

If it appears as though I am attempting to limit the narrative and territory through which this book traces the history of Irish photography by identifying these polarized extremes of Ireland's photographic culture at the outset of the discussion, that is not my intention. There are variations to the pictorial themes of the picturesque landscape and urban sectarian conflict in photographic representations of Ireland. Much Irish photography of the last three decades has visually interrogated the residua of colonial representations of Ireland in popular photographic imagery and photojournalism. This has been and continues to be motivated, curiously enough, by the influence of British photographic theory on one hand and postcolonial critiques within Irish cultural studies on the other.

The influence of British photographic theory introduced new political possibilities to Irish photography from the mid-1980s, with postmodernism and subjective documentary motivating a new generation of photographers to employ the photographic form to explore cultural identity.[6] These outside cultural influences demonstrate the difficulty in any attempt to limit the discussion of Irish photography to a narrow geographical or cultural terrain. This is as true for the beginnings of photography in Ireland in the nineteenth century as it is for contemporary photography. Indeed the narrative of the history of Irish photography is one of constant exchange between external and internal cultural politics, and aesthetic developments within photography internationally.

From the emergence of photography in Belfast in 1839, photographic culture on the island has been marked by the flow of photographers, technologies and aesthetic philosophies first between Ireland and England, and later between Ireland and England's colonies in Africa and the Middle East. This cultural exchange continued into the twentieth century between Ireland and countries such as America and Australia that became the destinations for generations of Irish immigrants. Cultural exchange continues to be woven into the story of Irish photography now, with many Irish photographers who have been educated in the United Kingdom and Europe returning to Ireland and influencing its photographic culture through their roles as photographers, educators and curators.[7] Indeed the relatively small scale of Irish photographic culture has meant that photographers have had to look outwards to find a wider audience for their work. This aspect of Ireland's photographic culture is little known outside the country and throughout the following chapters of this book I have attempted to emphasize the constant flow and exchange of photographers, aesthetic practices and indeed photographic imagery between Ireland and the rest of the world.

In some accounts of the history of photography in Ireland, the tension between 'the imaginary' and 'the real' has been identified as the difference between the alien eye of the colonial or foreign photojournalist, and the indigenous gaze of the native Irish photographer.[8] During the mid-1950s the English photographer John Hinde travelled Ireland taking photographs of tourist sites then just beginning to be promoted by the Irish tourist

board, Bord Fáilte.[9] Ireland had been a popular tourist destination for colonial travellers since the eighteenth century, but in the mid-twentieth century the Irish Free State began to aggressively commercialize the marketing of tourism through film and photographic imagery. Establishing the John Hinde Company in Dublin in 1956, Hinde turned his photographs into mass-produced colour postcards (illus. 1). Hinde utilized the latest photo-mechanical techniques to pump up the colours in his photographs to produce a saccharine image of Ireland as a prelapsarian, rural idyll.[10] Hinde identified in colour photography a spiritual positivity, a sort of evangelical vision that could be projected throughout society by the humble tourist postcard. His vision of Ireland is one that captures a spirit of optimism and progressiveness that is at odds with an image of the gritty realism of 1950s Ireland as economically stagnant and culturally repressed. Hinde's hyper-coloured postcards have therefore often been identified as emblematic of an 'imaginary' view of Ireland propagated by foreign photographers.

In the 1980s the Irish photographer Liam Blake produced a series of photographs published in the form of postcards and two books under the title *Real Ireland*.[11] Blake's photographs were produced to counter imaginary views of Ireland such as Hinde's with a new photographic reality that depicted the country in its 'warts and all' visible appearances. The artist Seán Hillen, on the other hand, approached the imaginary Ireland in Hinde's visual confectionary of picturesque cliches from an alternative perspective. In his series of photomontages *Irelantis*, Hillen did not provide an alternative photographic reality to counter Hinde's picture-postcard view of the island, but an alternative imaginary space emptied of history and the specificity of place (illus. 2). As one commentator observed, 'instead of taking the myth out of romantic postcards, he [Hillen] puts a lot more in'.[12] Hillen ruptured Hinde's picturesque views with fantastical scenes that extended the imaginary possibilities of the island of Ireland so that it began to collapse in on itself. *Irelantis* was an Ireland that was unsure if it existed in the past or was a mirage of a future created by the stifling heat of its own myths. As Fintan O'Toole observed, *Irelantis* is 'a society that became postmodern before it ever quite managed to be modern, a cultural space that has gone in the blink of an eye, from

2 Seán Hillen, 'Collecting Meterorites at Knowth', 1996, paper collage, from the series *Irelantis*, 1999.

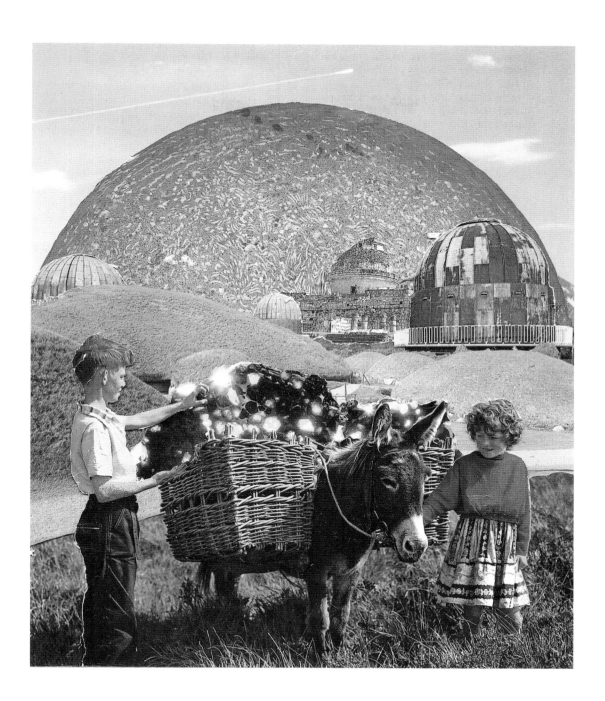

being defiantly closed to being completely porous to whatever dream is floating out there in the media ether. But this Ireland is also everywhere and nowhere . . . a world where all borders – political, cultural and psychological – are permeable.'[13] Through Hillen's surgical transplantation, Hinde's saccharine views of Ireland, for all their nauseating kitschiness, still have a place in understanding how contemporary Ireland projects an image of itself. What Hillen's photomontages achieve is a heightening of the extent to which the visual projection of Ireland as a geographical and cultural place is a complex amalgamation of photographic reality and photographic fiction.

While it would be remiss not to acknowledge the significance of the tension between 'the imaginary' and 'the real' in photographic representations of Ireland such as Hinde's and Hillen's, frequently the division between the imaginary colonial or tourist gaze of the foreign photographer and the 'real' indigenous optics of local photographers has been overstated. Visiting photographers from America, England and Europe have exerted a great deal of influence on the development of Irish photography, and the international developments of photographic culture have in very significant ways contributed to the formation of photography as a social and aesthetic practice on the island. In particular the emergence of subjective documentary practices throughout Europe during the 1980s and '90s provided Irish photography with a complex visual grammar through which to explore the historical legacy of representations of Ireland. International trends in photography have been explored by Irish photographers representing local social and political issues, which in a reciprocal fashion have expanded the possibilities of photographic practice. Additionally international photographers have influenced the profile and development of photography as a social and aesthetic form of communication in Ireland.

In writing this book I have been faced with a dilemma in accommodating non-Irish photographers who have produced work on Ireland into the cultural history of Irish photography. Although not 'Irish' photographers in terms of nationality, they are as much part of the patchwork history of Irish photography as indigenous photographers. Such is the volume of photographic imagery produced by photographers from outside of the country that one could easily conceive of a book on photography

and Ireland exclusively devoted to photography by non-Irish photographers.[14] Such a book would necessitate a different type of narrative, an alternative cultural history, as it were, than what is envisaged in the discussion of Irish photography that follows. At the same time the cultural history of Irish photography that I wish to trace is not one bounded by geographical territory or nationality. I have therefore incorporated the work of non-Irish photographers into the discussion of photography in several of the chapters. Their inclusion has been based simply on the contextual significance of their contributions to photographic culture on the island within this particular book's history of Irish photography.

Terra Infirma

The geographic parameters and cultural scope of a book on 'a photography' and 'a nation' would appear, at least on the surface, to be clearly defined. Ireland is, after all, an island with an identifiable geography of geological contours and physical borders with its own arena of photographic imagery and practices. These photographic practices, it is no doubt envisaged, reproduce and circulate distinctive visual registers, a set of visible codes and iconography, through which Ireland as a place is photographically communicated to the viewer of the image. This process requires a sort of unwritten intellectual contract between the photograph and the viewer. That is to say, the viewer expects the photograph to provide distinctive visual registers for him or her to read out of the image, and the photograph requires the viewer to read and understand the codes and iconography that it provides within its geometric visual form. Through this intellectual framework, photographs contribute to projecting and making meaningful, real and imagined visual experiences of the island and its people. Ireland, however, is no ordinary island, and to reiterate what I have previously noted, the role of photography in the formation of the visual culture of the nation extends well beyond the physical territory of Ireland's distinctive geography (illus. 3).

At the time of writing this book the island of Ireland is two nations – the 'home nation' of Northern Ireland and the 'sovereign nation' of the

Republic of Ireland – each with its own cultural range of photographs and photographic practices that are sometimes distinctive and occasionally overlap.[15] There is not the space in this short book to disentangle these contested geographical imaginings of Ireland, but their significance not only in shaping photographic culture on the island but also to the ways in which photographs are interpreted needs to be acknowledged.[16]

The two published survey histories of photography in Ireland are Edward Chandler's *Photography in Ireland: The Nineteenth Century* and W. A. Maguire's *A Century in Focus: Photography and Photographers in the North of Ireland, 1839–1939*.[17] Both historical accounts project back upon the nineteenth and early twentieth century the border between Northern Ireland and the 'Free State' that was established in 1922. With a few significant exceptions Chandler's account discusses the development

3 Elliot Erwitt, *Aran Islands*, 1962, black-and-white photograph.

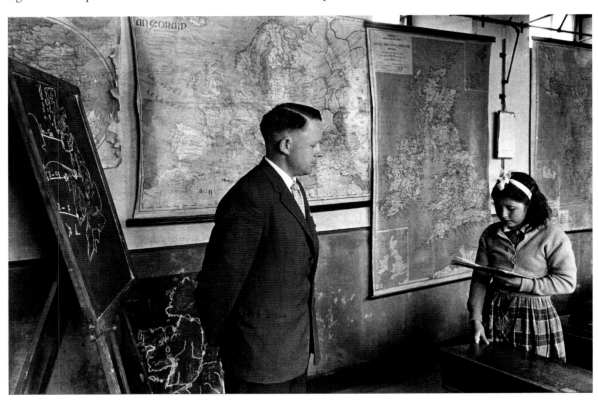

of photography on the island almost exclusively from the perspective of the south, while Maguire's consciously addresses itself solely to the history of photography in Northern Ireland. This is reflective of a strong 'regionalist' approach to photography in Ireland rather than a deliberate cultural bias. Many photographic collections and picture books have emerged out of regional historiography. Indeed libraries and bookshops are full of photographically illustrated histories of small towns and villages, and a vibrant scholarly environment of local history has contributed greatly to knowledge of photographic culture in Ireland.[18] While not ignoring the existence of the border between North and South, the approach taken in this book is to discuss the history of photography from the perspective of the island of Ireland rather than through a narrative that emphasizes photographic culture on one side of the border or the other. That being said, photography has been mobilized within cultural nationalism just as it has in the cultural politics of unionism. The point is that my approach has been to explore the specific contexts in which photography has been pressed into action in the various geographical imaginings of Ireland rather than making them central to the overarching narrative.

The shifting perspectives of the imaginative geographies of Ireland add a significant layer of meaning to how photography constructs a sense of the island as 'place'. Photographs, like maps, are abstract visual representations. They have a role in shaping not only the viewer's knowledge of concrete, geographical places from which they are separated both temporally and spatially, but also their cultural and political imaginings of that place. The most interesting photographic images of Ireland have been those in which the aesthetic frequently picks up what politics has left behind. Photography has been at its most sophisticated as a form of visual communication in Irish culture when it has been mobilized to express what has politically been left unsaid. This is central to the history of Irish photography I want to pursue in this book. In discussing photography's relationship to colonialism, nationalism or cultural identity in Northern Ireland I am not treating photographs as passive 'reflections' of Irish society or as documentary evidence of historical occurrences. Instead I want to emphasize photography as having 'agency'; that is to

say, the photographic image is conceived as being a culturally salient form of visual communication which has the ability to shape and alter 'perceptions' of Irish society. Indeed this might be a useful way of thinking about the aim of this book, which is nothing more than an exploration of the photographic form's contribution to altering and transforming the geographical imaginings of Ireland and the Irish.

The first chapter, the longest in the book, is a short history of photography in Ireland. This is to establish, if somewhat loosely, a historiography of sorts on nineteenth- and twentieth-century Irish photography. This short history is then followed by four thematic chapters and an epilogue which explore Ireland's photographic culture through a number of interrelated themes. These themes of colonial, postcolonial and transcultural histories and photographic practices are explored through topics ranging from the amateur photography of the colonial landlord to contemporary artists' exploration of the impact of globalization on Irish cultural identity. Identifying key historical and cultural developments in Irish photography, the chapters examine the tensions between colonial representations of Ireland and the formation of an indigenous photographic visual culture.

Photographic practices ranging from commercial photographic portraiture to landscape photography, criminological portraits, ethnographic photographs, photojournalism, documentary photography and contemporary photographic art are discussed in conjunction with one another in the exploration of the book's central themes. I have aimed to include as much information about Irish photography as possible and as wide a range of photographic material as could be included within the tight frame of this book. No aesthetic value-judgements have been placed on the photographic material included in the discussion, and as readers will discover I have treated the cheap mass-produced photographica of stereoscopic images, playing cards and *cartes-de-visite* as being as significant in the formation of Irish identity as the C-type prints of contemporary photography hung on the white walls of galleries and museums.

I am conscious of the omission of several notable photographers, histories and photographic collections from this book, including archival material from the past as well as the work of several emerging

Fanciful Applications of Photography

The emergence of photography in Ireland during the 1840s evolved through a series of cultural, aesthetic and commercial relations with photography in England.[6] From the announcement of photography's invention in 1839 to the close of the century, photographic operators, chemists, physicists and amateur photographers from the English land-owning classes moved between the two countries, bringing with them new technological developments and aesthetic philosophies of photography. Many early photographers presented scientific and aesthetic papers on the latest developments in photography at learned societies such as the Royal Dublin Society and the Royal Irish Academy. Instruction in producing daguerreotypes was available at the Dublin Mechanics Institute from 1840 and in the same year the Royal Dublin Society sanctioned the purchase of a parallel mirror camera to take daguerreotypes and to provide instruction to members of the Natural Philosophy Committee.[7] Amateur photographic societies also appeared in Dublin (1854) and Belfast (1857). The Belfast society was disbanded by 1860, however, and it wasn't until a quarter of a century later that the Ulster Amateur Photographic Society was established.[8]

Daguerreotype studios opened in both Belfast and Dublin in the 1840s; however, many did not remain in business for more than a year. Belfast in particular had few commercial portrait studios until the mid-1850s and it wasn't until the introduction of the *carte-de-visite* in the 1860s that commercial photography began to expand in Ireland's cities and large provincial towns.[9] The patchy emergence of studio portraiture across Ireland during the 1840s was in part a consequence of Ireland's political and economic relationship with England. The lack of either a large industrial middle class or – in the aftermath of the 1801 Act of Union – a political class in Dublin meant that there was not a large market for commercial photographic portraiture.

The significance of Ireland's relationship with England to the early development of studio portraiture on the island is evident in the origins of photography in Belfast in 1839.[10] The Belfast engraver Francis Stewart

Beatty worked briefly as an operator in coal merchant Richard Beard's Royal Polytechnic Institution in London in 1841. Several years later he described his time working at Beard's studio for *The Photographic News*. Beatty described himself as an 'amateur optician, chemist and careful manipulator', and was an established engraver when *The Belfast Newsletter* reproduced a report on the daguerreotype syndicated from *The Spectator* in February 1839.[11] The report described the process as 'nothing less than making light produce permanent pictures, engraving them at the same time' and the apparatus consisting of 'a camera obscura with the supperaddition of an engraving power'.[12] These descriptions of the camera as a mechanical engraving device caught the imagination of Beatty, who continued to call himself an engraver throughout his association with photography in Belfast, London and Dublin.

On 20 September 1839 *The Belfast Newsletter* reproduced a letter from Beatty describing the differences between images produced on silver paper and silver-plated copper. Beatty would later claim these to be the earliest recorded daguerreotype pictures produced in Great Britain.[13] In 1840 he also advertised for sale five views of the Long Bridge in Belfast 'by means of the Daguerreotype . . . also the apparatus by which they were taken'.[14]

Beatty's writings on photography were an attempt to situate himself amongst the list of figures who, as he stated himself 'had been an active part in the infancy of its invention . . . aiding to bring it to its present state of perfection'.[15] In the historiography of the origins of photography, Beatty may only have achieved what the photography historian Geoffrey Batchen, quoting Michel Foucault, has cruelly described as 'the dull grey of what everyone at a particular period might repeat'.[16] It is nevertheless from within this 'dull grey' that the origins of Irish photography are to be found.

Returning to Ireland after a short period working for Beard as an operator, Beatty established a portrait studio in Belfast in 1842, The Royal Daguerreotype Rooms.[17] However, the venture in Belfast was not economically sustainable. As Beatty himself later noted, 'the expense of the Daguerreotype being above the means of the general public, we had to abandon the undertaking'.[18] Resurfacing in Dublin the following year,

6 Leon Glukman, *William Smith O'Brien*, 1848, lithographic portrait from daguerreotype.

Beatty was joined by a long list of colourful personalities who established daguerreotype studios in the city. Although there was great interest amongst the public in the daguerreotype, of the half-dozen or so portrait studios that opened in the early 1840s only a couple remained in operation by the mid-1850s. Of these, the self-proclaimed professor of natural philosophy Leone Glukman, who opened a studio on the city's main thoroughfare, Sackville Street, stands out as one of the more commercially shrewd operators.[19]

In 1848 Glukman produced a series of daguerreotypes of the Young Irelanders, a group of nationalists who, inspired by the French revolution of 1848, staged a revolt against British repression in July of that same year. Glukman employed the artist Henry O'Neil to produce lithographic portraits based on the daguerreotypes taken by him of the leaders of the group, who had been arrested and sentenced to death for sedition for their role in leading the rebellion. These included a portrait of William Smith O'Brien who, originally due to be 'hung, drawn and quartered', received a commuted sentence of deportation to the penal colony on Van Diemen's Land, Australia (illus. 6).[20] In the midst of increasing political unrest and opposition to Home Rule, Glukman quickly identified the commercial potential for mass-produced portraits of nationalist heroes. Advertisements appeared in the national press offering for sale 'daguerreotype copies' of a portrait taken by Richard Beard of 'The Great Liberator', Daniel O'Connell, after his death in 1847.[21] Lithographic copies of the original daguerreotype taken in 1844 when O'Connell was detained at Richmond Gaol also appeared in *The Nation*, a newspaper founded by the leaders of the Young Irelanders. Photography, along with other mass-produced printed material such as newspapers and popular prints, contributed to an emerging visual culture of Irish nationalism in the mid-nineteenth century.[22] Lithographic copies after daguerreotypes of revolutionary and political figures established a pantheon of nationalist martyrs – an arena of images that increasingly relied on mass circulation as the century progressed. However, the uniqueness of daguerreotypes as visual objects, and the inability to reproduce them on an industrial scale, meant that mechanical engravings and popular prints rather

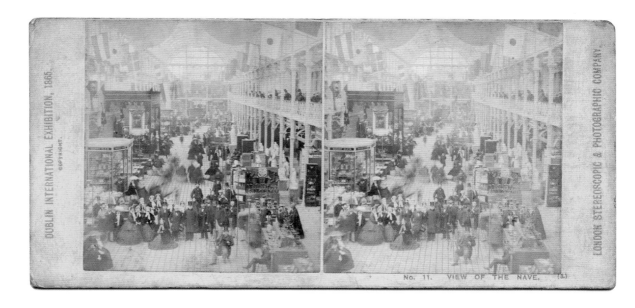

DUBLIN INTERNATIONAL EXHIBITION, 1865. COPYRIGHT.

LONDON STEREOSCOPIC & PHOTOGRAPHIC COMPANY.

No. 11. VIEW OF THE NAVE. (3)

7 London Stereoscopic Company, *View of Central Hall, International Exhibition of Arts and Manufactures, Dublin,* 1865, stereoscopic card.

than photographs dominated the visual representation of Irish political life for much of the mid-nineteenth century.[23]

With the advent of Disdéri's *carte-de-visite*, commercial portraiture expanded in cities and provincial towns in the 1860s.[24] The explosion of the *carte-de-visite* was most marked in Belfast, where commercial studios were concentrated around a small number of streets. In Dublin the tight geographical area in which studios had been established resulted in increasingly cut-throat competition for customers.[25] The expansion of studios producing *cartes-de-visite* in the city was reliant upon trade generated by colonial administration. Many studios advertised themselves as being patronized by the monarchy, or as photographers to military officers passing through the capital on their journeys to barracks in the south and west of the country.

The turning point for commercial photography emerged out of the success of the International Exhibition of Arts and Manufactures, held in Dublin in 1865 (illus. 7). In the year before the exhibition less than twenty photographers appeared in Dublin's street directories; by the end of 1865 the number had risen to over 30. The prevalence of industrial

portraiture in the photography section was not lost on the English photographer and writer John Werge, who sarcastically noted in his report on the exhibition that

> in graphs and the various forms and fanciful applications of photography to portraiture, &c., there are stereographs and micrographs, and the old-fashioned 'sit-on-a-chair' graphs, the 'stand-not-at-ease' graphs, the 'small carte' graph, the 'casket gem' graph, the 'magnesium' graph, the 'cameo' graph, the 'double-stupid' graph, and the latest of all novelties, the 'turn-me-round' graph.[26]

The most significant aspect of the photographic section for Werge was photography's unique designation within the exhibition's categorization of industrial objects.[27] Unlike the International Exhibition of 1862, on which the Exhibition of Arts and Manufactures was modelled, photography was categorized among the fine arts rather than with machinery.[28] Sir John Joscelyn Coghill, organizer of the photographic section to whom Werge exclaimed photographers were 'indebted' for the space allocated to their works, could even boast in his report for the exhibition catalogue that 'for the first time in the annals of International Exhibitions their [photographers'] remonstrances [sic] were listened to, and their works relieved from the degradation of being officially branded as the mere products of machinery'.[29]

The photography section included among its exhibits the latest landscape, portraiture and allegorical studies by Julia Margaret Cameron, Henry Peach Robinson and Oscar Rejlander, all of whose work exemplified photography's claims to the 'sensibilities' of an art form. [30] The inclusion of these international photographers contributed to the successful reclassification of photography in the schematic categorization of industrial exhibitions. This was identified as a milestone in the development of photography's place among the arts by Coghill, who proclaimed triumphantly in the exhibition catalogue that

> the small jealousies of a few narrow-minded art-pedants which proved so injurious, and indeed near fatal, to the formation of a

Cork, Bishop of (Dr. Gregg)

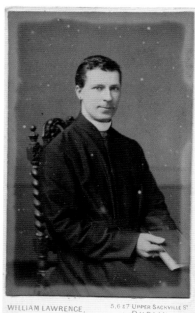

WILLIAM LAWRENCE. 5,6 & 7 UPPER SACKVILLE ST DUBLIN

8 Irish Commercial Portrait Studios, *carte-de-visite, c.* 1865.

9 William Lawrence, *Anonymous, c.* 1865, *carte-de-visite.*

collection of photographs in the London Exhibition of 1862, found no favour in the councils of those who watched over the interests of the Dublin Exhibition of 1865, and Photography was publicly assigned her rightful place among the sisterhood of 'the Fine Arts'.[31]

The year of the exhibition also saw the introduction of a new type of photographic enterprise on the streets of Dublin, which would dominate commercial photography in Ireland well into the twentieth century (illus. 8). In the city's newspapers an advertisement appeared announcing the opening of a new studio by William Mervin Lawrence on Sackville Street.[32] The Lawrence name was well established in Dublin's commercial life.[33] John Fortune Lawrence, William Lawrence's brother, operated a studio at the Civet Cat Bazaar on Grafton Street and their mother had run a chandlery store in the city since the 1840s.

Lawrence himself was no photographer. Although his initials 'W. L.' became the brand for all photographic imagery produced by the company,

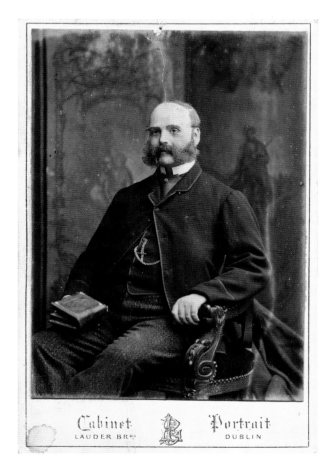

10 Lauder Brothers, *Anonymous*, c. 1890, hand-tinted cabinet card.

the advertisement noted that a Mr Taylor, 'late Principal Photographist at Cranfield's', would be operating the studio. Lawrence was a new breed of photographic capitalist whose incorporation of photography into the family business led to the establishment of Lawrence's Great Bazaar and Photographic Galleries, which included a Royal Archery Gallery and a toy shop. Lawrence combined the public's interest in the visual spectacle of the photographic studio with popular entertainment and leisure activities within one department store (illus. 9). Lawrence's Bazaar produced a range of photographica, from the *cartes-de-visite* of prominent religious and political figures exhibited in his galleries to photographic medallions, stereoscopic cards and, by the 1880s, a series of photographically illustrated tourist books published under the title *The Emerald Isle*.[34] The nearest commercial rival to Lawrence's Bazaar was the Lafayette Studio, run by Edmund Stanley Lauder and his sons, including James Stack Lauder, trading under the name The Lauder Brothers (illus. 10). The Lafayette company eventually became one of the most successful and popularly acclaimed portrait studios in Britain, receiving commissions to take portraits at the Duke of Edinburgh's Devonshire Ball to commemorate Queen Victoria's Jubilee in 1897.[35]

Irish photographers also established commercial enterprises in England's colonies overseas. One of the earliest commercial photographers in India was William Baker, a former Irish Sergeant with the 87th Regiment of the British Army. With John Burke, a soldier from Wicklow, Baker established commercial photographic enterprises in Peshawar and Murree from 1861, producing portrait and topographical imagery of northern India, Kashmir and Afghanistan (illus. 11). Baker and Burke incorporated the pictorial conventions of picturesque aesthetics in

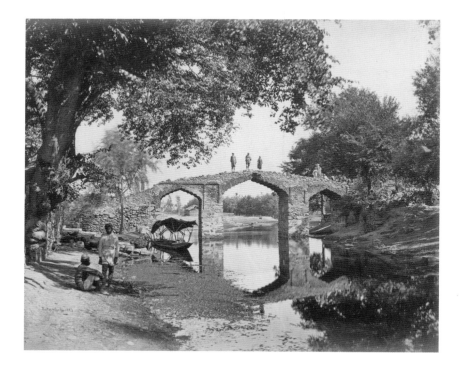

11 William Baker and John Burke, *Akbar's Bridge, Dull Canal, Cashmere*, 1868–72, albumen print.

their photographs, depicting for the European viewer the alien territory of India as aesthetically familiar yet visually exotic.[36] Burke was also a photographer for the Archaeological Survey of India in the 1860s and documented the British military's role in India and the second Afghan War of 1878–80.

On Mutual Relations

The introduction of calotype photography appeared in 1841 among landlords and military officers who travelled between Ireland and England. The Scottish physicist David Brewster had an ongoing relationship with the Royal Irish Academy and one of his associates at the University of St Andrews, the Dublin chemist William Holland Furlong, sent negatives through Brewster to William Henry Fox Talbot because he was unable to

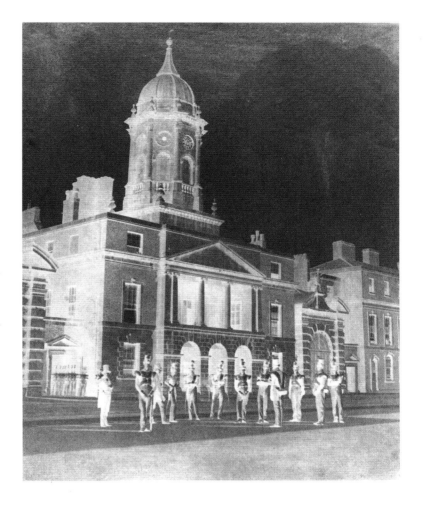

12 Captain Henry Brewster, *Guardsmen Standing Outside Castle Yard, Dublin*, c. 1840, calotype negative.

successfully fix a positive image from his calotype negatives.[37] Brewster's son, Captain Henry Brewster, was an officer whose regiment was stationed in Cork in 1842. Brewster experimented with oiling his negatives, successfully producing calotypes of the area surrounding his barracks in Buttevant as well as a series of portraits of military officers of the 46th Regiment of Foot in 1843 (illus. 12 and 13).[38]

Interest in calotype photography grew rapidly among the Anglo-Irish land-owning classes, who lived in what were popularly known as

the Big Houses scattered across rural Ireland. Geographically separated from the cosmopolitanism of England, and socially alienated from the peasant labourers who worked that land beyond the walls that enclosed the landlord's demesne, the Big Houses became sites of technological experimentation and innovation. Photography quickly became an essential part of expressing the modernity of cultural life within the confines of Ireland's Big Houses. Big House photography was characterized by the amateur ethos of early Victorian photography in England, and amateur photographers travelled between the two countries and to England's colonies on the popular Grand Tours. Among the earliest to pursue the calotype in both Ireland and England's colonies was John Shaw Smith (illus. 14). A wealthy landowner from Cork, Shaw Smith travelled on the Grand Tour of southern Europe and the Middle East in 1850 and 1851. Producing over 300 calotypes during his journey, Shaw Smith, like many other amateur photographers during this period,

13 William Brewster, *Officers of the 76th Regiment of Foot at Cork Barracks*, 1842, calotype.

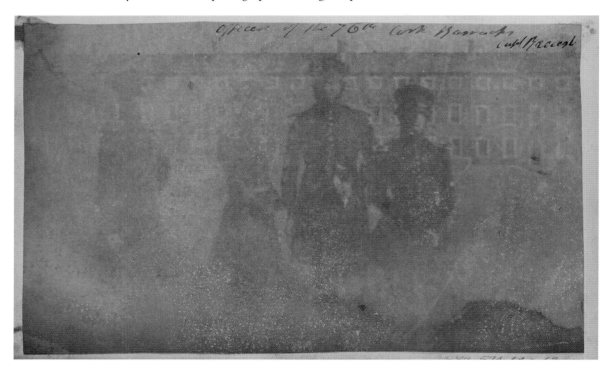

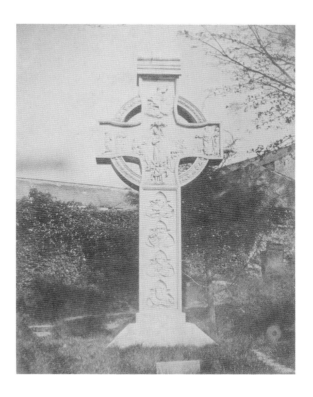

modified Talbot's process to make it more adaptable to the extreme temperatures of the Middle East.[39]

Despite the obvious meteorological obstacles that had to be overcome in their production, the role of Shaw Smith's photographs in the formation of the visual imaginary of imperialism is more complex than their technological execution. When François Arago announced Daguerre's invention to the Chamber of Deputies on 15 June 1839, he exclaimed that had the daguerreotype been invented in 1798 when France undertook a major survey of Egyptian antiquities, the world would now possess 'faithful pictorial records of that which the learned world is forever deprived by the greed of the Arabs and the vandalism of certain travellers'.[40] Shaw Smith's photographs depicted the architectural details of Egypt's monumental archaeological past, preserving them in the deep storage of the pictorial surface of the portable and reproducible geometric form of

salt-paper negatives, from which he produced calotype prints.[41] He compiled many of his calotypes into bound leather albums with letter-script instrumentally describing the location of each architectural detail photo-mechanically exposed by his camera. Shaw Smith took his photographs at the very moment when the discourse of possession through the image merged with the conflation of vision and power in European colonization of the 'Orient' and the Middle East.[42] The photographs of Egypt's archaeological heritage contributed to the shaping of the West's visual and visualizing perspective of the Middle East as an exotic yet vanishing ancient culture that required rescuing through the civilizing project of European imperialism. Photography's descriptive realism, and its ability to visually preserve the ruins of this ancient culture, placed it at the centre of European concerns to visually salvage the remnants of Egypt's archaeological past from the alleged barbarism of its own people.

Shaw Smith's calotype photography envisaged a form of iconographic cross-colonialism between the Middle East and Ireland. Amongst his photographs of architecture are salt-paper negatives and calotypes of ruined round towers and ecclesiastical architecture. Although his calotypes of Egypt and the Middle East dominate the albums he compiled in 1852, among his collection is a photograph of the ruins of a Celtic high cross. A visual comparison is established between the pictorial constructions of the two different colonies. The visual displacement of the centre-periphery model that dominated the reception of colonial imagery in the nineteenth century was collapsed into a broader imperial visual discourse of equivalence between Ireland and Egypt as requiring the pictorial preservation of photography to salvage the erosion of their archaeological heritage.

William Despard Hemphill's photographs display a similar paternalistic sentiment in the pictorial preservation of Ireland's ecclesiastical architecture. Hemphill, a surgeon with strong unionist views, once remarked that the 'mild and benignant laws under which she [Ireland] is governed, give her more temporal freedom than perhaps any nation on the face of the earth'.[43] Hemphill's stereoviews of Clonmel, which he compiled as the book *The Abbeys, Castles, and Scenery of Clonmel and The Surrounding Country* in 1860, drew attention to the temporal depth of Ireland's ruined architecture (illus. 15).[44]

Like many Anglo-Irish photographers, Hemphill's pursuit of photography was undertaken under the spectre of the Famine and the escalating conflict between Irish peasants and landlords. Various agrarian movements from the White Boys to the Ribbonmen had been active in Tipperary against the land-owning classes, with whom Hemphill socialized and who also purchased his serialized stereoscopic book. His introduction of the picturesque into his depiction of the ruined abbeys and castles was thus not an innocent attempt to bring aesthetic harmony to his photographs, but a compositional strategy that concealed any visible trace of agrarian conflict between landlord and tenant. The incorporation of the colonial picturesque into the photographic depiction of antiquities and ruins was not about making visible the remnants of a once illustrious past now lost, but rather the masking of social unrest through the aestheticization of the landscape.

While the aesthetics of the picturesque was used by Irish amateur photographers in their representation of Ireland outside the boundaries of the Big House, a number of amateurs turned the camera inwards. Taking as their subjects the domestic surroundings of their homes and the social life of the Anglo-Irish ascendency, the turn towards domesticity functioned as a symbolic counter-narrative of the primitive, conflicted world outside the private demesne of the Big House. Many amateur photographers followed the developments and aesthetic interests of amateur photographers in England, pursuing what Coghill proclaimed were the 'mutual relations of photography and art'.[45]

Mary, Countess of Rosse, whose husband, Lord Rosse, along with William Lake Price, convinced Fox Talbot to abandon his patent of the calotype, took photographs focused almost exclusively within the demesne of the Big House (illus. 16).[46] Like in many other Big Houses, photography was used to document the technological cosmopolitanism of domestic life as well as being an expression of modernity in itself.[47] A recurring theme in Lady Rosse's photographs was the modern technologies of sciences, learning and leisure. The Rosses built an 18-m (60-ft) telescope, 'The Great Leviathan', in the grounds of the castle, through which Lord Rosse attempted to take photographs of the moon with technical advice from Fox Talbot. Countess Rosse's photographs frequently

15 William Despard Hemphill, *Holycross Abbey, Clonmel, Co. Tipperary*, c. 1858, dry-plate.

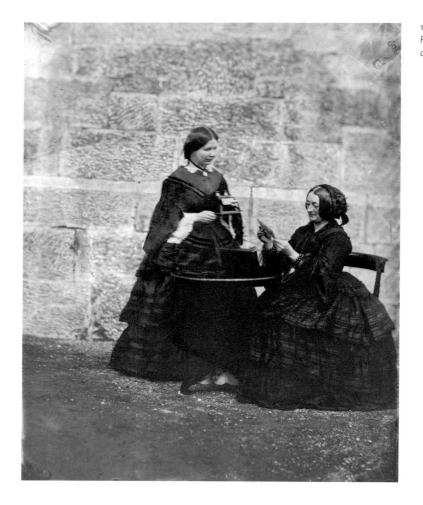

16 Mary, Countess of Rosse, *Mary Rosse Examining Stereo Transparency*, c. 1855–6, print from calotype negative.

depicted telescopes, microscopes, optical devices, cameras and other technological expressions of Anglo-Irish modernity. The cultural practice of photography as leisure activity was itself a sign of Anglo-Irish modernity. Lady Augusta Dillon and her family at Clonbrock House frequently photographed themselves taking photographs or incorporated references to photography into their repertoire of subjects (illus. 17). The Dillon family constructed a purpose-built 'Photography House' on the grounds of the estate, which frequently appeared in their

17 Dillon Family, *Augusta Caroline Dillon and Luke Gerald Dillon with Camera on Tripod reflected in a large Mirror*, c. 1865, print from glass photonegative.

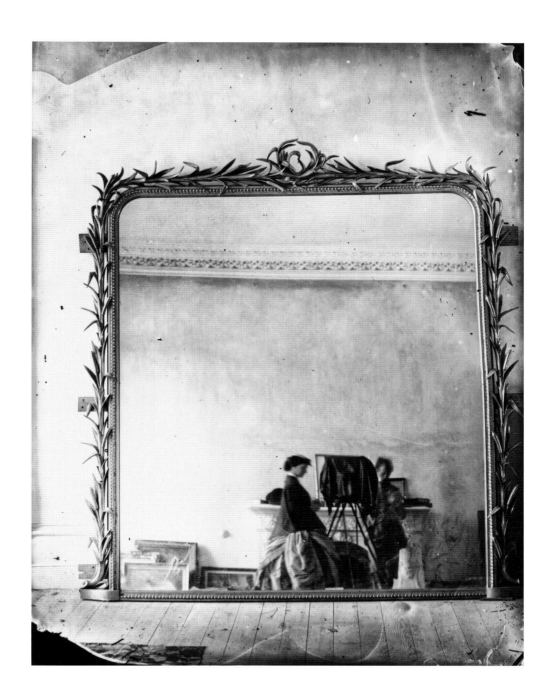

18 Lady Clementina Hawarden, *Grounds of Dundrum House, Multeen River in Foreground*, c. 1858–61, albumen print.

photographs, and photography contributed to the performance of their individual sense of modernity.

Other photographers, such as Lady Clementina Hawarden, also photographed within the confines of the Big House (illus. 18). Best known for photographing her adolescent children in London, Hawarden's photographs of life at Dundrum House, County Tipperary reflect a sense of introspection and isolation. Hawarden resided in Ireland at a time when the Famine still cast a shadow over rural life. Her photographs of the dense forest that enclosed the house from the outside world suggest the privileged seclusion of the landlords' demesne. By filling the frame with thick forest, Hawarden appears to deliberately limit the photograph's ability to visually imagine the horror of the Famine that scarred the landscape outside the physical boundary of the Big House.

adoption of a conservative camera aesthetic with a large depth of field that directed the viewer to the detail of the activity being displayed. His photographs documented traditional rural life, frequently through staged ethnographic performances of farming techniques and customs.

Photography was used by amateur antiquarians and ethnologists to produce a sense of communal identity and belonging. The depiction of Ireland's cultural heritage was not simply intended to preserve a vanishing way of life and to consign its visual manifestations in the photograph to the archive. History was made useful, the past became productive and the photographic image contributed to the collective memory of a shared cultural heritage.

Other amateur Irish ethnographers used photography to highlight the plight of indigenous populations in the colonies. In 1892 Roger Casement joined the British Foreign Service working in the Congo and Peru carrying out several reports of human rights abuses by the Belgian military, colonial companies and their employees.[55] Casement would pursue this role of photography in the struggle against Western imperialism throughout his career, including his reports on the Putumayo Indians of Peru in 1910 (illus. 23).[56]

Imagining Ireland

Photography was increasingly used to express political and cultural allegiances in the first two decades of the twentieth century. Magic lantern slideshows of royal visits and imperial conquests were publically exhibited to demonstrate loyalty to the British monarchy (illus. 22).[57] The invention of half-tone printing and phototelegraphy resulted in press photography dominating the representation of shifts in Irish society. From 1913 to 1921, when the Act of Treaty put into law the partition of Ireland into the six counties of Ulster and the 26 counties of the Irish Free State, press photography increasingly shaped emerging geographical imaginings of Ireland amongst nationalists and unionists.[58]

The Easter Rising of 1916 marked the culmination of a period of political upheaval resulting in the revolutionary struggle for Irish

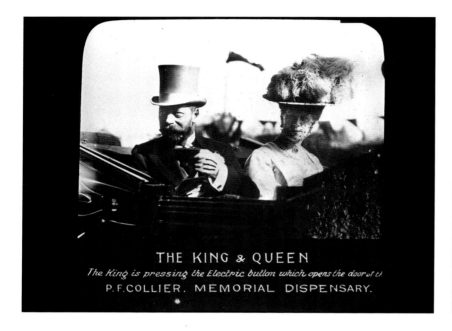

THE KING & QUEEN

The King is pressing the Electric button which opens the door of t[...]

P. F. COLLIER. MEMORIAL DISPENSARY.

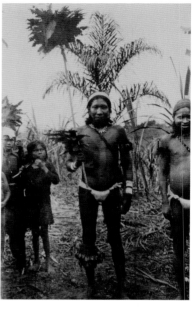

independence and the establishment of the Irish Free State on 6 December 1921 under the terms of the Anglo-Irish Treaty. Photography's ability to portray the rapidly shifting political landscape during this period was quickly identified by newspapers eager to exploit its potential to attract readers. As well as employing staff photographers to document conflict such as that between rebel forces and the Black and Tans during the War of Independence, the *Freemans Journal* newspaper frequently appealed for readers to submit photographs of the conflict they had witnessed in a form of early citizen photojournalism.[59] Joseph Cashman, who managed the photo-engraving department of the newspaper, photographed many significant events of this period, and his photographs contributed significantly to how Irish society witnessed the social and political upheaval taking place across the country.

Cashman's photographs not only bore witness to the political violence exerted by military forces during and after the War of Independence, but also through the camera's capture of the fleeting historical moment, his photographs formed an emerging visual

22 Unknown photographer, *King George v and Queen Mary in Dublin*, 11 July 1911, lantern slide.

23 Roger Casement, *Man Holding Spear, Putumayo region, Peru, Columbia*, c. 1900, black-and-white photograph.

culture of reportage that the public recognized as the pictorial materialization of the nation's history (illus. 24).[60] Thus the press photograph did not merely function as the depiction of a fleeting moment that became obsolete on the morrow of its printing in the newspaper. Instead it served as the pictorial inscription of the emerging nation's collective memory, shaping and giving meaning to the present and the past for the viewer of the photograph.

Politicians too increasingly became aware of the power of press photography to influence public opinion. Demonstrating a shrewd awareness of the impact the spectacle of political drama could have on public consciousness, the unionist politician Edward Carson carefully choreographed his signing of the Ulster Covenant for the camera in 1912 (illus. 25).[61] The dramatic lighting and angle of vision of the photograph emphasized the draped Union Jack flag over the table on which Carson penned the first signature, contributing to the sense of political theatre that symbolically reaffirmed unionist loyalty to Britain. Nationalist politicians and military figures engaged in the process of nation-building before the establishment of the Irish Free State also embraced the media to establish public profiles. Figures such as Richard Mulcahy utilized the

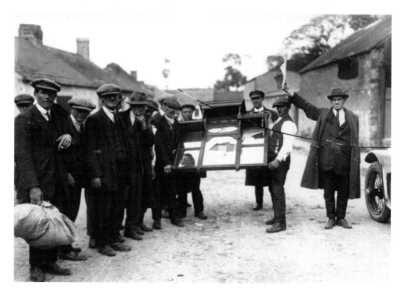

24 Joseph Cashman, *Sack of Trim, Co. Meath by Black & Tans*, 30 September 1920, black-and-white photograph.

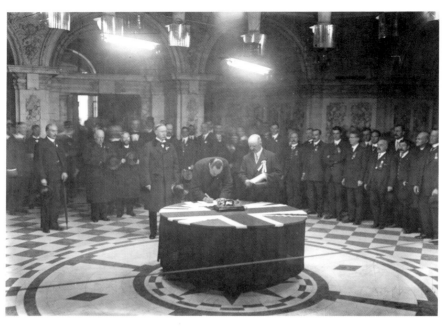

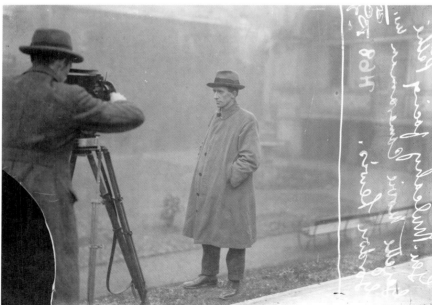

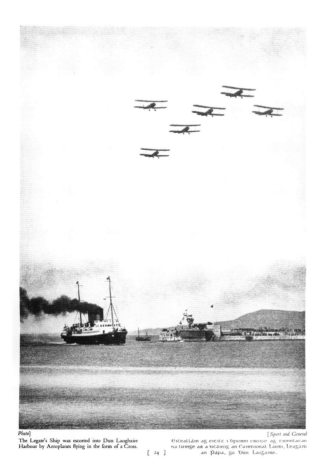

Photo] [Sport and General
The Legate's Ship was escorted into Dun Laoghaire éireaLLáin ag eiteilt i bpriom cnoise ag cionntacán
Harbour by Aeroplanes flying in the form of a Cross. na luinge ar a dtáinig an Caithíolaí Laurí, leagáiro
 [24] an Pápa, go Dún Laogaire.

27 Unknown photographer, photograph
from the *31st International Eucharistic
Congress, Ireland, 1932: Official Pictorial
Record*, 1932.

opposite:
25 Unknown photographer, *Edward
Carson signing Ulster Covenant*, 1912,
black-and-white photograph.

26 Unknown photographer, *General
Richard Mulcahy being Photographed by
Pathé Gazette Movie Cameraman*, 1919,
black-and-white photographic print.

presence of the media to project an image of urgency and authority in their efforts to establish Ireland as a politically autonomous nation (illus. 26).

The technological reproducibility of the photographic image, and its economies of circulation in printed form through half-tone printing techniques in newspapers, magazines and books, increasingly contributed to visual imaginings of Ireland as a modern nation in the years following the geographical partitioning of the country. In the newly established Free State photography's place in the nation-building process was to forge a new sense of progressive modernization in tandem with reinforcing the communal bonds and religious devotion of the Irish citizen. In 1932 Dublin hosted the 31st International Eucharistic Congress (illus. 27), which provided an opportunity for the state to project to itself and to the rest of the world the combination of these modern and traditional signs. With militaristic precision, a choreographed spectacle brought together the display of devotional imagery and Gaelic symbols in a visual projection of Ireland's credentials as a modern Catholic nation.[62] In the souvenir supplements of the national press, camera shops advertised the latest photographic apparatus 'to keep a photo record of the Congress procession'.[63] An official *Pictorial Record* was also produced with photographs of the Irish air force flying in crucifix formation over the arrival of the Papal Legate, electric sky-writing and the ephemeral architecture of round towers constructed on Dublin's main thoroughfares.[64] Through the *Pictorial Record* photography gave a visual permanence to the transitory appearances of national unity and religious devotion, the dynamic perspectives of the photographs as much as the spectacle itself demonstrating the modernity of the nation.

During the 1935 Jubilee celebrations for Queen Mary and King George V, public buildings and civic spaces were illuminated across

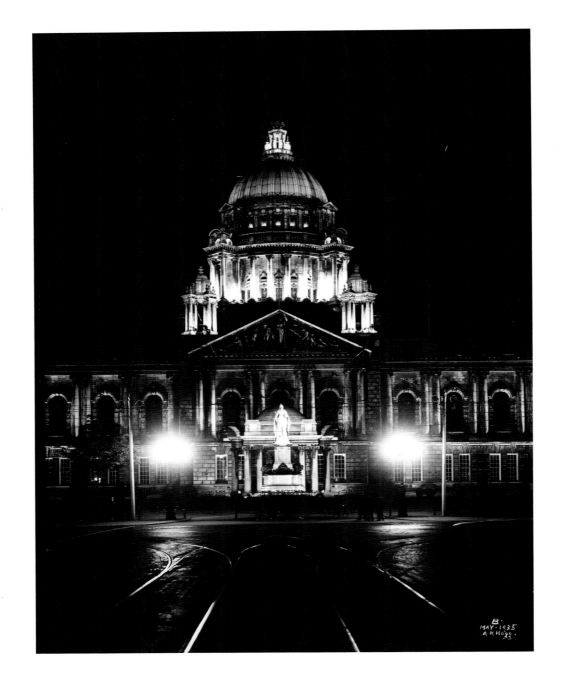

28 Alexander Hogg, *City Hall, North Facade Floodlit*, 1 May 1935, black-and-white print from glass photonegative.

Belfast. The photographer Alexander Hogg produced several photographs of illuminated monuments and buildings during the evening celebrations (illus. 28). The direct style of his photographs emphasized the dramatic visual effect of the lighting on the architectural structures without any supplementary camera aesthetic. The choice of public buildings and civic spaces, electrically illuminated, symbolically demonstrated loyalty to the British monarchy and the United Kingdom.

Documenting Nations

With the awareness of the power of photography to shape popular opinion, politicians also realized its potential for propaganda. Publication of photographs in the print media increasingly became subject to censorship in the Irish Free State during the Second World War because of their potential to influence public opinion of the war. While Northern Ireland was strategically important to Britain's war effort through its role in manufacturing and shipbuilding, on the other side of the border the government declared political neutrality. The war years were referred to as the 'Emergency' south of the border after an official state of emergency was declared in 1939, giving power to the government to censor any material that could undermine its neutrality or generate extreme views on the war.[65] Photographs for inclusion in Irish newspapers and magazines were frequently censored from publication, including those which depicted current weather conditions, because meteorological reports had been banned from print and broadcast media.[66] Illustrated publications including the *Picture Post* were also seized by authorities while photographs of atrocities were banned from publication in Irish newspapers until the end of the war.[67]

The introspection of the Emergency censorship generated a postwar photography that was less concerned with imagining Ireland as a distinct cultural or political community. Photographers began to represent Ireland from a perspective that emphasized a sense of universalism, taking as its subject-matter the ordinary, the commonplace and the routine. The most prominent photographers were chroniclers

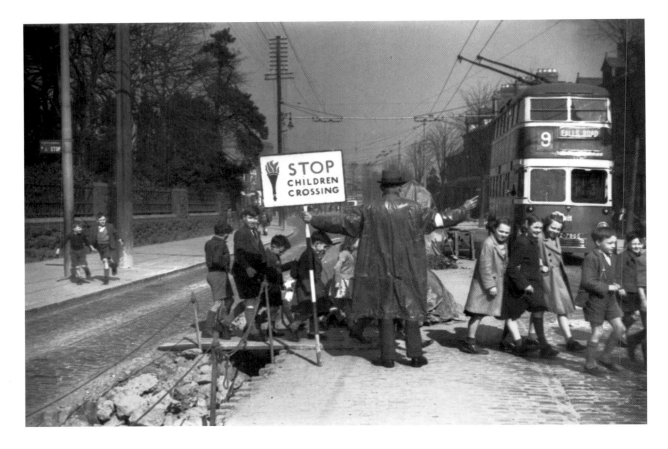

29 Francis Mary Hegarty (Father) Browne, *Guarding the School-Children*, Belfast, 1949, black-and-white photograph.

of Irish life, those photographers who either individually or as staff photographers for newspapers systematically documented Ireland over several decades.

Francis Mary Hegarty Browne (Father Browne), a Jesuit priest, was one such photographer. Father Browne, who took photographs during his chaplaincy of the Irish Guards during the First World War, documented Irish life across five decades as well as taking photographs of RMS *Titanic* during its maiden voyage from Southampton to Queenstown.[68] Father Browne's photographs depicted the particular characteristics of Irish life but from the perspective of universal themes of work, childhood, leisure and family (illus. 29). Colman Doyle, a photographer

with the *Irish Press* newspaper, similarly chronicled Irish society from
the 1950s, his earliest photographs representing the everyday flow of life
across cities and big towns to rural life in villages and outlying islands.[69]
As chroniclers of Irish life, Browne and Doyle travelled different routes
in their depiction of social change. Browne took photographs of his own
volition and it wasn't until 1985 that his meticulously indexed, annotated
and archived collection of over 35,000 images of Irish life came to wide-
spread public attention.[70] Doyle, on the other hand, had just settled
into the first decade of a career as a photojournalist in the year Father
Browne died. Doyle combined his press work with his own interests
in documenting Irish society, providing him with the opportunity to
organize his press photographs to chronicle cultural and political
change in Irish society.[71]

Doyle's and Browne's surveys of half a century each of twentieth-
century Irish society looked in opposite directions. While Browne's
photographs provided a nostalgic image of Irish life that was seemingly
unfettered by political upheaval or conflict, Doyle's photographs docu-
mented a society that was at once disappearing into the fog of myth and
tradition, yet emerging into an increasingly volatile and insecure cultural
and political future. What surfaces in Doyle's chronicles of more than
fifty years is an Ireland of stark oppositions; rural and cosmopolitan,
primitive yet modern (illus. 30).

The post-war years also witnessed a new phase of foreign photogra-
phers travelling to Ireland who worked in the photojournalistic tradition
of documentary. Henri Cartier-Bresson and Elliott Erwitt both visited
Ireland during the 1950s and '60s, bringing a rigorous photographic
formalism to bear on the contingency of Irish social life. Cartier-Bresson's
poetics of the photographic image, his now famous concept of the 'decisive
moment', identified photography's 'recognition of a rhythm in the world
of real things' as its core compositional quality.[72] Ireland provided photog-
raphers such as Cartier-Bresson with a range of 'fugitive moments', as he
described them, through which to explore photography's potential to
register the compositional unity of everyday life. The resulting image of
Ireland that emerged through this rigorous compositional approach was
skewed towards the esoteric rather than the social. Unlike photographers

such as Browne and Doyle, it was the form of Irish social life rather than the content that photographers such as Cartier-Bresson privileged (illus. 31). Photography's emphasis on ordinary life, the popular routine of the everyday, was devoid of any overt political resonance.

Out of the Shadows

One of the criticisms labelled at foreign photojournalists and documentarians has been the repertoire of stereotypes that they have continually produced of Ireland and the Irish. A succession of

30 Colman Doyle, *Garda with Lost Child, College Green*, c. 1950, black-and-white photograph.

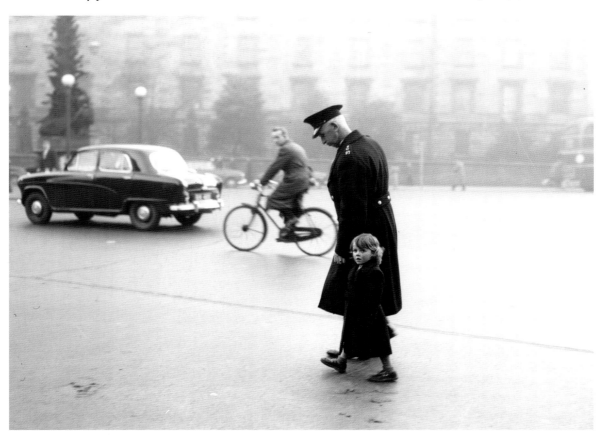

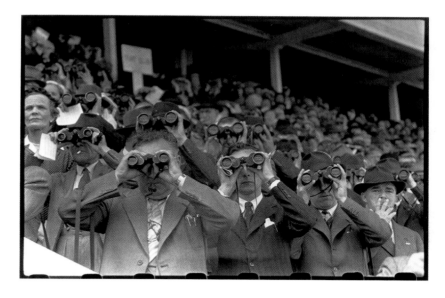

31 Henri Cartier-Bresson, *Horse Racing, Thurles, Co. Tipperary*, 1952, black-and-white photograph.

international photographers visited Ireland throughout the 1950s, '60s and '70s but were seemingly unable to break out from the prison house of pictorial codifications of Irish society. Each photographer proclaimed to offer a new insight into Irish life but few delivered anything more than slight variations or more technologically developed approaches to the existing visual cliches. While it is certainly true that many photographers reinforced and contributed to the photographic arena of stereotypes, several contributed to the development of photographic culture in Ireland.

Photographers such as Josef Koudelka and Martin Parr influenced an emerging generation of Irish photographers, if not so much by their particular style of photography, then certainly through their awareness of the possibilities of photography as a form of visual communication that could question how Ireland could be 're-imagined' in the late twentieth century (illus. 32). In the late 1970s and early '80s the emergence of a vibrant photographic culture appeared bolstered by the opening of a dedicated Gallery of Photography in Dublin in 1978.[73] The gallery exhibited the work of international photographers as well as promoting Irish photography to a national and international audience. The fledgling gallery's showcasing of Irish photography was supplemented

in 1981 by the Arts Council of Ireland's first survey exhibition of contemporary Irish photography, 'Out of the Shadows', followed by two further independent group exhibitions, 'Contemporary Irish Photography' in 1987, and 'Contemporary Irish Photography: Captured Light' in 1989.[74]

The photographic field in Ireland has clearly narrowed somewhat since then and several photographers who exhibited in the exhibitions drifted into obscurity. However many, such as Daniel de Chenu, Rod Tuach, Tony O'Shea, Derek Speirs, David Farrell and Tony Murray evidenced the breadth of Irish photographic culture, covering street photography, social documentary and the pursuit of photographic formalism (illus. 33). European aesthetic and political influences are clearly marked in photographic culture during this period, and were readily if somewhat negatively acknowledged by exhibition curators.[75]

33 Daniel de Chenu, *A Woman Experiencing a Statue of the Holy Virgin Manifesting Itself as the Faces of Jesus Christ and Padre Pio, Mountmellary Grotto, Co. Tipperary*, 1986, black-and-white photograph, from the exhibition 'Captured Light', 1989.

32 Josef Koudelka, *Ireland*, 1976, black-and-white print.

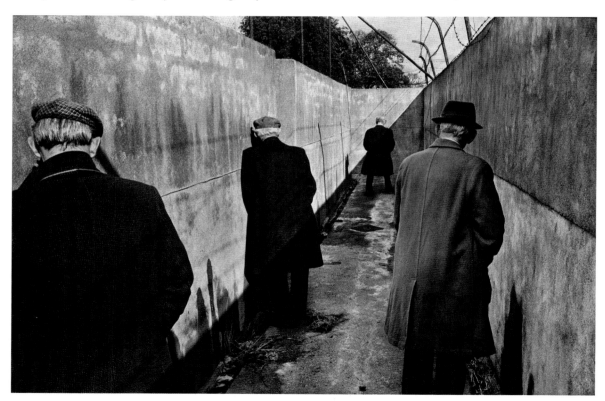

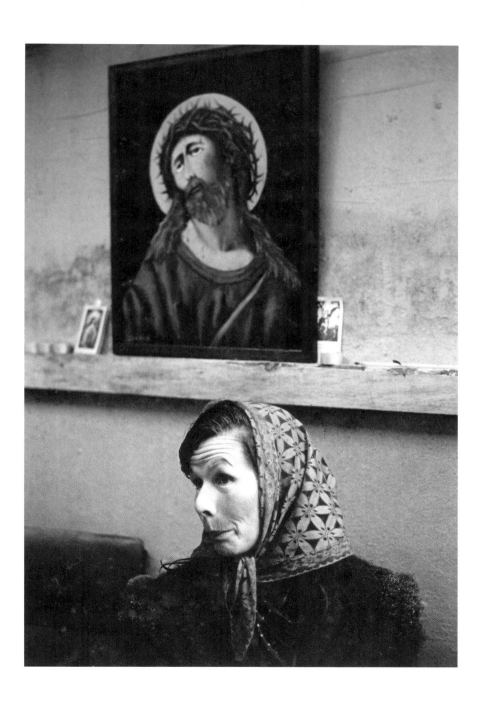

In the introductory essay to the catalogue for 'Out of the Shadows', the curator, explicitly referencing Cartier-Bresson's compositional aesthetic of the 'decisive moment', remarked that 'few Irish photographers intellectualise their work to this extent'.[76] This was clearly a miscalculated statement. Far from being a photographic backwater, Irish photography began to develop a critical approach to the aesthetics and politics of the photographic image and its cultural imaginings of Irish identity. This critical engagement with the politics of photographic representation was influenced less by the singular compositional instant espoused by Cartier-Bresson, than by the self-conscious awareness of the limitations and possibilities of the photographic form pursued by photographers such as Koudelka and Parr. The range of photographic work appearing in the magazine *Source* from the early 1990s, for example, is testimony to the engagement with contemporary photographic debates internationally and their re-articulation within the specific aesthetic and political concerns of photographic culture locally. Initially published as a newsletter by Photo-Works North in 1992, *Source*'s early issues were orientated toward the development of contemporary Irish photography, providing a much-needed vehicle for the emergence of a critical dialogue on photography within Irish society.[77]

Several significant projects emerged in the late 1980s and throughout the 1990s which laid the foundations for photography's critical intervention into contemporary Irish society. Paul Seawright's 1988 *Sectarian Murder* series combined conceptual approaches to documentary with the analysis of media depictions of the Troubles to explore the psychological sectarianism that had remained seemingly imperceptible to portrayals of sectarian conflict in photojournalism and the print media.[78] In 1990 the publication of Tony O'Shea's *Dubliners* utilized the form of the photo-book to combine his dark documentary images of the city into a dissenting vision of the hypocrisy and failure of the Irish state.[79]

Anthony Haughey, who like Seawright had studied documentary photography in Britain, spent a year photographing family life in a social housing estate on the outskirts of Dublin in the early 1990s. The series *Home* was a radical departure from the documentary work that had previously been produced on Ireland's working-class housing estates.

the mundane and the everyday to mask the carefully choreographed composition of the photographs. Starkey's spatialization of the decisive moment seems to amplify the boredom and alienation of the female characters that populate the generic, nondescript places that stage the performances she photographs (illus. 36).

The transnational themes explored in Morrissey and Starkey's work emerged out of the resurgence of Irish photographic culture in the 1990s. However, it would be incorrect to view this as somehow emblematic of a new-found, twenty-first-century transnationalism in Irish photography. The various 'routes' through which photography and Ireland have connected to the rest of the world have merely become more formalized and dynamic. What is worth reflecting on, perhaps, is how this may speak of the globalizing effects of the art world on the ongoing development of Irish photographic culture.

That Vast and Absorbing Subject

In 1937, the year a referendum was held in the south of Ireland to adopt a new Constitution, the London publishing firm B. T. Batsford issued the third in a series of illustrated travel books on Ireland.[1] Despite the political backdrop to the book's writing, the author was at pains to stress that his aim was merely to 'describe what Ireland really *looks like*, at least to my eyes'.[2] His only acknowledged political comment was confined to an observation on the border counties: 'For Ireland, whatever its political differences, is one country; and it is only the arbitrary significance of this dotted line, after all, that impels one to treat the Six Counties as a separate scenic entity.'[3]

What unified Ireland's discrete 'scenic entities' for the author was the seemingly transhistorical and transcultural aesthetic principle of the picturesque. Popular definitions of the picturesque usually describe it as being a word that designates an object – a landscape, building or even a person – as appearing like a picture. Certain objects, out there in the real world, are ascribed with the compositional qualities of an image before their actual representation in textual or pictorial form. This is how the word is applied to landscape in popular tourist parlance, and the publishers of *The Face of Ireland* stressed that the book was written 'in a pleasantly human vein which always takes into account the friendly picturesque life of rural Ireland'.[4] Despite its title, the book rarely described people, but the point was clearly made: a certain natural harmony was perceived to exist between the landscape and its inhabitants that bestowed Ireland with qualities of the picturesque. This was provided that the tourist was able to see Ireland as the author did, through his 'eyes', as it were. For

of Ireland also incorporates the cultural legacy of the Famine that continues to circulate within historical narratives and memories that are performed relationally between viewers and photographs of post-Famine landscapes. This process frequently operates through the viewer's mnemonic narrative performances of historical knowledge, diasporic experience and collective memory of the Famine and its lingering traces across a range of photographic imagery.

Within Irish visual culture the Famine is most conspicuous through its photographic absence; that is to say, its lack of depiction in the mechanical pictorial form of the photographic image. The Famine was represented in a range of mechanically reproduced images at the time but never, it would appear, in photographs. Somewhat mirroring Helmut Gernsheim's infamous question as to why photography was not invented sooner ('Considering that knowledge of the chemical as well as the optical principles of photography was fairly widespread . . . that photography was not invented earlier remains a mystery'), a question has emerged regarding the absence of photographs of the Famine.[20] In a similar spirit the question posed is that, given photography was invented in 1839, and that photographic processes and apparatus were democratically available in Ireland during the period of the 'Great Hunger', why are there no photographic records of the Irish Famine?

This question has more urgency given the assertion of historians that the Irish Famine was the 'first media famine of the modern era'.[21] The Irish Famine was represented extensively during the period in eyewitness accounts, journalistic reports published in books, and the popular illustrated press. Many artists used pre-photographic optical apparatus such as the *camera obscura* and *camera lucida* to depict the Famine for publications such as the *Illustrated London News*.[22] Given the level of public visual record and the availability of photographic technologies at the time, the absence of photographs of the Famine appears troubling to some historians.

In 1996, during the 150th anniversary commemorations of the Irish Famine, a short animated film by Steve Woods addressed itself to this absence. *Ireland 1848* was produced as a piece of cinematographic reportage in a similar vein to the silent Pathé News features of the late

nineteenth century. Produced by the fictional cameraman Lucien P. Hogan Esq., the animated film projects the invention of film back more than half a century to the Irish Famine. Threaded through this imaginary scenario is the concept that the invention of cinema, photographic realism and the Famine are bound together historically. The narrative of *Ireland 1848* imagines what the mechanical, photographic representation of the Famine would look like had it been documented in film. Some of the images produced using pre-photographic optical apparatus that appeared in the *Illustrated London News* are remediated in animated photographic form in *Ireland 1848*. This might suggest that had photographs been taken of the Famine they would not have differed much in form from the illustrations that appeared in the popular press. However, what is at stake in questioning the absence of photographic images of the Famine, it would appear, is not the non-existence of 'camera' imagery, as many contemporary pictorial images documenting the Famine through optical apparatus exist, but the longing for the authenticity and realism of the photograph.

The implication of the absence of photographic imagery of the Famine is one of cultural hegemony. Photographic culture during the Famine years was dominated by wealthy landlords whose tenants were dying or abandoning their cottages as a consequence of the Famine. These are the Big House photographers discussed in the previous chapter, whose photographic activities were largely confined to the insular world of their own private, walled, picturesque landscape. As this social class of photographers controlled the means of producing and distributing photographic imagery, it could be argued that they had a vested interest in making sure the Famine was not photographed, as this would result in documentary evidence incriminating themselves and their complicity in the Famine. This is a problematic thesis, not least because the philosophical and ethical concept of documentary, either as socially concerned practice or even a more instrumentally orientated process of 'documenting' catastrophe, had not entered the cultural lexicon of photography among the Anglo-Irish. By concentrating too much on the absence of the actual 'depiction' of the Famine, such a thesis also overlooks how the effect of the Famine may be identified in other ways in the cultural uses of photography. That is to say, the Famine can be traced in the form if not the content of photographs.

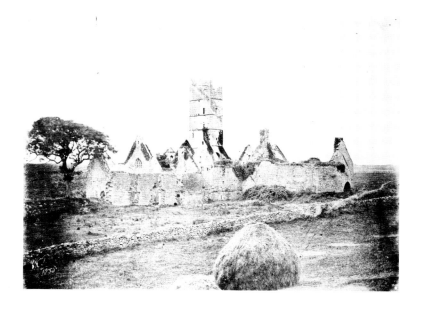

Edward King Tenison and his wife Lady Louisa, who lived in Kilronan
Castle in County Roscommon, acquired a licence from William Henry
Fox Talbot for the calotype process during the Famine.[23] Like many of
their contemporaries, the Tenisons journeyed on the Grand Tour during
the Famine years and Louisa Tenison authored two books illustrated
with lithographs from her travels in Egypt, Syria and Palestine in 1843,
and Spain in 1851.[24] On their return to Ireland, the Tenisons produced
photographs of ecclesiastical and monastic ruins, mostly around County
Roscommon and the neighbouring counties of Mayo and Galway, which
had been most affected by the Famine (illus. 38). The Tenisons were
influenced by the calotype aesthetics espoused most prominently by
William Lake Price in the 1860s, which they incorporated into their
photographs of Irish antiquities.

Louisa Tenison was an amateur archaeologist and financed the
enclosure of ruined abbeys with stone walls and metal railings. Through
this process the architectural remains of a Celtic past and their environs
were aesthetically cleansed of people and livestock which might further
damage ruined structures. The Tenisons used photography in a similar

fashion by utilizing picturesque aesthetics to visually cleanse the landscape of any unruly content that might disrupt their mastery of the post-Famine landscape. In their salt-paper print of Moyne Abbey, County Mayo, for example, the surrounding agricultural landscape is reduced to the compositional aesthetic form of the haystack pictorially framed in the foreground of the photograph. This combination of the picturesque, antiquarianism and the photographic image had symbolic function in the post-Famine visual culture of the landlord. The ruined architectural remains of an ancient Celtic past in the form of the photographic image was a triumph of possession. The photographic ruin could be optically ruminated over by a viewer who recognized in its aesthetic form a connection between past conquests and present victories. Rather than photograph the abandoned peasant cottages of the recent past of the Famine, a more aesthetically palatable image of colonial conquest could be sourced from a more remote history in the form of the architectural ruins of Ireland's Celtic heritage.

Evictions

The most prominent arguments on the desire for photographic evidence of the Famine have suggested that photographs of evictions during the Land Wars of the late 1870s to the 1890s have become posthumous surrogate images for the absence of photographic documentation.[25] Observing the increased use of these images in Irish historiography, Gail Baylis, for example, has noted that the preference for eviction photographs over contemporary mechanical illustrations of the Famine marks a shift towards a desire for the authenticity and realism of the photographic image.[26] This has been most marked in the formation of diasporic cultural memory of the Famine in Irish historiography. Photographs of evictions have become 'de-contextualised' from their 'historical location' and situated in the temporally empty space of diasporic collective memory.[27] This postmodern appropriation of eviction photographs and their re-situating within the context of the Famine is a politically charged one in the formation of nationalist cultural memory.

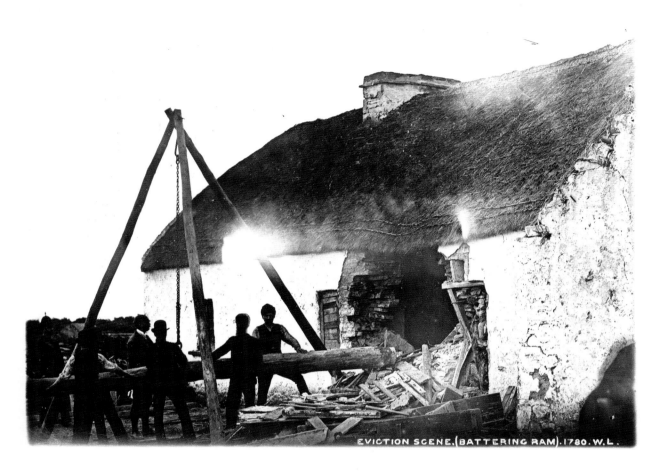

EVICTION SCENE. (BATTERING RAM). 1780. W.L.

39 Robert French, 'Eviction Scene (Battering Ram)', c. 1890, black-and-white photograph from lantern slide, from the series *Eviction* by William Lawrence & Co., c. 1897.

The re-contextualizing of eviction imagery in public expressions of anti-imperialism was perhaps more historically grounded at the end of the nineteenth century than at the end of the twentieth. Recognizing the historical connection between Famine and the Land Wars, a group of nationalists in the late nineteenth century projected these photographic visual traces of the post-Famine landscape onto the urban imperial spaces of the Dublin streetscape. This brief intervention of the photographic post-Famine landscape into the urban visual culture of the second city of the Empire was in defiance of Ireland's expression of loyalty to the British monarchy during Queen Victoria's Jubilee celebrations in 1897.

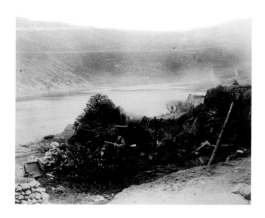

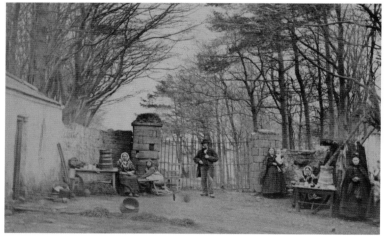

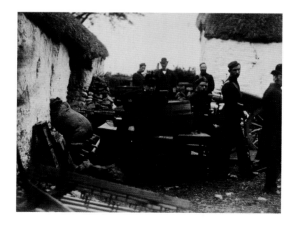

40 Francis Guy, *Widow Quirke's Cottage*, c. 1880, black-and-white photograph.

41 Thomas J. Wynne, 'Eviction Scene', c. 1873, from the *Souvenir Scrap Album* (c. 1873).

42 Unknown photographer, 'Eviction Scene', 1887, albumen print from the *Coolgreaney Eviction* album.

Throughout the 1890s William Lawrence's Bazaar and Photographic Galleries produced a vast catalogue of lantern slides of topographical and political material on Ireland. Included in this catalogue was a series of 60 lantern slides of evictions of tenant farmers during the Plan of Campaign organized by the Land League from 1879 to the 1890s.[28] Lawrence's chief photographer Robert French travelled to many landed estates involved in the evictions of tenants who had refused to pay 'rack-rents' to landlords.[29] French produced many such images of the Vandeleur evictions in 1897, which made up the majority of images in the *Irish Evictions* lantern slide series (illus. 39). Also included was an image relating to the Coolgreany evictions in Wexford in 1887. Photographs of these evictions were compiled in an album by Father T. Mallacy for another priest, Father Laurence Farrelly, who supported and actively participated in the Plan of Campaign in his Wexford diocese (illus. 40 and 41).

During the Jubilee celebrations in Dublin in 1897, the feminist revolutionary Maud Gonne projected these lantern slides of evictions, together with portraits of those who had been executed or died in prison as a result of anti-colonial struggle, onto the gable end of a building on Rutland Square from a window of the National Club.[30] Gonne had intended the lantern slide exhibition as a spectacular counter-demonstration to the Jubilee celebrations, which included illuminated displays along the city's shopfronts and main thoroughfares, which had been decorated with coloured lights celebrating Queen Victoria's reign.[31] The socialist James Connolly arranged for Corporation workers to cut power supplies in the area, allowing the photographic disruption of the triumphant visual spectacle of imperial rule. The photographic post-Famine landscape ruptured the collective memory of submissive loyalty to the British Empire through the ephemeral illuminated instant of the lantern slide projected across the night sky onto the architectural fabric of the city (illus. 42).

Picturing Poverty, Imagining Progress

In the early 1890s, Major Robert Ruttledge-Fair, an inspector with the Congested Districts Board, took photographs of rural life in Connemara,

County Galway. The album he compiled was for James Hack Tuke, a Quaker from Yorkshire who visited Ireland during the Famine in 1847 on behalf of the Society of Friends, and whose reports on 'distress' in the west of Ireland contributed to the establishment of the Congested Districts Board in 1891.[32] The term 'congested districts' applied to those parts of Ireland, predominantly along the western seaboard, that could not sustain the population living from the land. They were congested not through overpopulation but through poverty arising from 'over-dependency of smallholdings'.[33] The Congested Districts Board had legislative powers to compulsorily purchase land for redistribution, modernize farming practices, institute agricultural industries, enforce re-housing and finance emigration. These policies were instituted, as one report proclaimed, to 'raise the mode of life from the submerged condition to which it had been reduced to that of a virile, progressive, self-supporting and self-respecting community'.[34]

Ruttledge-Fair's photographs of Connemara depicted the barren, unproductive landscape to emphasize the poverty of rural Ireland in the pursuit of the colonial administration's policies for managing rural agricultural development. Connemara's stony landscape and coastal location on the western seaboard placed it at the heart of the colonial imaginary of the picturesque Irish landscape. One colonial tourist was to advocate it as the most uniquely picturesque part of Ireland for the artist and photographer while conceding that it also had its depressing side.[35] The duality of poverty and the picturesque became embedded in photography's role within the Congested Districts Board. The unsightly aspect of Connemara's landscape was deemed to be the native's responsibility, its beauty, God's. What was required was divine intervention in the form of colonial rule to help native Irish peasants, who populated the most desolate parts of the land, improve their plight. Morality, poverty and modernity were all conflated as the motivating factors of the visual improvement of the Connemara post-Famine landscape; one inspector, describing the need for the demolishing and re-housing of rural peasants, stated:

Insensible of any violation of human decency; living in such foul surroundings, and in such close association with the brutes of the

field, I have often marvelled how they are so moral, so well disposed and so good in so many ways as they are.[36]

Ruttledge-Fair's photographs measured the modernization of the landscape through colonial administration (illus. 43). His photographs were frequently composed with a large foreground of empty scrubland or rock that emphasized the unproductiveness and desolation of the land. Peasant labourers, many of whom were women carrying kelp from the shore as fertilizer for farms, appear as shadowy spectres passing through the landscape.

In the years following the establishment of the Congested Districts Board, photography was periodically used to document the progress and modernization of rural life initiated through the organization's housing and land redistribution schemes. J. D. Cassidy, a photographer from Ardara, County Donegal, and Robert John Welch were both commissioned to photograph agrarian industries and rural housing (illus. 44 and 45). In their photographs progress became collapsed into aestheticization as the clearing away of unsanitary housing and drawing of property boundaries were projected as the visual modernization of

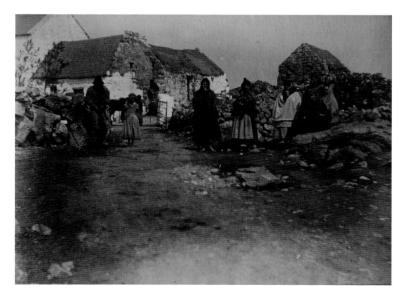

43 Major Ruttledge-Fair, *Family Gathered Outside Stone Cottage*, c. 1892, photographic print.

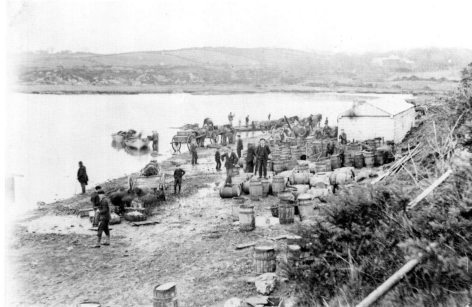

the landscape.[37] Their photographs mapped not only the landscapes they represented but also the colonial programme of managing the failed rural economy of post-Famine Ireland. The greater the level of intervention of colonial administration, the more aestheticized and picturesque the Irish landscape became.[38] Imperial progress was measured through photography's abstract aestheticization of the landscape.[39]

Shifting Temporalities

One of the functions of the Congested Districts Board was to physically and aesthetically remove any trace of communal forms of rural life such as the Rundale system from the landscape, and replace it with visible signs of property boundaries. Throughout the nineteenth century the aesthetic philosophy of the picturesque and private property became conflated in the visual discourse of Irish tourism. The Reverend William Gilpin's eighteenth-century theory of the picturesque advocated a discriminating eye to assemble a scene that would harmonize the whole of what was aesthetically pleasing into a single, uniform image.[40] This theory was pictorially absorbed into the conventions of photographic tourist imagery of the Irish landscape.[41] The landscape was divided into the sublimity of the uncultivated wilderness inhabited by the peasant or tenant farmer, and the tamed nature of the landlord's demesne transformed into the physical form of the picturesque image.[42] The task of the tourist was to demonstrate their ocular mastery by scanning across the landscape to avoid the unsightly wilderness of the peasant and identify the picturesque view constructed around the Big House.[43]

In the late 1860s Frederick Holland Mares's photographs were published in a series of books by Andrew Duthie, including one on Wicklow.[44] Each book comprised of twelve tipped-in albumen prints of Mare's Irish photographs. In *Photographs of Wicklow*, locations such as the waterfall in Powerscourt Estate were identified as worthy of the discerning gaze of the tutored sightseer (illus. 46). Even when tourist locations fell outside the boundaries of the private property of the landlord, photography was used to emphasize the guardianship of the picturesque Irish landscape

44 Robert John Welch, *View from the Dwelling House of Mrs Bridget Kelly, Lisvalley Vesey, near Tuam, Co. Galway,* c. 1906, photographic print, from the Congested Districts Board Collection.

45 J. D. Cassidy, *Herring Fishing at Yellow Banks, Ardara,* November 1907, photographic print.

through colonial administration. Positioning figures in the foreground of photographs displaying their visual mastery of the scene before them, created an imaginary distance between the viewer and the landscape's aesthetic pictorialization in the photographic image. Establishing viewing positions and perspectives that forged geographical imaginings of Ireland throughout the century, the composition of such photographs also reinforced the mobility of the colonial tourist's gaze as it jumped from one photographic rendering of the picturesque Irish landscape to the next.

46 Frederick Holland Mares, 'Powerscourt Waterfall', *c.* 1865, tipped in albumen print, from *Photographs of Wicklow with Descriptive Letterpress* (1867).

47 Unknown photographer, 'Lakes of Killarney', c. 1990, half-tone reproduction, from *Souvenir of the South of Ireland Illustrated and Described* by Simpkin, Marshall, Hamilton, Kent & Co. (c. 1900).

The introduction of photo-engraving and half-tone reproduction facilitated the mass-production of photographically illustrated books of tourist landscape imagery, much of which was dominated by two geographic locations, the Giant's Causeway in the north and Killarney in the south. These two tourist locations required two distinct photographic perspectives that emphasized different temporalities. The panoramic photograph of the Lakes of Killarney in the tourist book *Souvenir of the South of Ireland* depicted the landscape as an empty wilderness to be taken in through one sweeping gaze.[45] The emptiness of the landscape, devoid of people or the outward signs of modernity, conveyed a mythical belief in the geographical remoteness of Killarney. The empty wilderness depicted within tourist photography projected the fantasy of Ireland as being another space in another time (illus. 47). The Giant's Causeway was depicted as a series of discrete sights; a collection of distinct views which emphasized the multi-perspectival experiences of the basaltic columns perched on the coastline (illus. 48). Stereoviews and photographic view albums produced by local photographers such as the Lee Photographic Studios in Portrush drew attention to the visual experience of 'geological time' in series of photographs.[46] The photographic detail was combined with views of the Giant's Causeway that reflected its temporal vastness, the viewing positions and angles of vision emphasizing the travel writer John L. Stoddard's contention that 'in general the Causeway is to be looked down upon, not up to'.[47]

Photography's contribution to the picturesque Irish landscape in tourist guidebooks was tempered only by its technological realism, which merely served to validate its authenticity. The search for the picturesque Irish landscape became a search for an authentic Ireland, the identifiable

THE WISHING CHAIR, GIANT'S CAUSEWAY

LORD ANTRIM'S PARLOUR, GIANT'S CAUSEWAY

HORIZONTAL PILLARS, GIANT'S CAUSEWAY

THE GATE, GIANT'S CAUSEWAY

codes of which were a pre-modern, rural idyll beyond the corrupting effects of Western modernity. Photography became the vehicle through which this prelapsarian image of Ireland was pictorially validated. Although its initial conception was the outcome of the colonial modernization of the landscape, which in a peculiar logic aesthetically cleansed it so that it appeared visually more primitive, the Irish maintained and pursued this pre-modern myth in photography through marketing Ireland as a tourist destination, and in projecting an image of the nation. A photograph for the *Irish Independent* representing a couple looking down the mountainside of Croagh Patrick into Clew Bay in the 1920s, for example, demonstrates how even within popular press photography landscape

48 Unknown photographer, 'The Giant's Causeway', from *Photographic View Album of the Giant's Causeway* (1900).

served to build a sense of national cohesion and sovereignty (illus. 49). The angle of vision incorporated within one single photographic frame shows two perspectives of the landscape: the romantic, undulating contours of the hillside in the foreground, and the flat, cartographic form of fields below. Croagh Patrick has long been associated with religious pilgrimage and the aerial view opened up in the photograph between the two figures looking over their shoulders expanded the associations between landscape, nation and devotional ritual.

The photographic search for an authentic Ireland, a journey contextualized as movement back in time as much as to a distant geographical place, has also provided photographers with material to project their own

49 Unknown photographer (*Independent Newspapers*), *Croagh Patrick*, c. 1920s, black-and-white photograph.

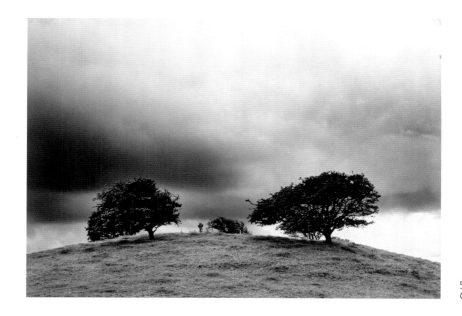

50 Edwin Smith, *Bealin Cross, Twyford, Co. Meath*, 1965, gelatin-silver print.

subjective voyage of the landscape. Edwin Smith's modernist photographs of the Irish landscape differed little in content from those of a century earlier (illus. 50).[48] Trained as an architect, Smith's photographs are heavily structured in their formal depiction of the landscape. The formal qualities emphasized, however, are those of the photographic depiction of the landscape rather than an emphasis of the picturesque qualities of this subject-matter itself. Where earlier photography had sought to conceal the conventions that transformed nature into the picturesque, Smith's self-conscious formalist approach pursued the Irish landscape as a subject that could amplify photographic codes and techniques of representation. From the compositional framing of the scene to the aesthetic qualities of gelatin silver prints, Smith's Irish landscapes functioned as a vehicle through which to celebrate the specific formal characteristics of the photographic medium.[49]

Social Landscapes

The English photographer Martin Parr exhibited his photographs of the west of Ireland at the Orchard Gallery in Derry in 1984.[50] Parr had

included photographs of Ireland in his first book, *Bad Weather*, two years previously, but the work he produced for *A Fair Day* offered a much deeper and troubling analysis of Irish culture than his previous works.[51] Parr had lived in the west of Ireland for two years between 1980 and 1982 and exhibited his work on Ireland at the Gallery of Photography, Dublin in 1983.[52] The west of Ireland had long been the subject for sympathetic, romanticized photographic views of a picturesque Irish landscape, but in *A Fair Day* there was a harshness to the photographs, and his sometimes acerbic gaze exposed a different type of myth that existed in Irish society (illus. 51). Parr photographed an Ireland in the aftermath of a false dawn of economic prosperity and cultural emancipation from the repression of Roman Catholicism. In the accompanying essay to the exhibition catalogue, the cultural critic Fintan O'Toole

51 Martin Parr, *St Mary's Holywell, Killargue, Co. Leitrim*, 1982, black-and-white photograph.

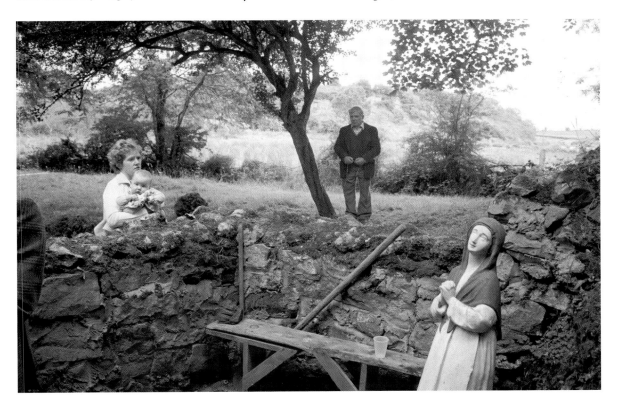

81

observed that before the economic boom of the 1960s, across Ireland were the 'saddest of ruins, on the verge of economic collapse. In the West of Ireland abandoned houses were more common than inhabited ones, as emigration continued to soar.'[53] Parr's series of photographs of rural bungalows displaying the outward expressions of accumulated wealth during the economic boom encapsulated the sometimes grotesque displays of affluence of the 1980s, but with hindsight they are also eerily prophetic of Ireland's current cultural and economic climate.

David Farrell's *Innocent Landscapes* documented the search sites of 'the disappeared' in an allegorical exploration of post-conflict Northern

52 David Farrell, 'Oristown (Graffiti)', 2000, from the series *Innocent Landscapes*, 1999–present.

subject as they gazed into the distance. As Benjamin observed, everything about these early portraits 'was built to last . . . the very creases in people's clothes have an air of permanence'.[11] However, these early portraits of the Anglo-Irish elite, many from the late 1850s, marked a threshold where the style of photography that 'lent fullness and security of their gaze' was beginning to give way.[12] Technological advances in the optics of the camera emerged which would explode the mythical form of the celebratory photographic portrait, bringing with it the decline of the class of subjects once so wholly congruent with the technological form of early portrait photography.[13]

The Deviant Face

In 1860 the Anglican clergyman, Christian socialist and historian Charles Kingsley journeyed through Ireland along the western counties of the Atlantic seaboard. Travelling through Sligo he commented in corres-pondence to his wife back in England on his anguish at what he witnessed of the poverty in rural Ireland. In a much cited example of Victorian anti-Irish racism, he wrote in terms that left no doubt as to the root of his unease at what he had witnessed:

> I am haunted by the human chimpanzees I saw along that hundred miles of horrible country. I don't believe they are our fault. I believe . . . that they are happier, better, more comfortably fed and lodged under our rule than they ever were. But to see white chimpanzees is dreadful; if they were black, one would not feel it so much, but their skins, except where tanned by exposure, are as white as ours.[14]

Kingsley's remarks on the appearance of the Irish face, replete with the rhetoric of evolutionism and the paternalism of colonial rule, are significant not because of their overt racialism.[15] The Irish had been described as being 'more like tribes of squalid apes than human beings' by another English historian much earlier in the nineteenth century.[16] The physician Robert Knox, who had proclaimed that the Celt was the lowest form of 'civilized

man', would even state in his published lectures *The Races of Men* that the 'source of evil lies in the [Celtic] race'.[17] What is significant about Kingsley's remarks, and is at the root of his anxiety about the physical appearance of the Irish, is the lack of visible racial markers that could distinguish the Irish Celt from the Anglo-Saxon.[18] The skin colour of the Irish peasant, it would appear, provided a 'dangerous supplement' that threatened the coherence of Victorian conceptions of the Irish race.[19]

Kingsley made his remarks at the very moment when visibility, physiognomy and evolutionary theories combined in the scientific pursuit of photography as an objective mechanical tool to identify the racial categorization of different peoples through the face.[20] Technological advances in optical lenses and chemical processes combined with the rapid industrialization of photographic portraiture through inventions such as the *carte-de-visite* had increased the fidelity of the photograph to an individual's face. The distance between the photographic portrait and the person's actual identity that had been so crucial to maintaining that 'air of permanence', as Benjamin described it, in early photographic portraiture of the Anglo-Irish elite, had collapsed under the weight of the technologically accelerated realism of the photographic image. This occurred in the 1860s precisely when historical shifts in Irish society had made the reading of the physiognomy of the face a political imperative, as increased agrarian unrest and political conflict began to threaten the comfortable stability of Big House culture and its environs.

Vision and knowledge were bound to belief in photography's confirmation that the outward appearance of the face was the visible, identifiable marker of difference. The Irish face, however, was deviant. Identified through their physiognomy as what John Beddoe described as 'Africanoid', the skin colour of the Irish constituted a problem in the belief of photography's power of seeing and knowing.[21] The Irish face refused to conform to the rational application of photography to pictorially reveal racial characteristics. The photographic documentation of the Irish face thus required supplementary characteristics to emphasize visible difference from the Anglo-Saxon. Compiled in different types of albums to those crafted in the Big Houses, photographs turned the deviancy of the Irish face in on itself in an attempt to discipline the

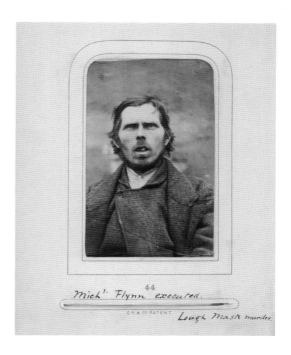

unruly appearance of Irish physiognomy. The deviant face was photo-
graphically transformed into the face of the deviant.

The 'criminalization' of the Irish face was constructed through the
racialism of the 'simian' Celt in the English illustrated press throughout
the 1850s and '60s.[22] Stereotyped imagery in publications such as *Punch*
visually exaggerated the *prognathous* physiognomy of the Irish to empha-
size the savagery of the Celt. Much of this imagery emerged out of the
political anxieties surrounding the rise of the Fenian movement. The
Fenian Brotherhood was founded in the United States in 1858, and emerged
in the aftermath of the Young Irelanders' uprising a decade earlier.[23]
The radicalism of the organization generated official and public interest
in the visual depiction of the organization and its leaders. In conjunction
with the simianized illustrations of *Punch,* an expansive visual typology
of the Fenian face emerged that criminalized Irish identity (illus. 62).
The discourse of criminality surrounding the Fenian face was such that one
journalist countered the conflation of physiognomy and criminality by

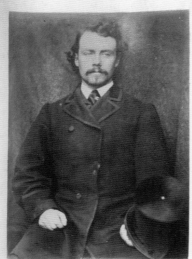

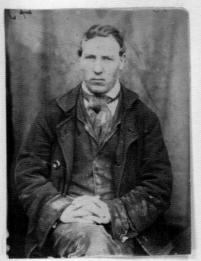

J. W. Byron, late Colonel
in the American Service.

William O'Dea

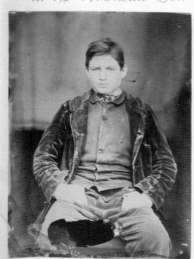

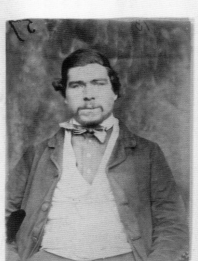

John Hart.

Thomas Hogan.

commenting on a series of published engraved portraits that 'I can discover no evidences of "villainy" in the panorama of faces now before me.'[24]

By 1857 advances in the mass-production of photographic portraits allowed authorities in Dublin's Mountjoy prison to routinely photograph prisoners and distribute images to regional gaols across Ireland.[25] The mass reproduction of these portraits fed into official penal archives, the personal photographic albums of intelligence officers and colonial administrators. Thomas Aiskew Larcom, the Under-Secretary for Ireland from 1853–68, collected two such albums (illus. 63).[26] The earlier album contains some of the first prison photographs taken in Mountjoy prison in 1857 and includes oval, albumen prints of individual convicts. The second album, described in an inscription by the photographer as 'a most unique *Book of Beauty*', are of Fenian prisoners taken in 1865–6 under the powers of the Habeas Corpus Suspension Act.[27] The albumen prints, captioned with the names of prisoners, their affiliations to the Fenian movement and suspected crimes, include details of the rank of former American military officers who had travelled to Ireland to participate in Fenian activities.[28] The Republican leader Jeremiah O'Donovan Rossa, arrested and tried under the terms of the Act, wrote of the routine involved in the execution of such photographs during his internment in Mountjoy prison in 1865:

> After being shaven I was led to have my picture taken. The photographer had a large black-painted pasteboard prepared, with my name printed across it in white, and pinning it across my breast, he sat me in position. I remained sitting and looking according to instructions till he had done, and he never had the manners to tell – what artists never failed to tell me – that I made an exceedingly good picture.[29]

The detailed information accumulated with these photographs worked to bring the deviant face of the Fenian closer to the viewer.[30] Photographs provided a visual resource for intelligence operations of the British authorities against the activities of the Fenian movement.[31] Samuel Lee Anderson, an intelligence officer in Dublin Castle, collected portraits of Fenians as well as Ribbonmen involved in agrarian unrest in

63 Thomas Aiskew Larcom, *Fenian Prisoners*, c. 1857, albumen prints.

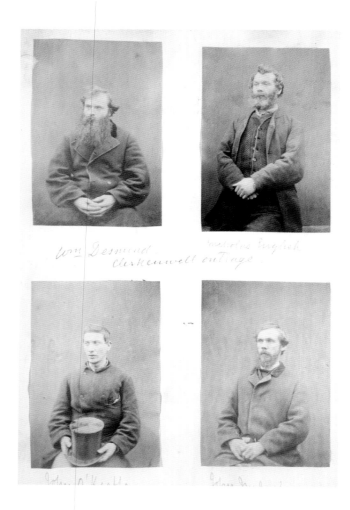

Westmeath in the early 1870s. The album, which included the inscription 'members of the Fenian Brotherhood, especially those who distinguished themselves by being convicted of treason-felony at the Special Commission of 1865–66, or arrested under the *Habeas Corpus Suspension Act, 1866*', contained over 200 photographs of detained and convicted members of the Fenian movement and other secret societies (illus. 64).[32] Like the Larcom album of Fenian prisoners, the albumen prints were presented in the patterned formation of the photographic grid. The uniformity of the

pose and the blank backdrop of each photograph mirrored the geometric pattern of the collective album. Difference was emphasized in the imaginary unity of the individual portraits, each displayed as merely one photographic instant of a collective 'panorama' of the Fenian face.

The organization of the photograph into columns and rows of Fenian 'types' emphasized the technological power of photography to visually arrest and confine the body for the disciplining gaze of imperial authorities. Collectively the photographs came to signify conformity, obedience and submission of the subject.[33] However, strategies of visual display masked the refusal of individual prisoners to conform to this disciplinary use of photography. O'Donovan Rossa wrote of his resistance to being photographed while incarcerated in Millbank prison in England in 1867. Informed that the prison regime refused him possession of his own personal family photographs, he jocularly recounted an occasion of being led from his cell to the prison yard to be photographed. Assured by the photographer 'that these photographs are for the prison authorities, and they do not leave the prison', O'Donovan Rossa stipulated that the only condition that he would allow a picture to be taken of himself was 'that the Queen write to me for it, and promise she will not let it out of her own possession'.[34] Demonstrating an acute awareness of the process of objectification entailed in being photographed as a Fenian prisoner, he concluded 'I would not give them the satisfaction of letting them make a picture of me.'[35]

Irish Types

Photographs of types in Ireland covered that 'ever-evolving race' identified by Robert Lynd in the early twentieth century. A market existed for *cartes-de-visite* of generic street-types like those produced by the Metropolitan Photo Co. in the 1860s as well as for more culturally specific Irish types associated with tourism (illus. 65). Photographs of Irish types became a major feature of what might be termed ethnographic tourism in the late Victorian and Edwardian era. Particular peasant types such as the 'Irish Fisherman', the 'Spinning Woman' and the 'Colleen' were as much a tourist attraction for photographers as the picturesque landscape.

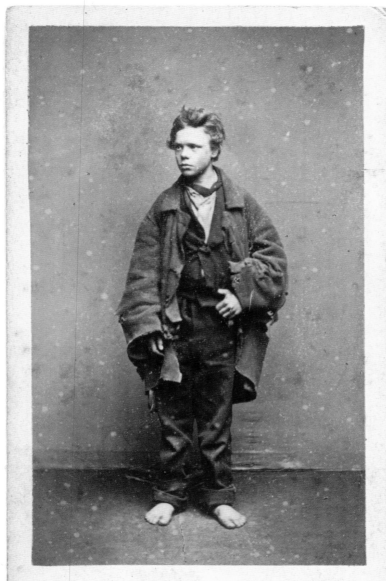

METROPOLITAN PHOTO. COMPY 22, WESTMORELAND ST. DUBLIN

66 Unknown photographer, *Eily O'Connor, The Colleen Bawn*, c. 1865, *carte-de-visite*.

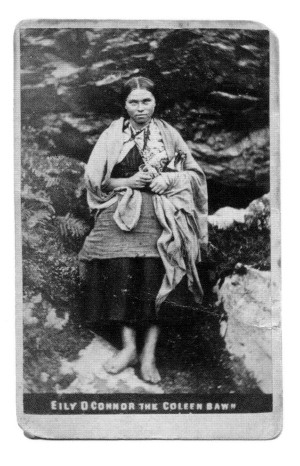

EILY O CONNOR THE COLEEN BAWN

65 Unknown photographer, *Street-Arab*, c. 1865, *carte-de-visite* by Metropolitan Photo Co.

The gendering of Irish types in photographica produced for the tourist market was largely a question of geography. Stereoviews of the Giant's Causeway frequently included peasant women smoking clay pipes sitting in the 'Wishing Chair' (illus. 67). In a series of *cartes-de-visite* of Eily O'Connor produced from the late 1860s (illus. 66), geography was collapsed into myth in the commodification of the exotic Irish female type. Young peasant women such as O'Connor sold refreshments to tourists at the Gap of Dunloe, Killarney, and were collectively described as the Gap Girls. O'Connor was frequently described in *cartes-de-visite* as 'The Colleen Bawn', literally meaning 'The White Girl'. The 'Colleen Bawn

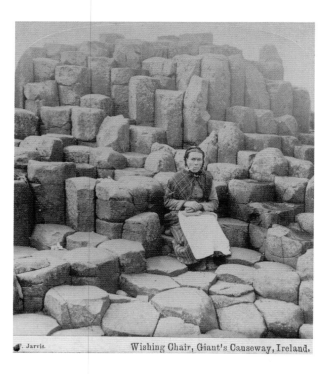

Rock' was a prominent geological feature in Muckross Lake from where – legend had it – a young peasant girl jumped to her death because of her unrequited affection for the son of a local landlord. The commodification of O'Connor through the mythologizing narrative of the unrequited love across the class divide of colonial relations positioned her as an object of visual possession for the tourist. Entirely visible and knowable, she remained in photographic form a visually titillating reminder of the taboo of relations between the male tourist and the exotic figure of the female Irish peasant.[36]

The search for Irish types was also incorporated in tourist narratives that celebrated the power of photography to reveal the mysteries of Irish cultural life. The English travel writer J. Harris Stone, writing of his travels in Connemara, wrote in such terms about his photograph of 'Straw Boys' or 'Moonlighters' (illus. 68), of which for years he had attempted without success to find visible evidence:

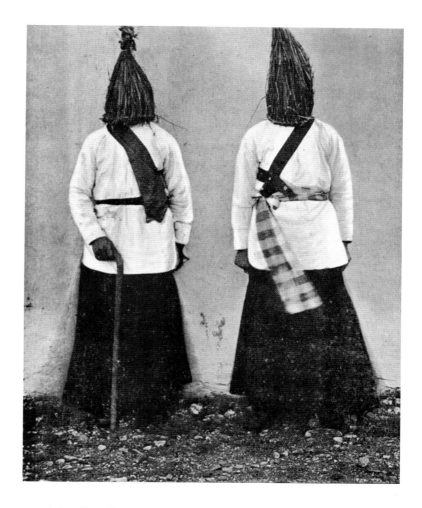

At last, by a fortuitous concurrence of circumstances, I was able to take a photograph of two natives in the actual disguise . . .

How I managed and where I managed to take this photograph I am precluded from disclosing. Suffice it to say that I arranged my whole-plate camera to take any persons who would happen to stand on a certain spot at a certain time; that in the daylight – certainly very early – two peasants in the real costume of the 'Straw Boys' did stand momentarily on that spot, and I obtained their likeness.[37]

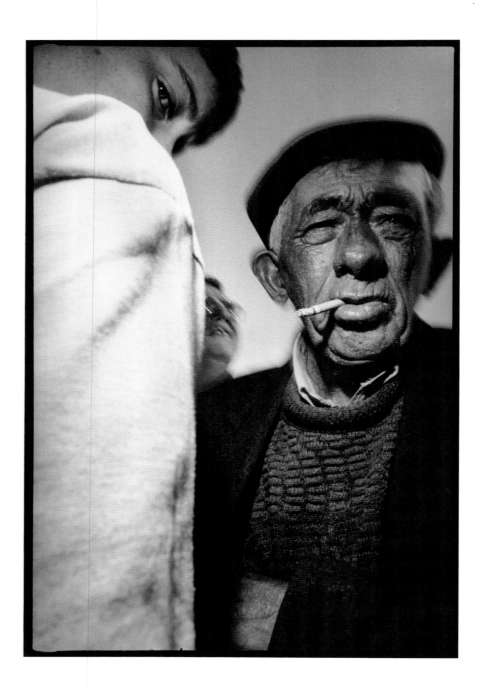

Stone's narrative, with its references to secrecy, complicity and the mechanical modernity of the camera, aimed to demonstrate the technological competence and skill of the intrepid travel photographer as they pursued the exotic, ethnographic Irish type.[38] This search for the Irish type has been a feature of language and narratives that surround the work of foreign photographers, and its traces can be identified across colonial tourism, ethnography and photojournalism. Even at the end of the century a series such as Bruce Gilden's *After the Off* (illus. 69) continued to exploit the photographic form to emphasize the persistence of an Irish type distilled in the physiognomic contours of the face. Using fill-in-flash to amplify the expressive characteristics of the face, Gilden's photographs transformed the crowds at race meetings into a series of caricatured Irish types.[39]

Ethnographies

In the closing decade of the nineteenth century the English zoologist Alfred Cort Haddon established an Anthropometic Laboratory in the Department of Anatomy of Trinity College, Dublin.[40] Modelled on Francis Galton's laboratory established at the International Health Exposition of 1884, the Dublin laboratory undertook a series of surveys of the islands and counties along the western seaboard by Haddon's assistant Charles R. Browne (illus. 70 and 71). Browne incorporated photography into methods of 'anthropography', which quantitatively calibrated the bodies of the subjects into a series of mathematical measurements.[41] Photography was combined with rigorous anthropological methods to subject the indigenous population of the islands to a systematic series of mathematical and visual calibrations. Numerically and visually spatialized as a series of quantifiable figures, vertically and horizontally displayed for scrutiny of the scientific eye in graphic tables, charts and photographic grids, the subjects were represented as a series of mathematically and pictorially calibrated Irish types.[42] Despite photography's promise to provide empirical visible evidence of the Irish face, however, Browne's photographic types failed to provide anything

69 Bruce Gilden, 'Portrait of Man at Races', 1998, black-and-white photograph, from the series *After the Off*, 1999.

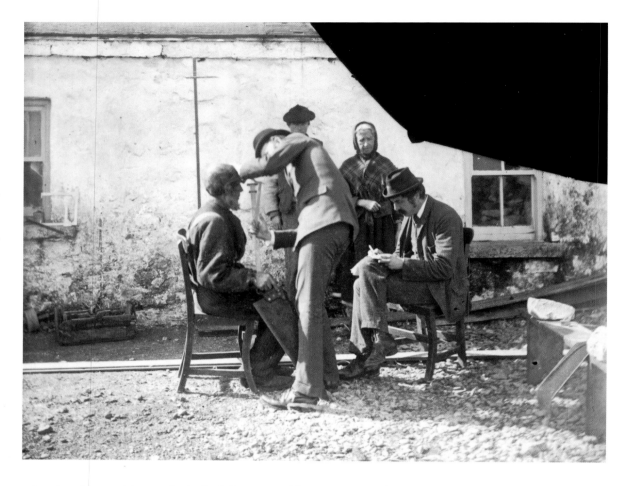

other than the repetitive, aesthetically dull pattern of the conventions of anthropological portraits.[43]

During the same period the Irish playwright John Millington Synge used photography in his ethnography of the Aran Islands in a more romantic and ethnographically sophisticated manner (illus. 72). Synge turned to the rural communities of the west of Ireland as if turning to a past that had yet to be corrupted by Anglocentric modernity.[44] The island's geographical remoteness off the western seaboard had been identified by both colonizers and Irish nationalists, although for very different reasons,

70 Charles R. Browne, *Alfred Cort Haddon Measuring Man*, c. 1890–91, lantern slide.

71 Charles R. Browne, *Types at Inishturk*, c. 1890–91, from lantern slide.

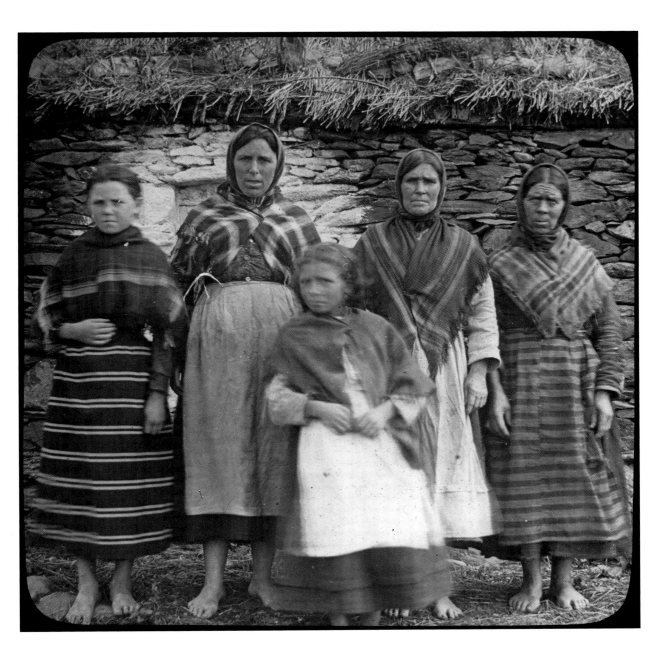

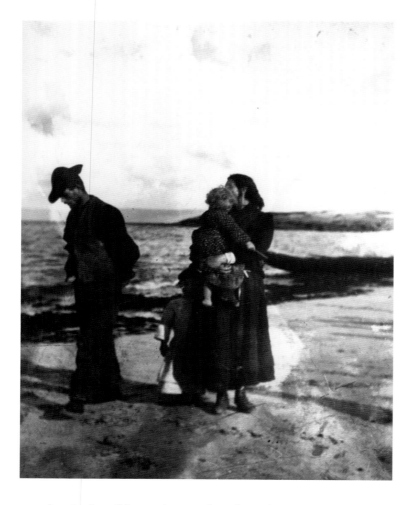

72 John Millington Synge, *Couple Standing on Slip, Aran Islands*, c. 1897, black-and-white photograph.

as authentication of the persistence of a truly Gaelic people and way of life.[45] Although Synge looked west to find this living museum of a distant space in a distant time, his visual references came through the optics of the East. Describing the burning of kelp on the island, he remarked:

> In Aran even manufacture is of interest. The low flame-edged kiln, sending out dense clouds of creamy smoke, with a band of red and grey clothed workers moving in the haze, and usually some petticoated

boys and women who come down with drink, forms a scene with as much variety and colour as any picture from the *East*.[46]

Synge employed photography in a crude form of participant-observation and commented on his photographs being 'examined with immense delight, and every person in them had been identified' by the indigenous islanders.[47] His photographic imaginings, however, demonstrated characteristics of an 'Atlantic pastoral' through which the islanders became idealized, romantic figures of a Gaelic past on the fringe of an Anglicized Ireland.[48] Described by Synge as the most primitive race in Europe, he believed the islanders had so internalized their own sense of cultural symbolism as bearers of the nation's authentic Gaelic past that he reinforced the 'realism' of his photographs by proclaiming in his ethnographic notebook that 'the peasants have a further intuition for picturesque arrangement and each group is in perfect pose for my camera'.[49]

The romantic, 'picturesque' qualities of photographic representations of the Aran Islands become so ingrained within the geographical imaginings of an authentic Gaelic Ireland that they did not only operate within the repertoire of images produced by the colonial gaze of the foreign photographer or pictorial representations of the Revivalists. Bill Doyle's *Aran Islands* from the late 1960s to the '80s gave a visual expression to Aran as the Other within Ireland long after the foundation of the Irish State (illus. 73).[50] Doyle's photographs fed into a national appetite for visual expressions of the persistence of an authentic Irish past in the present. Doyle's humanist, photojournalistic style invoked a sentimentalized vision of a world outside of time. Through Doyle's sympathetic gaze Aran was not only imagined as geographically distant from the Irish mainland, but temporally dislocated from the modern nation. The recurring image of men gathered on the shore looking out across the sea, a visual trope repeated across the arena of visual images of the Aran islands, emphasized their cultural distance from the ongoing erosion of a distinct Irish way of life on the mainland.

In contrast to the romantic ethnographies that appeared amongst the Revivalists and within the visual culture of Irish nationalism, ethnographic use of the camera by photographers in the north was more instrumental.

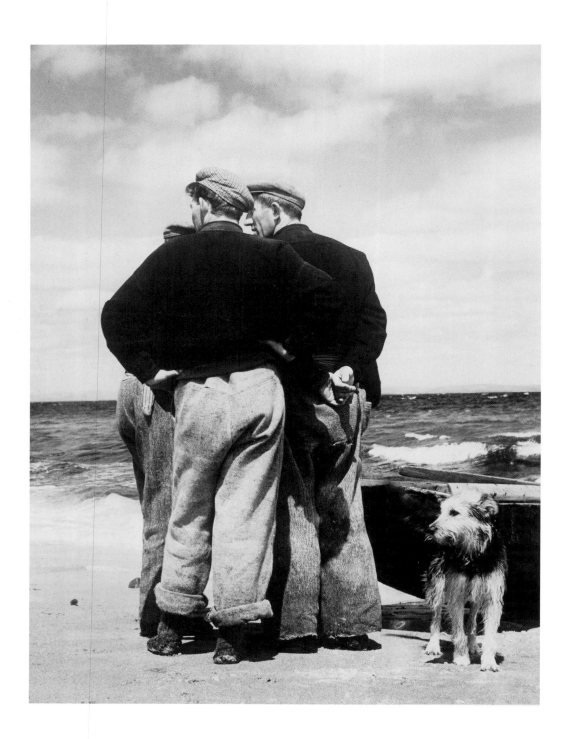

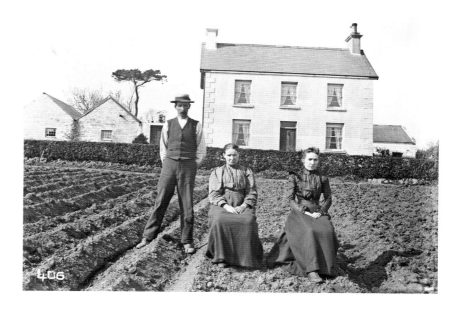

74 William Fee McKinney, *Potato Drills in Front of Local Farmer's House, Sentry Hill, Co. Antrim*, 1901, black-and-white photograph.

73 Bill Doyle, *Máirtín Folan and Páraic Cholí Ó Conghaile, Inis Oírr*, c. 1970, black-and-white photograph.

What distinguished photographers in Ulster from their contemporaries was a style of photography that was largely unadorned with the aesthetic romanticism of their subjects. One of the most aesthetically distinct uses of photography was by the Presbyterian farmer William Fee McKinney. McKinney's ethnographic interests in his locality were vast and covered geology, folklore and natural history. In addition to being a member of the Belfast Naturalists' Field Club, he also established the Carmoney Mutual Improvement Society to hold literary meetings and public debates.[51] McKinney photographed neighbouring small, tenant farmers and tradesmen within the local community of Carmoney, County Antrim near his home at Sentry Hill in a direct manner that emphasized the descriptive qualities of the photograph (illus. 74).[52] Wealthy landowners and smaller farmers were all posed in a uniform manner in front of their homes, while journeymen labourers displayed the tools that signified their trade. McKinney used the pictorial space of the photograph sparingly; everything arranged within the frame was pared back to its most essential form. Combined with this rational use of pictorial space,

each subject was photographed in a direct manner, providing a visual typology of the local community.

Photographs of the Irish 'type' were frequently constructed through ethnographic surveys of Irish folklore (illus. 75). Leland Lewis Duncan, a founding member of the Lewisham Antiquarian Society who wrote several articles on Irish folklore, produced portraits along with photographs of the material culture of the farming communities around Annadale House in County Leitrim (illus. 76).[53] In 1913 two French women, Marguerite Mespoulet and Madeleine Mignon-Alba, travelled to Ireland as part of the wealthy banker Albert Kahn's *Archives of the Planet* (illus. 77).[54] Using autochromes, they took photographs of Irish antiquities, transportation and rural housing. Like many ethnographers their photographs were less concerned with the physical anthropology of the face and more to do with the primitive culture of the rural peasant. Portraits became the opportunity to document traditional clothing, domestic industries or staged performances of folk culture. Although Mespoulet wrote in her notebooks of the dark Irish as being descendants of the Spanish, the physiognomy of the Irish face began visibly to recede in its symbolic importance in the construction of Irish identity. What replaced it was the documentation of ethnographic performance for the camera.

Photographing local customs, labouring practices and rituals was popular amongst amateur ethnographers. Rose Shaw, a governess of a family near the Clogher Valley in Tyrone, trekked across the countryside photographing farmers, labourers and storytellers. Shaw illustrated her book *Carleton's Country* with these photographs (illus. 78). The book was a travelogue of sorts, recounting the countryside and people that featured in the writer William Carleton's sympathetic novels on Irish peasantry.[55] Shaw wrote in the introduction to a chapter: 'full many a glorious morning have I seen flatter the mountain-tops with sovereign eye, when I have gone forth,

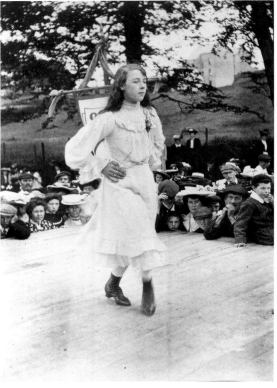

75 Francis Joseph Bigger, *Cassie O'Neill Dancing at Feis, Glenarm, County Antrim*, 1904, black-and-white photograph.

76 Leland Lewis Duncan, *Old Mrs Reynolds Draped in Bonnet and great Shawl, with boy in doorway*, 1893, black-and-white photograph.

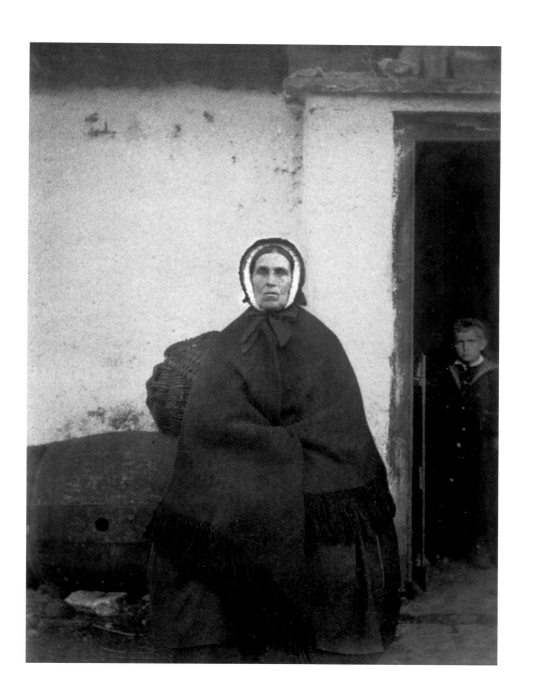

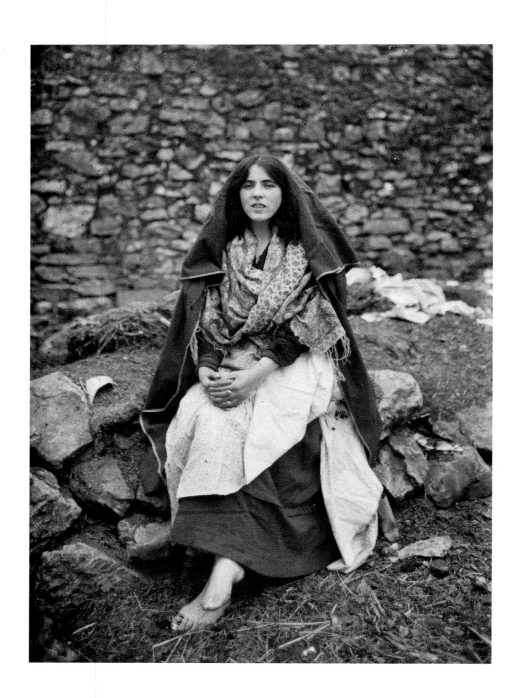

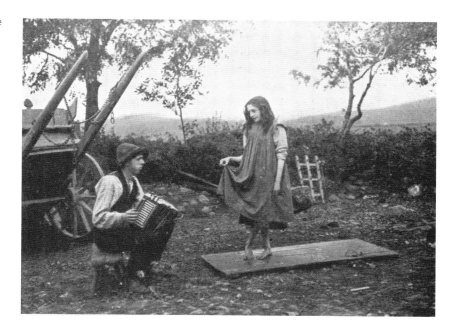

camera in hand to seek out Carleton's haunts and Carleton's people in the beautiful Clogher Valley'.[56] Shaw captured 'Carleton's people' through photographing ethnographic performances of agrarian labour and peasant customs such as 'the dance on the door of the house'. The photographs she took provided a sentimental image of agrarian labour, particularly the farming customs of women, and collectively the photographs reduced peasant culture to a series of idealized ethnographic spectacles.

Diasporas

In 1865–6 Julia Margaret Cameron produced a photograph of her maid Mary Ryan (illus. 79). Originally from Limerick, Ryan was spotted by Cameron begging on Putney Heath in 1859.[57] Cameron took Ryan in as maid and used her as a model for a series of allegorical photographs formally composed through the aesthetic romanticism of the Pre-Raphaelites. In her portrait of Ryan from 1865–6, Cameron inscribed

77 Margeurite Mespoulet and Madeleine Mignon-Alba, *Woman wearing Shawl, Co. Galway*, 1913, autochrome for Albert Kahn's archive.

115

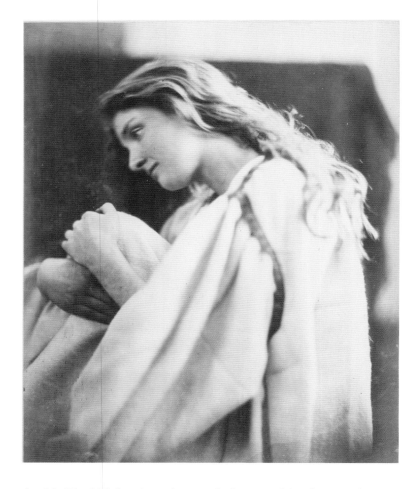

the title 'The Irish Immigrant' across the bottom of the photograph.
Ryan was an Irish immigrant, but Cameron's photograph idealized the
experience of immigration through photographic techniques that masked
the mechanical veracity of the photograph. The soft focus, blurring and
use of light in Cameron's portrait transformed Ryan's experience as an
immigrant into an aesthetic object which could be purchased on the
open market. The history of Ryan's life, however, provides a different
narrative of immigrant experience.

 Ryan went on to leave Cameron's home to marry the civil servant
Henry Cotton. After her marriage Ryan became Lady Cotton and
emigrated again, this time to India when her husband became Chief

Commissioner of Assam.[58] Ryan's journey from Irish beggar to Irish immigrant and the hyphenated identity of Anglo-Indian is an example of how immigrant experience constantly shifts and transforms identity, a process that cannot be adequately captured through the solitary photographic image. The immigrant experience is a journey that shapes not only the identity of diasporic communities, but also how identity is imagined in the homeland. Photography has played an important role in shaping the identity not only of Irish emigrants to England and North America, but also that of the Irish at home through narratives of community, belonging and loss that are performed through photographs. The process of identity formation through the movement and dispersal of the Irish also poses a challenge to photography, drawing attention to its limitations in adequately capturing identities that are in constant flux. But in its struggle to adequately portray the multiplicity of diasporic identities, photography has also been explored as a vehicle through which the visual can imaginatively transcend the geographical borders that separate communities of people.

The significance of documentary photography in constructing Irish identity as a benign and flexible ethnicity in the post-war period is evident in Dorothea Lange's 1955 photo-essay 'Irish Country People' (illus. 80).[59] Lange travelled to Ireland in 1954 after being influenced by an anthropological book, *The Irish Countryman*, which emphasized the deep kinship ties between the rural people of County Clare. Lange would state of one portrait of a young Irish girl: 'Look at that face . . . isn't that a beautiful face? That's Ireland. That's pure Ireland.'[60] In the pages of *Life* this authenticity and permanence of the Irish face was given more elasticity and racial significance for the American public. The accompanying text positioned the Irish as the primitive incarnates of Western Europe: 'Serenely they live in age old patterns', read one subheading. The Irish in Lange's photo-essay became signifiers for the persistence of a primitive culture living in another time and another place.

Through *Life* magazine's positioning of documentary humanism as a transcultural form of visual communication, however, the Irish were also endowed with transnational status. In the editorial the photo-essay was introduced with the statement 'A Rural World in Ireland – Dorothea Lange takes a sympathetic look at the parent stock of a far-flung race as it

lives on calmly amid the culture of a bygone day'. The faces of the primitive Irish published on the pages of *Life* reflected back upon the reader authentic symbols of their own ethnic origins.[61] The editorial spoke directly to the American readers' sense of racial identity, calling the primitive Irish 'good ancestors to have' and placing the Irish-American diaspora within the white ethnicities of the suburban middle classes.

Lange's photo-essay circulated among the Irish-American diaspora and their relatives back in Ireland, including the people of Clare who featured in *Life*.[62] The exchange and circulation of photographic images between the Irish diaspora and their relatives in the homeland has contributed to the evolving geographical imaginings of the Irish at home and abroad. In his installation piece *Our Special Day* (the title was drawn from the artist's grandmother's term for the annual Whitsun processions), Lawrence Cassidy used photographs, census records and contemporary

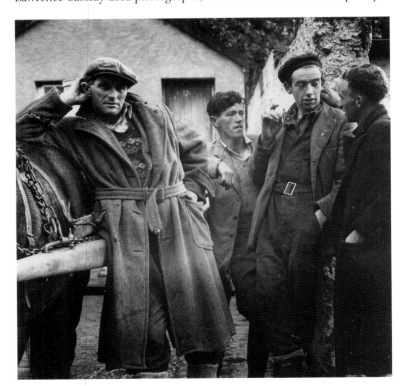

80 Dorothea Lange, *Farmers at Creamery*, 1954, black-and-white photograph.

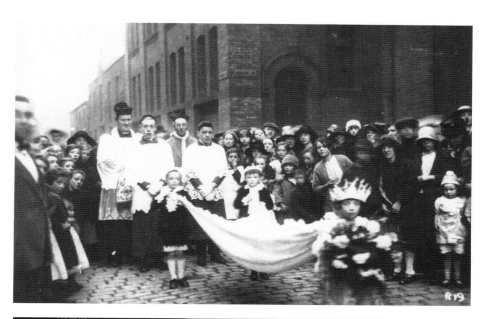

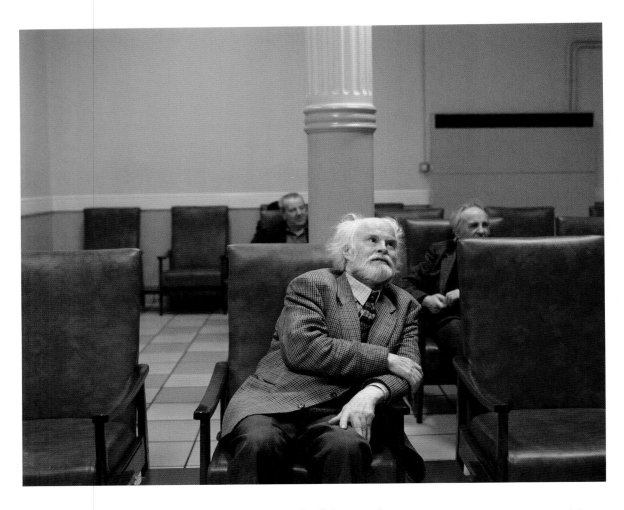

photographs of the working-class Irish communities of Collyhurst and
Angel Meadow (Irish Town) in Manchester (illus. 81). Archival documents,
family photographs and documentary images of the communities were
brought together in an exploration of the collective memory of Irish
working-class migrant experience. Incorporating the official records
of migration with photographs of the Whitsun walks by the working-
class Catholic communities through the relational strategies of display,
the installation pieced together the fragments of an imagined community
within Britain that was grounded in the fabric of the industrial cities
and everyday life.

82 Deirdre O'Callaghan, photograph from
the series *Hide that Can*, 2002.

The use of photography to establish networks, connection and associations in the construction of diasporic experience have also been explored in Anthony Haughey's *The Edge of Europe*.[63] The series traced migrants and their descendants from the deserted Blasket Island to Massachusetts and Connecticut. Haughey's series of photographs teased out the hybrid identities formed through the cultural exchange between the Irish, American and other diasporic communities. A more literary approach of immigrant experience has been pursued in Timothy O'Grady and Steve Pyke's photographic novel *I Could Read the Sky*.[64] The combination of text and image pushed against the limitations of each other to adequately portray the immigrant journey across the sea to England and imaginatively back to Ireland through memories and recollections. In another exploration of the Irish migrant experience, the photojournalist Deirdre O'Callaghan spent four years documenting the homeless Irish at Arlington House in London (illus. 82). Arlington houses impoverished and destitute Irish labourers, who travelled to England to find work as navvies in the 1950s, '60s and '70s. Many had never returned home, and O'Callaghan's project depicted the fantasies and anxieties of the diasporic desire for the homeland.[65]

What these series all highlight are the multiplicity of immigrant experiences and how photography can contribute to making sense of evolving formations of Irish diasporic identity. Employing various strategies photography has been used in all to explore the ways in which geographic connections, cultural exchange and cultural memory form diasporic consciousness.

Changing Identities

From the 1960s, photo-reportage and documentary photography have contributed to documenting Ireland's marginalized peoples and communities. Alen MacWeeney and Pat Langan have documented the impact of urban modernity on Ireland's Traveller community, whose nomadic existence across the country was increasingly curtailed by the economic imperatives and policies of the state to settle Traveller communities in 'halting sites' or to assimilate them into settled communities.[66] MacWeeney's project

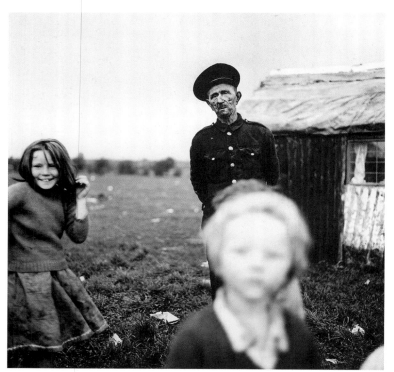

opposite: 85 Krass Clement, 'Untitled', 1995, black-and-white photograph, from *Drum: Et Sted I Irland* (1996).

83 Alen MacWeeney, *Willie Donoghue and Children, Cherry Orchard*, 1965, black-and-white photograph.

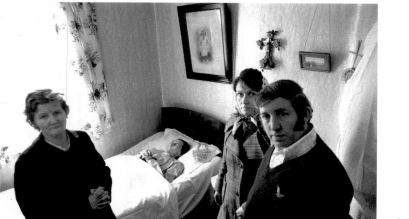

84 John Minihan, 'The Wake of Katy Tyrell', 1977, black-and-white photograph, from the series *Shadows from the Pale*, 1996.

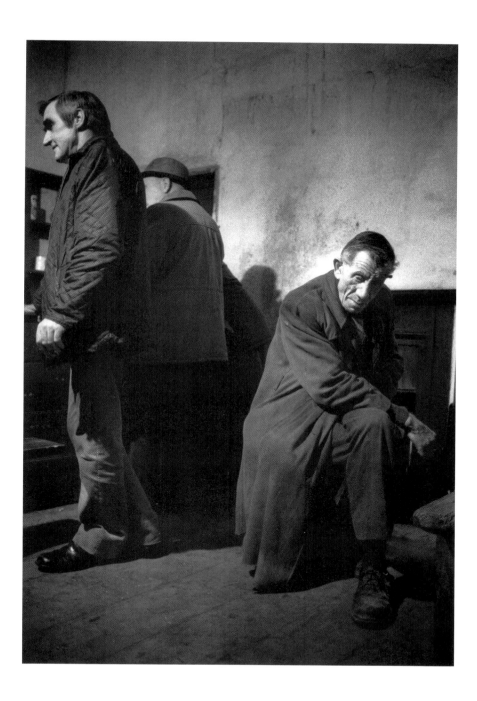

87 Noel Bowler, 'Untitled', colour photo-
graph from the series *Iman*, 2009.

86 Victor Sloan, *Vietnamese Boat
People, Moyrafferty Community Centre,
Craigavon IV*, 1984, silver gelatin
print, toner and watercolour.

included ethnographic recordings of Traveller folklore and music and is
an example of 'salvage photography' in its documentation of the erosion
of the customs and social life of Ireland's 'others' (illus. 80).

John Minihan's *Shadows from the Pale*, a study of the midlands town
of Athy, similarly captured something of the disappearing traditions of
small-town Irish life in his photographs of 'The Wake of Katy Tyrell', the
last traditional Irish wake to be held in the town (illus. 84).[67] In the same
year that Minihan published his book on Athy, the Danish photographer
Krass Clement issued his photo-book *Drum: Et Sted I Irland* (illus. 85).[68]
The photographs, taken mostly over one night in a pub in the town of
Drum, are a sustained observation of one solitary, frail man's alienation
amid the hustle and bustle of social life around him. The starkness and
claustrophobic world Clement constructed through his 'thick depiction'

of the man projected the masculine and sombre way of life that was disappearing in Irish society.

The publication of Clement's book along with several other documentary/photo-reportage books in the mid-1990s marks the transition of the symbolic use of the face in the representation of Irish culture. The old world of tradition was beginning to give way to new complexities of Irish identity emerging out of economic prosperity, the Peace Process in Northern Ireland and – for the first time in the history of Ireland – inward migration of other races and ethnicities. When Robert Lynd wrote in 1910 of the Irish being one of the world's puzzles, and of the differences between the gradations of Irishness being unified as one ever-evolving race, it is unlikely that he envisaged a century later that this would include the many diasporic communities now settled in Ireland from Asia, Africa, Eastern Europe and the Middle East (illus. 86). His vision is too utopian perhaps to accommodate the complexities of the many hyphenated identities that make up the strata of Irish society in the twenty-first century.

Like many 'developed' nations, Ireland has a culturally diverse population, and as in many nations this has caused divisions and anxieties around Irish identity, nationality and citizenship. Visibility is a significant dimension to this anxiety. In 2004 the Irish Constitution was amended, denying citizenship to any child born in Ireland after that date who did not have at least one parent who had or was entitled to Irish citizenship. As a result of the amended constitution the conception of Irish identity was provided with another layer of complexity. What and how Irish identity is to be visually portrayed in the future is as uncertain as it has always been. The use of photography to document the undocumented migrants hidden in Irish society, to give a voice to detained asylum seekers, making visible the 'new Irish', continues to play an important role in representing this fluidity of Irish identity.[69] Noel Bowler's *Iman* (Faith) series, which documented the Islamic Cultural Centre of Ireland over a year, provides an intimate portrayal of the religious and domestic life of the many nationalities associated with Irish-Islamic life (illus. 87). Bowler's detailed studies of individuals, groups and their domestic, religious and social environments are an important reminder of photography's importance in documenting the ever-evolving Irish race.[70]

four

Conflicting Images

In 1998 the Good Friday Agreement was endorsed by the majority of
political parties in Northern Ireland and by both the British and Irish
governments to introduce a political mechanism that would end over
a quarter of a century of paramilitary conflict.[1] The 'Agreement' was
envisaged to mark the end of the Troubles, initiating a new political
dispensation through devolved power-sharing government, and the
cessation of paramilitary, sectarian violence. To persuade the public
to endorse the terms of the Agreement a copy of the document was
distributed to every household in Northern Ireland before a referendum
later that year. On the cover of the document was a photograph of
a family walking along a beach in silhouette against the golden orange
of a sunset with the words 'It's your decision' written across the bottom.
The photograph also appeared on billboard posters throughout the
latter half of 1998 and was the most ubiquitous photographic image
throughout Northern Ireland that year.

 The photograph, despite its benign connotations of familial harmony,
was not, however, without its controversy. The editors of the photography
magazine *Source* inquired into the photograph's provenance and discov-
ered that it had been taken by the German photographer Roger Ellis in
South Africa in 1996.[2] The photograph was a generic stock photograph
that had been sourced by the advertising agency who had wrestled it into
the context of post-conflict politics of Northern Ireland. The questioning
of this photograph by the editors of *Source* is, on the one hand, an indica-
tion of the iconoclasm within the visual culture of the Troubles. Images
have been flashpoints of contestation; wall murals, emblems, insignia,

cinema and photojournalism have been the focus of political and cultural conflict. The tearing down and erasure of sectarian imagery has even been pursued through official arts policy in post-conflict Northern Ireland, but images have been enmeshed within the cultural politics of Northern Ireland even before the beginnings of sectarian conflict in the late 1960s.[3] On the other hand, the questioning of the history of the photograph demonstrates the importance of 'context' in the representation of conflict in Northern Ireland. Context or its absence have been embedded within the visual culture of the Troubles, from photojournalistic depictions that reduce history of the conflict to the visual spectacle of sectarian violence, to documentary photographers and artists who have drawn on the photographic fragment of dissociated objects to interrogate the conflict.

Photographs produced and viewed in one historical context may be viewed ten, twenty, thirty years later, radically re-contextualizing their meaning. Context is thus not a matter of a single position in which photographs are produced or viewed, but a range of historical and cultural variables and possibilities that constantly shift and give mobility to meaning of the static photographic depiction of the world. The history of the photographic representation of conflict in Northern Ireland is one in which the shifts and ruptures of context are played out to provide new perspectives and vantage points of viewing the Troubles. In photojournalism, documentary and photographic art, the contexts of language, history, viewing and the photographic form itself have constantly been wrestled over to explore alternative narratives of conflict. In this chapter, then, context will be a theme that is threaded throughout the discussion of different genres, styles and artistic practices of photography of the Troubles.

Photojournalism

On 30 January 1972 the Italian photojournalist Fulvio Grimaldi covered a civil rights demonstration in the Bogside in Derry, which was to become a watershed in the history of the Northern Ireland conflict, and known as Bloody Sunday. In his testimony to the first Tribunal into the events of

that day, Grimaldi recalled how after shots had been fired through a window of a flat in which he had briefly taken cover from the fighting outside, a woman shouted 'this is at you for taking those photos . . . you must tell them you are a photographer'.[4] At that very moment photography and conflict appeared to take on added significance for the photojournalist and indeed the woman who scorned his actions for taking photographs through the window. The split second involved in the taking of a photograph was no longer a simple technical procedure: it suddenly became a life or death situation that had the potential to cause collateral damage to all those in and outside of the frame of the camera's viewfinder.

The 25 years of the Troubles and the post-conflict peace process have not been as prominent in the international media as other twentieth-century 'image wars'.[5] The nature of the conflict, meshed with everyday life and hidden between the flashpoints of violence depicted in the print and broadcast media, meant that its representation was not a media spectacle, yet the image of conflict in Northern Ireland was no less contentious. Indeed as the woman's remonstrations towards Grimaldi demonstrate, photography may have been physically dangerous for both herself and the photographer, but it also posed a threat to the British authorities through its potential to provide visual testimony and 'bear witness' to atrocities against civil rights. Her pleas that Grimaldi identify himself as a photographer suggest an awareness of the importance of photography in documenting the events unfolding outside her window, if not the naive assumption that a press pass offered sanctuary against being shot at by the British security forces or paramilitary groups.[6]

The photographic image has become a site of struggle between the international media, military authorities and local artists and photographers who have sought to counter dominant media portrayal of the Troubles. During the first two decades of the conflict, however, photojournalism determined how the Troubles came to be perceived by the outside world. The overlap between the final years of the Vietnam War and the emergence of the Troubles in the late 1960s is perhaps the reason why so much photojournalism was to emerge in the international press on the violence in Northern Ireland. Photojournalists constantly migrate to the newest geographic locations of conflict, either moving between or

moving to the latest newsworthy war. As newspapers and photographically illustrated magazines such as *Life* sought out conflicts to replace coverage of the war in Vietnam, the conflict in Northern Ireland increasingly became a recurring topic for contemporary international photojournalism.[7]

The types of imagery and the editorial rhetoric of the early photo-essays in American magazines such as *Life* and the British print media quickly established how the conflict was to be perceived by the international community. Photojournalism portrayed the Troubles as an urban conflict not between armies, but between a violent civilian population against a British military that had been deployed on the streets to maintain law and order. Photographs of the violence were rarely placed in context and a familiar theme of combat photography emerged in which the British military were portrayed as invigilators of violent confrontations between the Protestant, unionist communities and the Catholic nationalists. More frequently the representations depicted the conflict from the perspective of the soldier by emphasizing violent confrontations between the nationalist youths and the British Army (illus. 88).[8]

In the early 1970s *Life* magazine published several photo-essays on Northern Ireland that included the codifications of combat photography the American public had been familiarized with through the Korean and Vietnam wars.[9] Larry Doherty's photograph of a clash between nationalist youths and the British Army in the Bogside, Derry, was used in a double-page spread by *Life* magazine in a short photo-essay in 1970 (illus. 89). Doherty had been a photographer for the *Derry Journal* and also gave evidence at the Bloody Sunday inquiries. Doherty's photograph visually emphasized the division between the two groups through the gable end of a house. Visually separating the unruly mob from the organized line of British troops equipped with riot shields, the hard edge of the building highlighted the territorial and cultural divisions within the conflicting groups. Accompanying the photograph was a headline, 'A Classic Scene of Irish Violence', and a short caption with the commentary: 'In the picture a classic street-fighting situation has developed. Angry Catholics from the Bogside section have attacked soldiers on the fringes of the area, and the soldiers are moving in to contain them.'[10] Moving in to contain the photograph, the caption

88 Phillip Jones Griffith, *British Soldier Facing a Hostile Crowd of Youngsters, Belfast*, 1972, black-and-white photograph.

empathized with the fate of the combat soldier. Violence was equated with Irish identity: the description of the photograph's depiction of the confrontation as a 'classic' scene of Irish violence implies that the conflict is a historical enactment of past traditions.

Such representations lapsed into old colonial stereotypes while sympathizing with the fate of the combat soldier. Photographing violent clashes *in medias res* (in the midst of the action) also had the effect of portraying the conflict as a series of isolated, random acts of terrorist violence. During the initial years of the Troubles this resulted in a perception of the conflict generated by the media orientated toward the threat posed by nationalists to civil society and of British authorities as upholders of the rule of law. In the American print media, a polarized image of the conflict emerged between the irrational violence of the nationalist community and the restraint of the British Army, an image

89 Larry Doherty, *A Classic Scene of Irish Violence*, from *Life*, LXIX/10 (4 September 1970).

A Classic Scene of Irish Violence

For the extremist mobs of Northern Ireland —who usually wind up fighting the authorities whenever they attempt to fight each other—it has been another violent summer. The only difference is that last year's authorities—local constables—have been replaced by English soldiers like the ones shown here on William Street in Londonderry. In this picture a clas- sic street-fighting situation has developed. Angry Catholics from the Bogside section have attacked soldiers on the fringes of the area, and the soldiers are moving to contain them. A few rioters gather behind barrels in an empty lot where a betting shop was burned down in last year's riots. But some soldiers out- flanked them and soon had the area cleared.

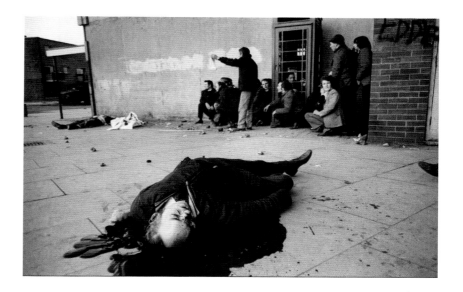

90 Giles Peress, *A Victim, Barney McGuigan, lies in a pool of blood as the shooting stops on Bloody Sunday*, 30 January 1972, black-and-white photograph.

mirrored in the pictorial space of Doherty's photograph. This portrayal was established through the editorial and journalistic contextualization of the photojournalistic image as evidence of the innate violence of the Irish.

Much photojournalistic imagery of the Troubles was woven into the fabric of an editorial rhetoric that traced the narrative outlines of an 'official perspective' that suited the purposes of media and state.[11] In the immediate aftermath of Bloody Sunday, the international media began to openly question the public relations perspective of the military and its role in shaping the portrayal of the conflict. In 'The Beat of Life' section of *Life* magazine in 1972, the caption accompanying a double-page spread of photographs of Bloody Sunday dominated by the work of French photojournalist Gilles Peress noted: 'Afterward, military authorities insisted that the troops had been fired upon first. But 13 marchers lay dead.'[12] Photojournalism, it appears, was also open to contested claims to truth and objectivity, and alternative vehicles for publishing photographs emerged that offered visual narratives which were oppositional to representation of the conflict in the print media (illus. 90).

Fulvio Grimaldi published a short booklet with low production values, *Blood in the Street*, which included photographs, journalistic essays and

133

witness testimony to counter the official version of events in the international media. Impartiality was put to one side. Grimaldi noted in the introduction: 'We are not interested in objectivity, aloofness, that can only derive from indifference or vested complicity with those who have everything to lose.'[13] As Grimaldi saw it, 'They [the British Army] kill to stop unfriendly, truthful photos.'[14]

Photography was a source of much contention between the British military, activists and photojournalists during Bloody Sunday. At the Bloody Sunday inquiry Larry Doherty recounted being informed by the Army press officer that he should avoid taking up a position with demonstrators in the day before the Civil Rights demonstration, and being confronted at gunpoint by a soldier after they had opened fire on the demonstration. Grimaldi and Peress both gave testimony to the inquiries and many of their photographs were introduced as evidence. Large numbers of photographs and film taken by British troops went missing, as did photographs taken by civilians and professional photojournalists. An *Irish Times* photographer, Cairn Donnelly, also claimed that negatives of shootings he submitted to the 1972 Widgery Inquiry appeared to have been deliberately scratched to distort or erase parts of the scene depicted in the photograph.[15] The burden of proof was clearly not isolated in photojournalistic depiction of the events of that day, but also in the absences, control, destruction and distortion of photographic evidence.

Photojournalistic images were also compiled in books and magazines that attempted to bring more contextual depth to photography of the Troubles. The photojournalist Clive Limpkin published a book of photographs of the events leading up to confrontation between nationalists, the Royal Ulster Constabulary and the British Army in August of 1969. Limpkin worked for the *Daily Sketch* and *The Sun* newspapers and later published his photographs in the book *The Battle of Bogside* (illus. 91 and 92), which was awarded the Overseas Press Club of America's Robert Capa Gold Medal for best photographic reporting in 1972.[16] The book included subtle photographic narratives which placed the conflict in the context of the long-running tensions between the two communities living in Derry, and photographs of street violence between residents of the

Bogside and security forces. Some of the photographs depicted life in the area from the perspective of the residents, which provided a more rounded portrayal of the conflict than had been seen in photojournalism up to that point. Limpkin also included extended captions with the photographs, which attempted to explain the background to the scenes depicted. The combination of photographs and text in the book aimed to provide a greater social context of the experience of conflict by adopting visual perspectives and vantage points that positioned the viewer on the side both of the military and the civilian.

Some photojournalism began to shift attention away from an emphasis on street violence in a critically engaged and innovative way that was reflexive of its own role in contributing to the public perception of the conflict. In England the cultural Left played a significant role in

91 Clive Limpkin, cover of *The Battle of Bogside* (1972).

92 Clive Limpkin, *The Battle of Bogside*, black-and-white photograph, c. 1972.

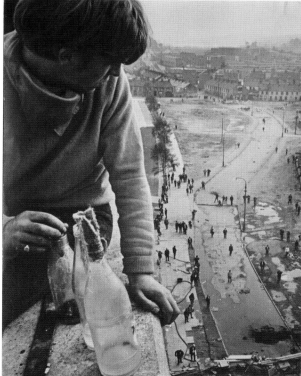

deconstructing the photojournalistic discourse of the Troubles and providing alternative strategies to represent the conflict. In 1979 the Halfmoon Photography Workshop published a special issue of their magazine *Camerawork* to mark the tenth anniversary of the deployment of the British Army in Northern Ireland.[17] *Camerawork*'s contributors had been at the forefront of introducing culturalist approaches to understanding photography combined with Marxist analysis of the ideology of the media.[18] In the special issue the editorial foregrounded the role of the media in the public misunderstanding of the conflict:

> The way they [photographs] have been used distorts our understanding of events by failing to put them into an appropriate context. The information we receive is censored both by the Army and by editorial

93 Chris Steele-Perkins, *Youths held for Security Check, Belfast*, 1978, black-and-white photograph.

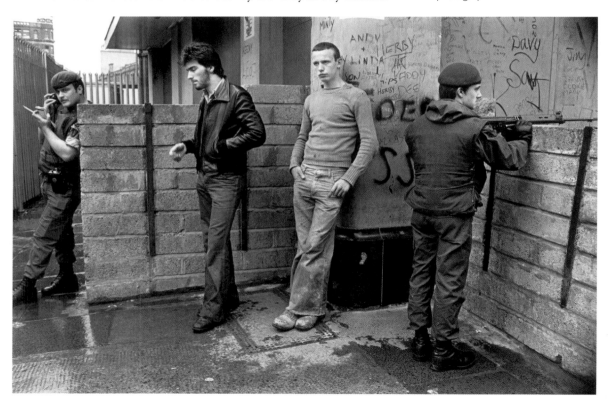

decisions within the media . . . *Camerawork* makes no claims to provide answers to the problems of Northern Ireland; but we feel that we can publish photographs in a context that will demystify the issues that affect the Six Counties – a context in which they can be understood.[19]

The issue contained interviews with photojournalists, a report from a British Army photographer and articles on surveillance and the state, the economics of the conflict and the bias of the British press in its reporting of the conflict. The deep contextual approach and the reflexive analysis of photography's role in reinforcing cultural biases provided the most critical evaluation of the role of photojournalism in the representation of the conflict at that date. The issue also included two photoessays of 'Catholic West Belfast' by Chris Steele-Perkins (illus. 93), and 'Pictures from Protestant Ulster' by a selection of local and international photojournalists.

The Protestant community was nearly anonymous in international photojournalism of the Troubles in the international media, and even over a decade after the *Camerawork* issue, the American photojournalist Ed Kashi observed that the Loyalist community treated him with hostility in the belief that he was biased in his sympathies towards Catholic nationalists simply by dint of being American and a photojournalist.[20] Kashi's book *No Surrender: The Protestants* avoided any sensationalist or sympathetic depiction of the Loyalist community around the Tiger's Bay area of Belfast (illus. 94). Depicting the tensions within a working-class Protestant community caught in the extraordinary circumstances of sectarian conflict, Kashi represented the uneasiness of even the quietest of moments in an enclosed urban environment where religious and political identity appeared to be marked in every gesture between individuals.

Mike Abrahams's photographs for the book *Still War* similarly explored the everyday reality of the conflict for people in the cities, towns and housing estates that had become defined in the international media as the battlegrounds of conflict between paramilitary groups and the British military (illus. 95).[21] Abrahams made several extended visits }to Northern Ireland and unlike the photojournalistic goal of attempting

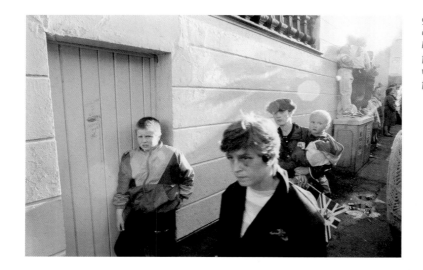

94 Ed Kashi, *Spectators in the Crowd of an Orange march in East Belfast. The Protestant celebrations are not always fun and play, with the hard life of the working class reflected in some of their faces*, 1989, black-and-white photograph.

to capture the essence of conflict in one definitive image, his collection of photographs played down the sensationalism of the violence. What he drew attention to instead were the forms through which the conflict in the streets had permeated the domestic life of the families and individuals who lived amongst the residue of conflict.

There is a curious paradox within the political economy of photojournalism. On the one hand photojournalistic images are required to become immediately obsolete once they are published, and on the other they operate successfully only if they are striking enough in their visual impact to remain within the public consciousness. In order for photojournalism to function as a commercial activity, as a cog within the ever-spinning wheel of the global print media's representation of conflict, it needs to allow for the continuous process of obsolescence. While the print media search for the decisive image of violence to shock the public, they need photojournalism to make each shocking image redundant by replacing it with other shocking images. At the same time the print media also require each photojournalistic image in itself to become the iconic image of a particular violent event in order to attract readers. Through this process the redundancy of the photograph on the morrow of its publication is what familiarizes the public with the photographic depiction of violent conflict.

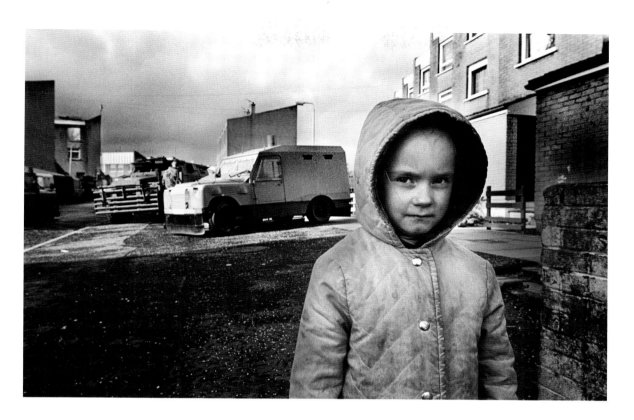

95 Mike Abrahams, *RUC and British Army Raid, Ballymurphy Belfast*, black-and-white photograph.

A quarter of a century after Limpkin photographed a nationalist youth in a gas mask during clashes between residents of the Bogside and the police, the photograph formed the basis of a commemorative wall mural by the Bogside Artists Collective on the gable end of a house in the shadow of Free Derry Corner.[22] The media philosopher Vilém Flusser has observed that society has become so habituated to the ever-changing photographic universe it occupies that it no longer takes notice of the majority of photographs that continuously enter the 'photoscape' of everyday life. The permanently changing photographic universe 'where one redundant photograph displaces another redundant photograph' has become familiar, 'run-of-the-mill', to the extent that change, 'progress', has become uninformative.[23] What would be truly shocking, Flusser argues, is a standstill situation, a society where the same photographs

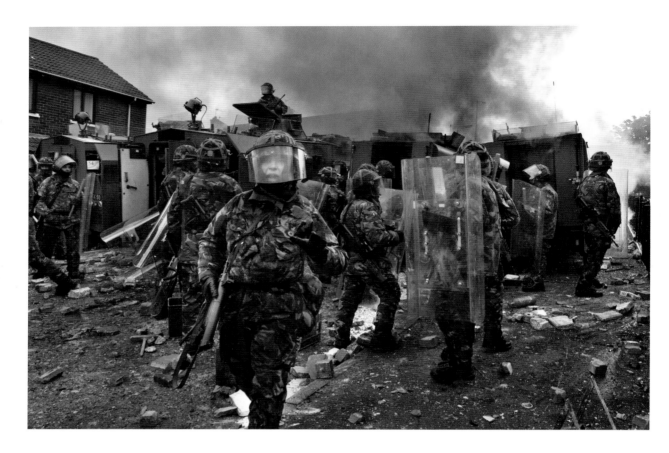

would be experienced day after day. By incorporating the monochromicity of photojournalism into the painted wall mural to commemorate the events of Bloody Sunday, the rapid displacement of photographs which has become the function of the apparatus of global media have been interrupted. Change has been brought to a standstill so that what was intended as the photographic documentation of the contemporaneous event has been transformed into commemorative visualization of the past event within the very geographical place it depicts. Grimaldi's iconic image of Bloody Sunday representing Father Edward Daly waving a white handkerchief as he leads a group carrying the dying body of Jackie Duddy, an image submitted with Grimaldi's own testimony to

96 Crispin Rodwell, *Army landrovers burn during serious rioting in a Loyalist area of west Belfast on Saturday following the re-routing of an Orange Order march. Automatic gunfire and blast bombs were used against the police and army and three armoured military vehicles were destroyed by the rioters*, September 2005, colour photograph.

the Saville Inquiry, has similarly been transformed through the commem-
orative practice of wall murals countering dominant narratives of Bloody
Sunday and the Troubles. In Northern Ireland the photojournalistic
image continues to hover over the space of its production not simply as
a remediated, shadowy simulacrum of itself but as the visible material
of the past 'that weaves memory into the scene of everyday life'.[24] The
photojournalistic image thus continues to operate beyond the scope of its
intention, serving within the judicial context of eyewitness testimony and
the socio-cultural practices of memory production that seek to contest
official visual histories of the Northern Ireland conflict.[25]

Photojournalism remains an important photographic form in
representing the Troubles, frequently dispelling the myths of the post-
conflict peace process and serving an ameliorative role in archival projects
of the collective memory of the conflict.[26] Mainstream photojournalism
has been supplemented with photography by local press photographers
and communities to illuminate the grey areas of everyday life that the
international press cropped out in favour of the sensationalist depiction
of violence.[27] Photojournalism continues to portray sectarian tensions
and conflict in Northern Ireland in the aftermath of the Good Friday
Agreement. Terrorist attacks by dissident paramilitary groups and
social conflict have maintained a visible presence within national and
international media through the work of photojournalists such as Crispin
Rodwell, who have captured the dramatic events of continued sectarian-
ism (illus. 96). The agreement is not a radical break with the past, and
the 'peace process' is just that, a process that continues to unfold unevenly
across society. Sectarian divisions are in some instances more visible than
they ever were.

Renegotiating the Image

The contesting of photographic meaning and the expansion of the
parameters of the documentary form in the 1980s contributed to a sig-
nificant body of photographic work that renegotiated the context of
media representations of the Troubles through language, text and the

photographic form itself. From the 1980s the photographer and artist Victor Sloan worked with and on the documentary image in his critical intervention into photography's depiction of the Troubles.[28] The photo-journalistic image's requisite legibility and visual clarity, its codification of rapid and unfettered communication, have been consistently punctuated by Sloan's processes of what have been described as 'marking' the photographic print.[29] Sloan's photographs, usually placed in a short series, are worked upon either through the manipulation of the negative or the stripping away and layering of the print. Sloan uses bleaches, toners, paint and the scalpel in an extended process of materializing an image that ruptures the veracity of the documentary photograph while retaining the remnants of its structure. The finished photographic print is envisaged by Sloan to have extra areas of latency that are required to be slowly 'marked' out, a process that is orientated around aggregated marks of highlighting as well as faint lines of obfuscation that contribute to the opacity of the photograph (illus. 97).

Sloan's work has often been cited for its process of puncturing the 'authenticity' and 'realism' of the documentary image, yet the traces of the photograph which remain in every image contribute to their effective intervention into the representation of the Troubles.[30] It is precisely the dialectical tension between the realism of the photograph and the artifice of its 'marking' which makes his work so deeply problematic within the arena of imagery that depicts the Northern Ireland conflict. Sloan combines two semiotic forms of the indexical within the single pictorial space of the image: the photographic 'index', that is to say the causal relationship between the object or scene that was present in front of the camera and the photographic representation of it; and the 'indexical trace' left by the physical bleaching, marking and scarring of the photograph by his own hand. This process marks out the codification of the photograph, drawing attention to the photograph 'as photograph' by rupturing its claims to the pictorial clarity of the real. Sloan's photographs are mostly of seemingly mundane, calm scenes whose potential to incite a violent response is revealed in the almost frantic marking of the photograph that materially visualizes the slow release of psychological violence that cannot be represented in the quick exposure of the mechanical press photograph.

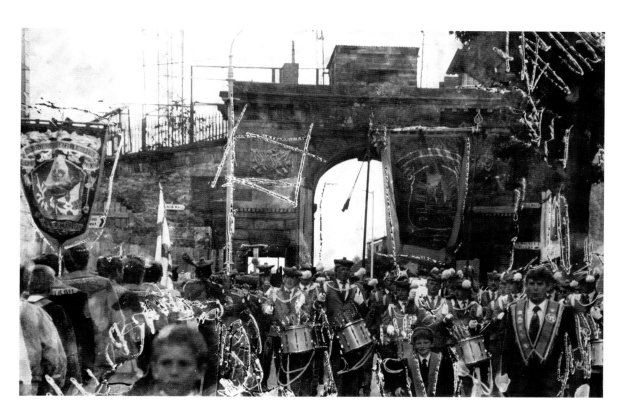

97 Victor Sloan, *Observation Point, Derry*, 1989, silver gelatin print, toners, gouache.

The psychological aspects of the conflict that Sloan marked out on the photographic image have been pursued by a number of other photographers who have questioned the capacity of the photograph to adequately represent the Troubles in any other way than from a specific ideological position. The artist Willie Doherty, who has combined photography with video and installation in his numerous works on the conflict in Northern Ireland, addressed the significance of positionality embedded in the visual construction and perception of representations of the Troubles in a series of works from the 1980s to '90s (illus. 98).[31] Doherty combined the photographic document with text in a process that established a series of relations between the textual and the visual, language and looking, viewer and image.[32] The photograph's significance was not what it represented but the geographical vantage point from which it was taken and

143

SHROUDING

PERVADING

FOG
ICE

98 Willie Doherty, *Fog: Ice/Last Hours of Daylight*, 1985, black-and-white photographs mounted on masonite with text framed, diptych, edition of three.

the perspective of the spaces depicted in the photograph. The stencilled text across the photograph played on the complexities of language in both confining meaning and providing the possibility for its emancipation. Frequently exhibited in diptychs and triptychs, the works were displayed in the gallery space in such a way that the viewer was caught in the cycle of positioning between one perspective and the next. This exhibitionary strategy was not establish a balanced perspective but to place the viewer within the contested space of textual and visual representation where meaning is always conflicted.

The relationship between text and image incorporated by Doherty into the pictorial space of the photograph demonstrates the significance of language in media representations of Northern Ireland.[33] While the use of language in the construction of photographic meaning had been

STIFLING
SURVEILLANCE

LAST HOURS OF DAYLIGHT

explored through the significance of context in the print media's use of photography in the reporting of Northern Ireland, Doherty, along with several other photographers, deliberately foregrounded the complexities of language's relationship with the photographic image. Doherty's incorporation of text into the surface of the photograph presented language not as an agent of anchorage but as something that was literally floating within the space of the image, detached from the world that had been photo-chemically fixed on paper. Paul Seawright's series *Sectarian Murder* took a different approach to the detachment of text and image (illus. 99). Producing oblique perspectives of sites where sectarian murders had taken place several years after the event, Seawright used textual descriptions of the murders that had appeared in the media to place the photographs in the context of sectarian violence. Combining what

145

Monday 3rd July 1972

'The man had left home to buy some drink; he was found later on waste ground
nearby. He had been badly beaten and it seems he had been tied to a chair with
barbed wire before being shot through the head.'

William Stott described as the two tendencies within the documentary genre to give 'information to the intellect' and to 'inform the emotions', Seawright's work established disconnections between the textual description of the murder and its visual representation.[34] This combination of the supposed 'objectivity' of the media and his own subjective approach to the documentary genre sought to draw out the psychological territorialism that sectarian murder instilled in both the Protestant and Catholic communities and which remained long after the media representations of it had disappeared.

The spatial politics of sectarianism, the geographies of conflict and the psychology of terrorism have been themes emerging out of the difficulties and struggles to represent the Troubles in the documentary form. Paul Graham's 1987 series *Troubled Land* represented the sectarian landscape through the visible signs of sectarianism marked out in painted kerbstones and the distant presence of British Army checkpoints. Graham recognized the difficulty in adequately representing the Troubles through the visual depiction of scenes of conflict or violence.[35] Commenting on his experience photographing in Northern Ireland, he observed that:

> What I overlooked at first, but which became extremely important to me later, was how the reality out there completely changes according to one's polarized perspective of it. There's this territory in Northern Ireland, and some people are seeing it as Irish and claiming it as theirs, and trying to alter it to match their reality . . . yet other people were seeing it completely from another perspective, another reality, according to where they came from.[36]

Graham retreated from the close depiction of sectarian violence of photojournalism, creating a distance between the viewer and the traces of conflict marked across the landscape. In a series produced for his Fellowship exhibition at the National Museum of Photography, Film and Television at Bradford in 1991, Graham turned his camera away from any traces of conflict to represent the emotional affect of the mediated images of political violence. The photographs taken during his work on the *New Europe* series were exhibited and published as *In Umbra Res*, Latin for

99 Paul Seawright, *Sectarian Murder*, 1974.

'in the shadow of things'.[37] Graham used the photographic fragment combined in diptych and triptych to explore the psychological experience of mediated images of violence, such as the execution of two British soldiers who drove into mourners at a Republican funeral at Milltown Cemetery. Graham's work demonstrated the limitations of photography in the representation of the Troubles and an acknowledgement that the different realities of the communities required a radically different form of documentary practice that was attuned to the psychological impact of violence on everyday life (illus. 100).

Patrick McCoy's series *The People's Taxis* used the documentary form to counter the stereotypical representations of Northern Ireland by producing intimate portraits of passengers who travelled in the black cabs of the Falls Road Taxi Association (illus. 101). The series was devised to shift the context of the representation of Northern Ireland from the stock of cliched depictions of urban conflict to the relationships established through the collective experience of the claustrophobic space of the taxi cab.[38] Bringing the viewer into close proximity with the subjects by replicating the anxieties of eye contact established through the seating arrangements of modern transportation, the portraits are deliberately confrontational. Unlike the photojournalistic image which attempts to mask the construction of what it represents by refusing any signs that recognize the presence of the photographer within the content or form of the image, McCoy, along with Paul Quinn and Gareth McConnell who also used the genre of portraiture, acknowledged their presence by bringing the subject closer to the camera.[39] The viewer of the photograph was positioned in close proximity to the subject through the directness of the camera's gaze, reminding them of the constrained spaces through which social life is played out in territories marked by conflict.

Post-conflict

The influence of postmodernism and the emergence of subjective approaches to documentary practice positioned Northern Irish photography

100 Paul Graham, 'Roundabout,
Anderstown, Belfast', 1984,
from the series *Troubled Land*.

traces out through the painted whitewash that has attempted to erase them forever, the photograph has not only been mobilized to preserve the post-conflict erasure of the collective memory of the Troubles as a memory in itself, but is a critical reminder that the aesthetic cleansing of the city is no panacea for the trauma of the past.

five

The City in Ruins

One of the first known photographs taken in Ireland was of the Long Bridge in Belfast by the engraver Francis Stewart Beatty, taken in 1840. The photograph and the bridge no longer exist as material forms. Beatty's photograph of the Long Bridge is only in the historical record of Irish photography because of a notice that appeared in the Belfast newspaper which exclaimed that 'Our ingenious and indefatigable townsman, Mr F. S. Beatty, has produced another photogenic drawing of a portion of the now fast-fading Long Bridge of Belfast taken from the Western bank of the River.'[1] The Long Bridge was beginning to fade from view at the very historical moment when Beatty took his 'photogenic drawing', the bridge's crumbling masonry and sagging arches about to be replaced with the concrete and steel of the Queen's Bridge which began construction in 1841.[2] The new bridge, with its modern design and construction materials, was a symbol of Belfast's industrial modernity, and Beatty's photograph of the 'fast-fading' Long Bridge was an enduring trace of the past preserved as a reminder of historical change and progress.

The recognition of the photograph's capacity to preserve ruins for future contemplation in the Belfast newspaper has been identified by other commentators on photography, even those critical of its aesthetic pretentions. Charles Baudelaire, in his critical thesis on photography and art, argued: 'Let it [photography] rescue from oblivion those tumbling ruins, those books, prints and manuscripts which time is devouring, precious things whose form is dissolving and which demand a place in the archives of our memory.'[3] When Baudelaire made his eloquent appeal for photography to be utilized for its mechanical attributes, the

instrumental concept of the photographic image's preservation of ruins was already being overshadowed in Ireland. The photographic ruin provided a visual space through which the destructive history of Ireland's past could be aesthetically explored, allowing the viewer to invest the ruin with a series of possible meanings ranging from an aesthetic object to be gazed upon for its picturesque qualities, to an image that could be ruminated over as a symbol of the destructive power of nature or the power of the clash of cultures to reduce buildings to hollowed-out, crumbling edifices.[4] Irish cities have been represented through different configurations of the photographic ruin, from documenting its changing architecture to the rupturing of the streetscape by revolution, conflict and civil war. In this short chapter, the aesthetics and politics of photography's representation of the city in ruins are explored as a form of representation that reveals the fortunes of the island in the past and for the present.

Documenting Change

Cities are always characterized by a set of propositions that claim the city is always 'something' other than just geographical spaces. Among these is the claim that the city is always already a representation of itself, in that it is planned and mapped out in architectural drawings expressing political ideologies before it is constructed in concrete and steel.[5] There is never just 'a city', but a multiple divided entity of 'cities', each with its own arena of often contesting representations. The city is always a process caught in the perpetual cycle of development and renewal; it is always 'becoming' something other than what it is already. To this list of suppositions we could add that the city is always in ruins, that even in the midst of the construction of the newest forms of architecture are the beginnings of urban decay and the disorderly collapse of structures that threaten the desire for visual uniformity of the cityscape (illus. 110).[6] Photography's capacity to structure the spatial and temporal amalgamation of these transient forms of the city into an image, its ability to capture and retain the process of the city's transformation so that it becomes visible and observable, have given the ruins of the Irish city a visual legibility that

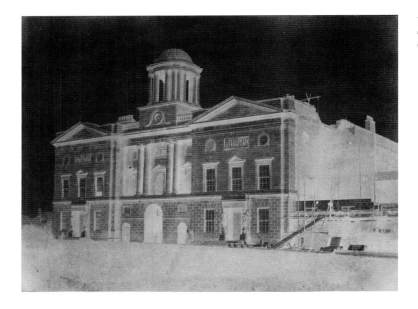

110 Unknown photographer, *Construction of East-Wing, Kings Inns, Dublin*, c. 1845, calotype negative.

allows them to be contemplated as both the historical remnants of the past and as allegories of an uncertain future.

This combination of aesthetics and politics in photographs of the city fed into the fear in Irish culture that the catastrophe of war or revolution would rob society of lasting images of a city's architectural heritage. The fear of the ruination of the Irish city carried within it utopian aspirations for the image to preserve for the future the ravages of time, and pre-dated the invention of photography. In the eighteenth century the authors of an illustrated record of imperial Dublin lamented of the failure of civilized nations to pictorially document the city:

> When in the revolution of States and Empires, the power and riches of ancient nations have been annihilated, and even the remembrance of them lost, buildings although in ruins, remain faithful monuments of their former splendour . . . These afford striking proofs of the maturity of the arts of the time of their erection; and it equally affords subject to regret, that either delineations of them in their original state were not preserved, or that the mouldering hand of

time, the ravages of conquest, and barbaric ignorance, should have deprived us of those models of perfection.[7]

The authors were joined in their pleas nearly two decades later by the artist James Malton, who called for the appointment of a 'City Delineator' so that 'an invaluable body of the architecture and history of the city would be preserved, and form a repository of the variations in the arts, and the causes that have successively influenced them'.[8] The first accounts of photography, which in their grasping for a lexicon to describe the new invention frequently observed that the process made objects 'delineate themselves', would no doubt have ignited the imagination of those who made a pre-photographic appeal for a city delineator.[9]

The prophetic appeals by artists such as Malton were to preserve an eighteenth-century image of Dublin that reflected its position as the second city of the British Empire.[10] From the mid-eighteenth century the city had been opened up through the adoption of the European aesthetic principles of the 'city beautiful' to establish a series of vistas and street-scapes that had been woven with the architectural symbols and monarchical statuary of British imperialism.[11] Opening up the city's main thoroughfares through the carefully planned and executed widening of the streetscape, Dublin was imaginatively constructed as a series of discrete sights that provided a visual backdrop to the outward expressions of the city's loyalty to the Empire. From the mid-1840s photography contributed to the visual integration of these distinct views into a harmonious imaginative geography of Dublin as an imperial metropolis.[12] Photographic images of the architecture of colonialism – municipal buildings, monarchical statuary, cathedrals and symbols of commerce – not only depicted the physical manifestations of Dublin's imperial status but established points of view and angles of vision that simultaneously emphasized its submissive loyalty through the political power of the Empire. Frederick Holland Mares's view of Sackville Street, included in his 1865 book of tipped-in albumen prints, *Photographs of Dublin*, projected the city's imperial status by emphasizing the towering monument to Horatio Nelson that was positioned as a focal point of the city's main commercial thoroughfare (illus. 111).[13] Such photographs functioned to

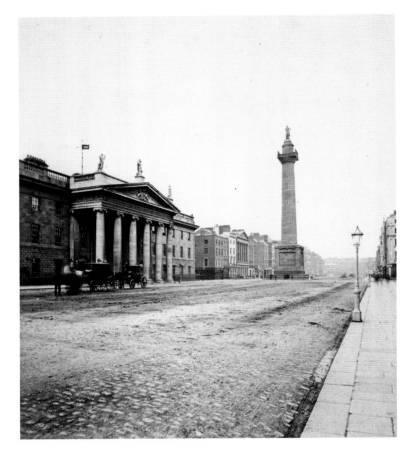

project the modernity of the urban landscape and the imperial authority which legitimized the municipal modernization of the city's public spaces. The photograph did not just provide a document of the city's architectural forms but also established 'points of view' and 'angles of vision' from which a coherent image of the imperial city could be visually experienced. In *Pictures of Dublin* the accompanying text to Mares's photographs of Sackville Street observed:

> Standing on Carlisle Bridge a general idea may be obtained of its extent and beauty; looking northward, in the direction of the magnificent

112 Unknown photographer, *Sackville Street, Dublin*, c. 1865, stereoview.
.

column erected to commemorate the glorious victories of the immortal Nelson, we perceive in the immediate vicinity of that column . . . the General Post Office, and in the distance, a portion of the Rotundo . . . while beyond, towering above every other building, is seen the elegant spire of St George's Church, and Rutland Square Presbyterian Church. Looking in an easterly direction, we see on the left bank of the Liffey the Custom House . . . while, to the south, the eastern portico of the Bank of Ireland and the northern portico of Trinity College.[14]

The imperial image of Dublin that such nineteenth-century photographs projected began to be challenged by an alternative image of the city in popular photographic imagery by the late 1860s. The architectural symbols of Georgian imperialism were still physically present across the Dublin streetscape but they were already beginning to be visually dissolved by the photochemical form of the photograph image. A photographic view of the city emerged in the 1860s, softening the hard edges of the imperial streetscape before it was to actually crumble. The view from Carlisle Bridge (now O'Connell Bridge) looking from the south of the city towards the north along Sackville Street (now O'Connell Street) and Nelson's Column had quickly been established as a photographic symbol of Dublin through the stereoscopic card. In the earliest popular prints and photographs of this imperial streetscape, Nelson's Column was always clearly foregrounded in a pictorial validation of the idealized vantage point from which to visually consume within a single viewing an assemblage of architectural signs of Dublin's imperial status. As the century progressed, however, the photographic view of Sackville Street began to draw back and Nelson's Column began to dissolve into the pictorial space of the photograph (illus. 112). The horizon began to shift with the architectural symbol of imperialism, transforming it into a muted, faded outline of its former glory. Physically the masonry may have still been *in situ*, but the imperial city was projected as beginning to decay before it had been reduced to the crumbling ruins of the collapsed and hollowed-out facades that appeared in the early twentieth century.

Revolution and War

The nineteenth-century photographs of an eighteenth-century imperial
city in the inertia of decay prefigured the rapid and violent reduction of
Dublin to a landscape of smouldering ruins that appeared in photographs
of the aftermath of the Easter Rebellion of 1916. On Easter Monday of
that year a group of Irish Volunteers (Óglaigh na hÉireann), led by
Patrick Pearse, took over the General Post Office on Sackville Street.[15]
In the six days of ensuing battle between the Volunteers and the British
Army, the imperial streetscape had been reduced to an urban landscape
scattered with the ruins wrought by the new technological warfare of the
twentieth century (illus. 113). Commemorative publications and special
issues of magazines and newspapers appeared within weeks of the end
of the Rebellion, illustrated with the 'late photography' of modern tech-
nological war already familiar to the public through the photographs
 of the ruined European urban landscapes of the First World War.[16]
The writer James Stephens who witnessed the events of that week
asked rhetorically:

> The Insurrection is over, and it is worth asking what has happened,
> how it happened, and why it happened? . . . The first question is
> easily answered. The finest part of our city has been blown to
> smithereens, and burned to ashes. Soldiers amongst us who have
> served abroad say that the ruin is more complete than anything
> they have seen at Ypres, than anything they have seen in France
> or Flanders.[17]

Technological warfare, it seemed, had fashioned Dublin into a repre-
sentation of the other ruined cityscapes that had already been circulated
in the photographs of the First World War. In proto-postmodern terms
one journalist proclaimed: 'The greatest thoroughfare which the citizen
of Dublin was accustomed to describe as "the finest in Europe" has been
reduced to the smoking reproduction of the ruin wrought at Ypres by
the mercilessness of the Hun.'[18] The ruined cityscape of a once imperial

113 Unknown photographer, *Corner of Sackville Street and Eden Quay, Dublin*, 1916, tipped sepia half-tone, from a commemorative album.

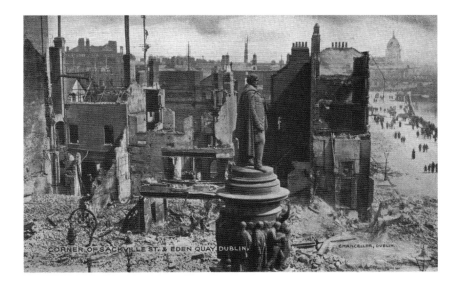

Dublin was given a visual legibility through the photographic image that allowed it to enter the collective memory of the public experience of war.[19] The photographic depiction of the grey, smouldering ruins of the administrative, legal and commercial architecture of the city were also open to allegorical readings that attempted to overwrite each other in their interpretations of the ruined city as a symbol of the destruction by barbarism, or as a contemplative cityscape marked with the fragmented forms of its future demise.

The ruin in the landscape has figured within pictorial aesthetics as the appearance that architecture has been drawn down into the composition of the landscape as if through the power of nature.[20] In the photographs of the ruined city, however, the ruin can only ever be a symbol of the neglect of societies that fail to halt architectural decay, or an expression of the clash between cultures that reduce cities to the scattered detritus of conflict. It is this latter figure of the ruin that dominated photographic representations of the city in Ireland for much of the early twentieth century. Throughout the War of Independence from 1919–21 and the Civil War of 1922, photography of the city provided a visual imaginary of the ravages of the clash between imperialism and

nationalism.[21] The press photographer W. D. Hogan extensively documented the War of Independence for newspapers and photographically illustrated commemorative pamphlets.[22] Amongst his photographs of the War are images of the destruction of Cork by the Black and Tans (illus. 114), an auxiliary division of the police drafted from veterans of the First World War to suppress the revolution by Republicans. Hogan also photographed the hollowed-out shell of the Four Courts during the Civil War of 1922 (illus. 115). The photographs contained within the structured framing of what was described as the 'Temple of the Law' the visual tropes of the Palladian ruin replete with ruined ornate columns, and the truncated and dismembered fragments of figurative sculpture.[23]

114 W. D. Hogan, *Cork after attack by Black & Tans, Irish War of Independence*, 1919, black-and-white photograph.

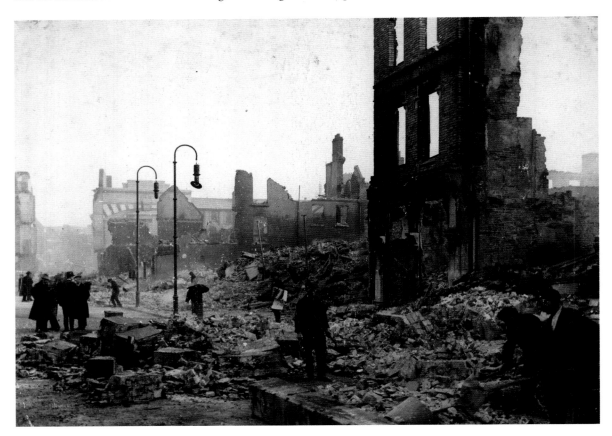

115 W. D. Hogan, *Main Hall, Four Courts*, 1922, black-and-white photograph from photonegative, for *Independent Newspapers*.

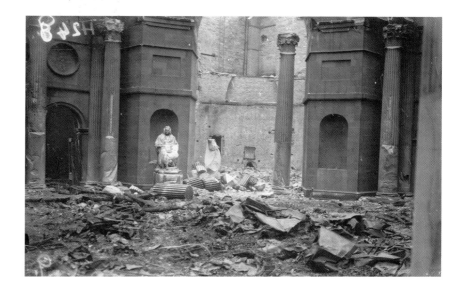

Taken from a vantage point slightly outside the entrance to the central hall, the photograph represented the ruined interior of the building as if it were an elaborate theatrical stage on which the tragic drama of Ireland's turbulent history had just been enacted.

In 1941 the photographic representations of Belfast in ruins carried within them a very different set of possibilities that saw within the destruction wrought by aerial warfare resilience and responsibility for the future destiny of the city. In April and May 1941 the city had been bombed by the German Luftwaffe during its Blitz of Britain and Northern Ireland.[24] The *Belfast Telegraph* published a commemorative photographic booklet of the bombings later that year titled *Bombs on Belfast* (illus. 116).[25] The booklet emphasized hope and stoic resilience in the midst of war, contextualizing the ruined cityscape as an emblem of future potential. Opening with photographic images of the destruction of the city interpreted as 'the price of its loyalty to the British Empire', it depicted the cleared-away streetscapes, concluding with an image captioned: 'In the heart of Belfast, where well-remembered landmarks stood, the last "All Clear" will be the signal for the citizens to begin work of building anew.'[26] The authors of the booklet clearly envisaged the

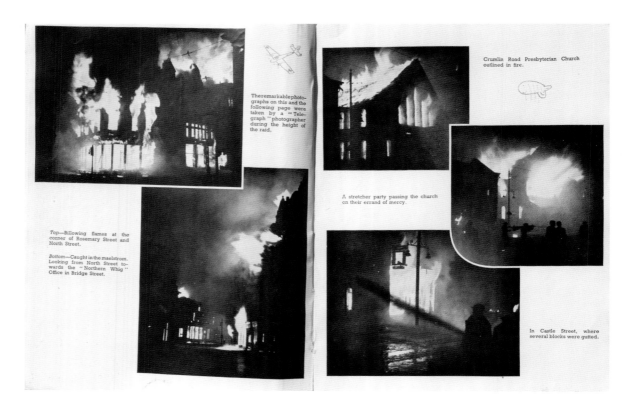

The remarkable photographs on this and the following page were taken by a "Telegraph" photographer during the height of the raid.

Top—Billowing flames at the corner of Rosemary Street and North Street.

Bottom—Caught in the maelstrom. Looking from North Street towards the "Northern Whig" Office in Bridge Street.

Crumlin Road Presbyterian Church outlined in fire.

A stretcher party passing the church on their errand of mercy.

In Castle Street, where several blocks were gutted.

viewer of the photographs of the ruined cityscape as contemplating the future as they gazed upon the skeletal remains of Belfast's civic and religious architecture. In the concluding remarks of the book's introduction the authors noted:

> One bright gleam emerges even from scenes so depressing . . .
> With gardens and open spaces as garments of beauty there may
> arise a new Belfast with interior worthier of the unrivalled setting
> which nature has endowed the city of Lagan.[27]

116 Unknown photographers, from *Bombs on Belfast*, 1941, commemorative photo-book.

Picturing Slums

In the shadow of the imperial streetscapes of Ireland's cities photography illuminated the congested capillaries of the urban slums, which were endowed with their own aesthetic of decay. Photography was used by private developers, municipal governments and charitable organizations to document the living conditions of the urban poor, drawing on the stark contrast of darkness and light of photographic discourse for dramatic effect. Charles Dickens wrote of Dublin's slums:

> Possessing vomitoria seemingly innumerable in the shape of lanes ... with an almost indescribable aspect of dirt and confusion, semi-continental picturesqueness ... I would strongly advise all travellers ... and lovers of picturesque catholicity, by no means omit a walk in the Coombe when they visit Dublin.[28]

Photography was perceived to offer visual evidence of the dark recesses of the city, its power to optically enter into spaces that the general public wouldn't physically transgress contributing to an imaginative geography of what became termed the 'darkest' cities of Belfast, Limerick, Cork and Dublin (illus. 117).[29] The aesthetic of photographic processes such as the platinotype were utilized to fill the frame of the image with a hazy, silvery atmosphere that contributed to the perception of the city's slums as murky, confined and repressive. The photographic depictions of streets falling into decay through the inertia of its inhabitants, unable to embrace the accelerating pace of urban progress, were frequently used by charities and government bodies as the first step towards petitioning for the opening-up of slums to the luminosity of moral and civic reform. Many of the photographs produced for municipal reports were transformed into lantern slides by moral reformers keen to exploit photography's potential to shock the viewer and ameliorate the deprivation of the urban poor. The power of photography to illuminate the darkness of the slum was inverted in one account by a priest, who exclaimed to a committee investigating the housing conditions of Dublin's working classes:

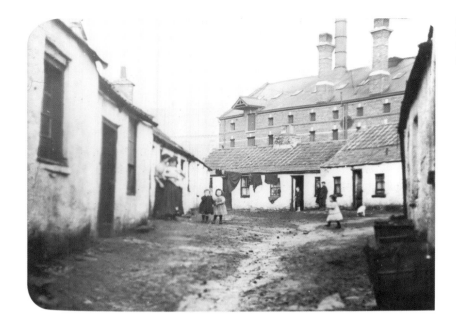

117 Unknown photographer, 'Forbe's Cottage, Forbe's Lane', 1913, from *Darkest Dublin* (1913), black-and-white photograph from lantern slide.

Even on a bright day in summer it is sad, for the glad smile of god's sunlight barely lights the enclosure. I tried to have a photograph taken of it by a friend, but the Goertz lens of his camera failed to reproduce the picture. He told me he would try a longer exposure to reproduce the photograph I desired to get of his dismal slum . . . Plants would wither there. What of the child-life? [30]

The binary opposition of light and dark, the lexicon of photography and the biblical conception of good and evil are merged to construct an impression of place. The reality of this imaginary geography of Dublin's slums is not to be found in the photographic image, however, but in the priest's perception of photography's technological limitations in illuminating the dark recesses of the city's slums.

Street Photography and the Nation

The city as a space through which to explore the failure of the modern nation to fulfil its promise has been a theme of Irish street photography since the 1950s. Photographs of the ruins of society, marked in the weary bodies and faces of the urban working classes, and the shabby, worn facades of experiments in social housing, have become a distilled image of societal breakdown of the modern nation. In the 1950s the artist Nevill Johnson produced a series of street photographs of Dublin that mingled the almost forensic details of the discarded detritus of material culture with street scenes that moved between the banality of everyday life and the esoteric visual forms that emerged from the flow of urban modernity (illus. 118). When Johnson published these photographs over a quarter of a century later, he titled the book *The People's City*, acknowledging that it was the character of the people rather than its architectural facade that gave Dublin its meaning.[31] Johnson's optic view of the city was modernist, working between the fragment and the stilled ephemeral instant. He represented a city in the aftermath of the Second World War as economically bankrupt but culturally rich in its imaginative possibilities of visual forms that could be captured by the camera. In the foreword accompanying the book James Plunkett observed that 'here was a world edging only slowly and uncertainly away from the shortages, the austerities, the isolation of the war years; a world discarding almost unconsciously the customs and concepts of outmoded society'.[32] Johnson's photographs spoke of an era and an ideology of the nation that was beginning to fade away as Ireland embarked on the process of diplomatic and international relations with the rest of post-war Europe.

Johnson, together with photographers such as Fergus Bourke and Bill Doyle, honed his vision on the people of Dublin, the city frequently appearing as a force that bore down on the individual, moulding them into wearied but resilient characters.[33] Bourke's photograph *A Pickeroon* of a girl collecting fallen coal of delivery trucks in the street, conveyed the oppressiveness of city life as its citizens foraged along the asphalt to maintain a meagre existence (illus. 119). Bourke's photographs illustrated

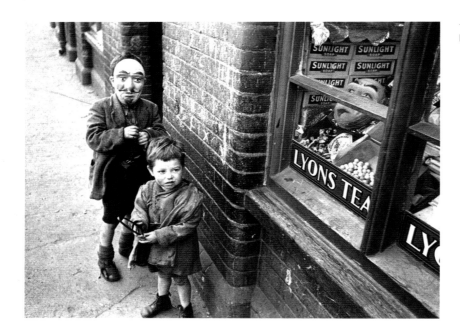

the novelist Edna O'Brien's autobiographical recollections *Mother Ireland*, and his photographs of city life in that book reflected a nation that had still not vanquished the austerity identified by Plunkett as being on the threshold of disappearing in Johnson's photographs of 1950s Dublin.[34]

The work of photographers such as Bourke, Johnson, Doyle and Elinor Wiltshire (illus. 120) drew in varying degrees on a latent documentary humanism. In the late 1980s and early '90s, however, a much bleaker and more cynical photographic image of the Irish city emerged in two different types of book. Magnum photographer Donovan Wylie, together with the writer Robert McLiam Wilson, published a book in the early 1990s of three cities in Britain and Northern Ireland, London, Glasgow and Belfast.[35] All cities were in the political shadows of Thatcher's Britain and Wylie's photographs depicted a Belfast that was suffering under the burden of both economic repression and political sectarianism. Wylie's co-author observed that the photographer 'ran the risk of not quite believing that the city which had nurtured him could be so cruel

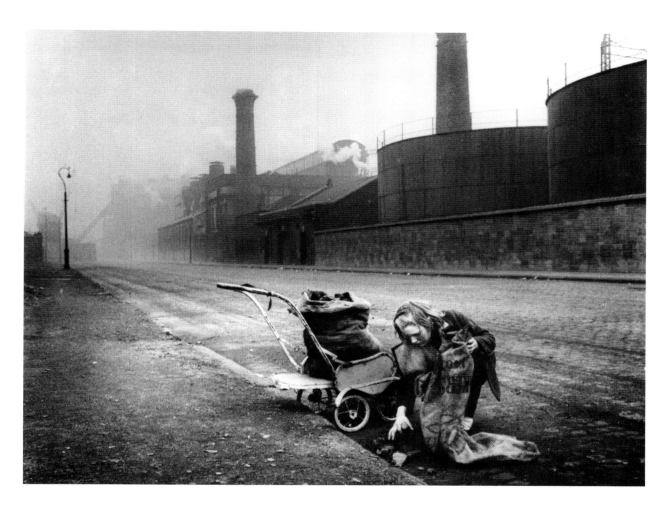

119 Fergus Bourke, *A Pickeroon*, 1962,
black-and-white photograph.

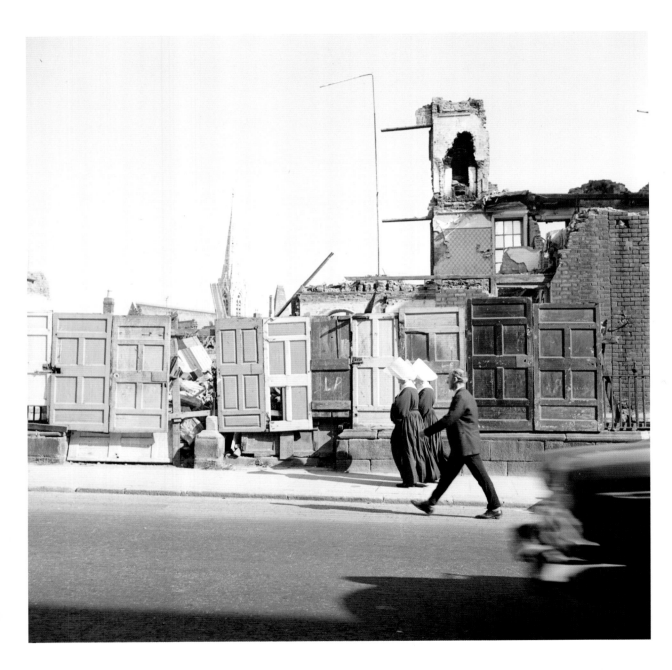

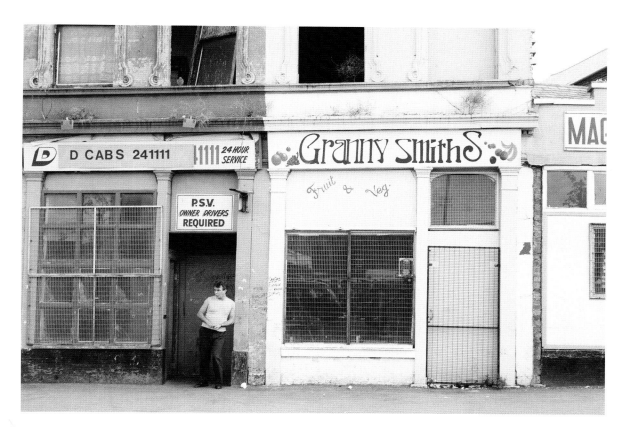

121 Donovan Wylie, *Homeless Man, Belfast*, 1990, black-and-white photograph.

120 Elinor Wiltshire, *Nuns Passing Demolition*, 1964, black-and-white photograph from photonegative.

or bereft', his experience of Belfast not quite matching the image he would ultimately portray of it in his photographs.[36] Wylie's photographs represented Belfast as a city constantly on the precipice of despair, its people pulled between the stagnation of the past and the false progress of the present (illus. 121).

Two years earlier the photojournalist Tony O'Shea had published *Dubliners*, a book that not only portrayed a city but provided one of the most incisive and troubling visual critiques of the failure of the modern Irish state.[37] O'Shea adopted a perspective and photographic style that framed the city tightly within the viewfinder, not to crop out what was unimportant but to pull the viewer into the visual density of what was represented within each photograph. The political significance

of O'Shea's book, however, was in its visual arrangement of photographs, which sometimes crudely but deliberately juxtaposed photographs of the cronyism of Ireland's political and cultural elite and the abject poverty of inner-city life. O'Shea's photographs of 1980s Dublin depicted the cultural austerity which was a nightmarish aftermath of the unrealistic vision of prosperity by successive Irish governments in the 1970s following the economic boom of the 1960s. Through his cleverly edited and arranged photographs, Dublin appeared as a city ruined by the empty rhetoric of church and state. Decades of political failure appeared in O'Shea's photographs to be congealed in the social alienation of Dublin's inner city, and the residual architectural forms of failed planning and social experiments of suburban housing (illus. 122).

122 Tony O'Shea, 'Halloween Ballymun', c. 1988, black-and-white photograph from the book *Dubliners* (2000).

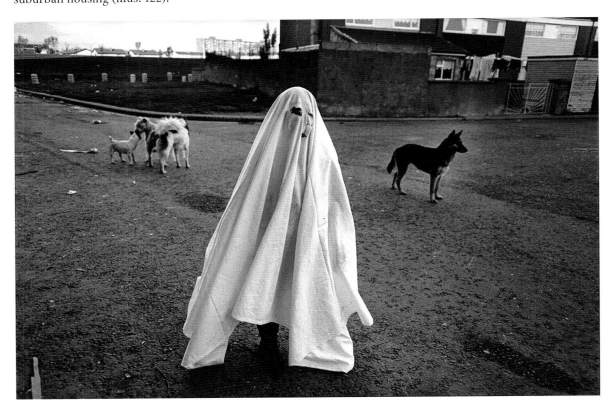

primitive landscape with a visual familiarity.[4] The image of Ireland described by Sekula already had a universal currency when he wrote this essay in the early 1980s, and had a particular resonance within Irish-American popular culture through films such as John Ford's *The Quiet Man*.[5] In the early 1980s it was to resurface again when plans were in place for US President Ronald Reagan to travel to Ireland in 1984 to visit the ancestral home in Ballyporeen. Much to the disappointment of the international media it was not the rural Arcadia depicted in *The Quiet Man*, but a simple mound of dirt in the middle of a disused bog. Despite Reagan's own shattered dream of the picturesque homestead nestled amongst the rolling hills of the Irish countryside, the myth of the ancestral Irish home as a primitive land, in another time and another place, continues to be circulated in the universal visual economy of photographic imagery of Ireland.

I began this book with a discussion of similar types of images by the photographer John Hinde. One of Hinde's photographers, David Noble, recounts taking a photograph of a similar type of scene to that described by Sekula, but it was one that had its own history of myth-making:

> While I was going around the island [Aran] I came across a perfect cottage, thatched, everything, sat right in front of the horizon of Connemara. It was a perfect picture so I set up and took it. I found out afterwards it was the cottage that Flaherty had had built for the family who appeared in his film 'Man of Aran'. He'd deliberately chosen the spot because it made *a good picture*.[6]

There has been a tendency to treat accounts such as Noble's as one more example that endorses the proto-postmodernism of photographic representations of Ireland.[7] Collapsing the postcolonial into the postmodern, much critical theory has interpreted Hinde's postcards and other photographic images like them as circulating within the Baudrillardian orbit of the simulacra.[8] In this account of photographic imagery of Ireland, if photographs such as Hinde's are evidence of anything it is of the feigning of what was never there, the photograph providing the viewer with an imaginary presence of what is and always

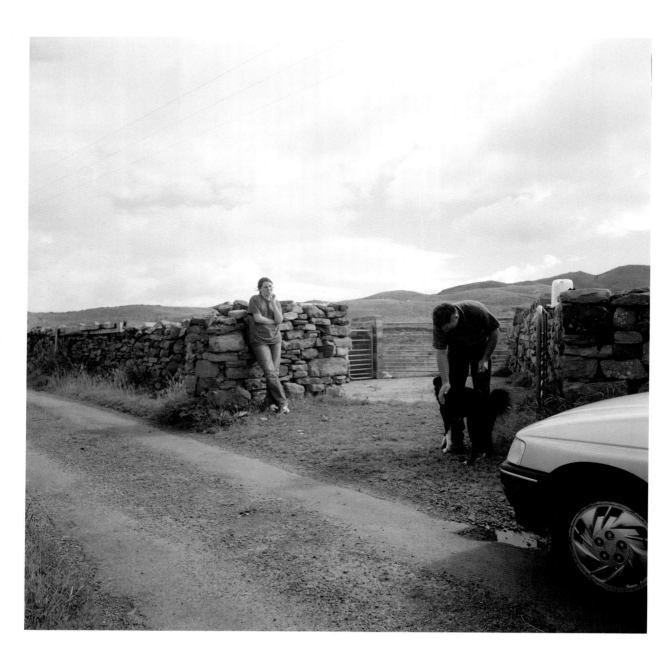

has been absent. This is partly Sekula's point when he observes that 'everything that is absent is made present', but his anecdote introduces another dimension into the universal photographic currency of Ireland as a pre-modern, rural idyll.[9]

In Sekula's anecdote, the experience of the photograph is imbued with contrasting temporalities. The image of a distant geographical location existing in a seemingly empty temporality is viewed from the position of the cosmopolitan present. It is the position from which this image is experienced, drawn out so subtly in Sekula's anecdote, which is significant here. The image of a primitive Irish landscape is not an end in itself; it reinforces the viewer's own sense of modernity and visual mastery. Positioned on the outside looking in, the viewer is located in the ongoing fluidity of urban modernity, gazing upon the stilled, primitive world of rural Ireland, an imaginary place made real through the photograph.

In 2006 the photographer Jim Vaughan produced a body of work, *This Time, This Place* (illus. 126), representing life on Clare Island in the Atlantic ocean off the west coast of Ireland.[10] Clare Island has long been the subject of representations by tourists, anthropologists, naturalists and archaeologists, who have perpetuated a discourse of the island and its inhabitants as a primitive culture living in a bygone day.[11] The island, seen from the outside as undeveloped, has been the subject of photographs similar to those of John Hinde's postcards and the Kodak advertisement which have portrayed it as dislocated from normal temporal development and free from the corrupting effects of modernity. Vaughan's response was to work with the local islanders to produce photographs that looked out from within the community and in at their experiences of an island life that co-exists with the postcard imagery of the west. The photographs produced by Vaughan and the local community focused on the everyday life of the island's inhabitants with their own sense of modernity and place within the land outside of the cliched tourist imagery that has been produced of it. What has characterized photography such as Vaughan's is a visual flatness, an eschewing of the definitive, compositionally correct photographic depiction of place in favour of oblique views that meander between one banal scene and the next. There is an almost anti-tourist aesthetic at play in their work,

126 Jim Vaughan, 'Untitled', from the series *This Time, This Place*, 2006.

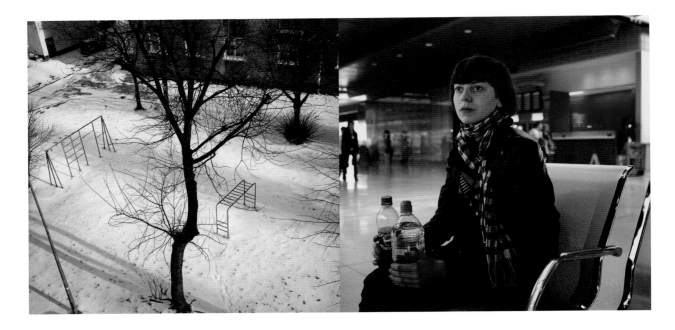

the compositional rules of the picturesque being jettisoned with objects jutting up through or across the pictorial space of the photograph. The universal language of photography has been turned on its head and would seem to render the universal photographic image of Ireland unfamiliar.

The opening chapter of this book began with a discussion of photography's role in the imaginative geographies of Ireland as place and I want to conclude with two different examples that demonstrate how the distinctiveness and familiarity of Ireland as place has been further complicated through the photographic image. Joe Sterling has documented Polish migrant workers in Ireland in the series *Working Distance* (illus. 127). Combining photographs of locations in Poland with portraits of migrant workers, including one of workers waiting in the departure terminal of an Irish airport to travel home, Sterling presents his photographs in diptychs that merge the legible photographic traces of the migrant's homeland with the non-place of the airport. Sterling's photographs document the experience of the migrant worker but they also provide a particular perspective of Ireland as place. The depiction

127 Joe Sterling, 'Julia Waits to Board Flight 254 to Gdansk', colour photograph, diptych, from the series *Working Distance*, 2008.

128 Mark Curran, 'Ebelonga, Clean Room Operator, 10.22 a.m., Thursday, November 20th 2003 (Leixlip, Ireland)' and 'Untitled, Gowning Room, Building 7, 11.02 a.m., Monday, November 11th 2003 (Leixlip, Ireland)', ultrachrome archivals, both from the project *The Breathing Factory*, 2006.

of his subjects within the airport departure lounge emphasizes that for the East European workers who travelled to the country during the much vaunted Celtic Tiger economy, Ireland is no more than a transient space, a stop along a journey that is always homeward bound.

The final example is the photographer Mark Curran's detailed observation of global labour practices in the factories of the multinational computer manufacturers Hewlett-Packard (illus. 128).[12] Curran's *The Breathing Factory* is a reflexive, ethnographic account of globalized labour in Ireland in the twenty-first century which combines photography with video and text produced out of his interviews with the multinational's employees. Curran's photography is a deeply ethical gaze on the labouring body within post-industrial Ireland. The direct, eye-level photographs of migrant workers evidencing the dialogical process and negotiation involved in producing the subjects' portrait. The photographs of the high-tech spaces of the factory floor, the administrative spaces of the open-plan office and the low-rise, fabricated exteriors of buildings all contain the similar pallid, grey-blue hues of globalized space. A muted

colour palette fills the frame of every photograph, giving a sense of sameness to each individual image, the only variation appearing in the distinctive features of workers' faces looking directly at the camera. There is much depth to Curran's photographs and their visual sophistication operates across many interconnected levels, but what is worth observing is that his view of Ireland in the twenty-first century is one that is devoid of the cultural specificity that would allow the viewer to identify the spaces represented as Ireland. Unlike Sekula's colour-saturated, globalized image of Ireland in which all that is distant is made present and familiar in its entirety through the 'universal language' of photography, Curran's direct camera aesthetic has transformed all that is close and contained into the indistinct and the detached.

References

Introduction: Geographical Imaginings

1 Declan Kiberd, *Inventing Ireland: The Literature of the Modern Nation* (London, 1996), p. 9. Kiberd's full statement is: 'If Ireland had never existed, the English would have invented it; and since it never existed in English eyes as anything more than a patch-work-quilt of warring fiefdoms, their leaders occupied the neighbouring island and called it Ireland.' As readers will see, this colonial relationship with England is significant to the history of photography in Ireland discussed in this book.

2 Joly's process involved placing a screen of coloured lines on a glass plate in front of the photographic negative to filter the red, green and violet colours. From this negative a positive colour image could be produced. In addition to numerous photography-related inventions, Joly also invented the Dublin Method of Radium Therapy for cancer sufferers. For an account of his career see Jon R. Nudds, 'The Life and Work of John Joly (1857–1933)', *Irish Journal of Earth Sciences*, VIII/1 (1986), pp. 81–94. On his invention of single plate colour photography see Stephen Coonan, 'The Joly and McDonough Colour Processes', *History of Photography*, XVIII/2 (1994), pp. 196–7.

3 Shaw's writing on the aesthetics of photography extended to his novel *An Unsocial Socialist* and also appeared in Alfred Stieglitz's *Camera Notes*. For an overview of his connection with photography and his collected writings on the culture and aesthetics of amateur photography see Bill Jay and Margaret Moore, eds, *Bernard Shaw on Photography* (Wellingborough, 1989).

4 This is reflected in the voluminous publication of glossy coffee-table books of the Irish landscape available in most bookstores. There are too many to list here, but several of these publications have been designed with a specific European or North American audience in mind, mirroring in many respects the marketing of Ireland as a tourist destination. Group exhibitions of Irish photography internationally have also been orientated towards the Troubles, particularly the work of contemporary artists and photographers who have addressed the media portrayal of the Northern Ireland conflict. For a more progressive example of the exhibition of the conflict, see the catalogue of the exhibition *Revealing Views* held at the Royal Festival Hall in 1999; *Revealing Views: Images from Ireland*, Royal Festival Hall (London, 1999).

5 Although photographic collections have been held in many archives and libraries, it has only been since the 1980s that photography has been actively collected and conserved by major cultural institutions in Ireland. The most significant private collection is that of Sean Sexton, photographs of which have been published as Sean Sexton, *Ireland: Photographs* (London, 1989) and Sean Sexton,

Ireland: A Photohistory (London, 2002). The history of Irish photography has also only recently appeared in the curricula of a small number of university degrees.

6 The emergence of theory in photographic culture during the late 1970s and '80s through journals such as *Screen, Screen Education, Camerawork* and later *Ten.8*, did not influence Irish photography directly. It was returning Irish photographers educated in British universities and the influence of European photographic practices that brought new possibilities of representing Irish society to the fore in Irish photography during the 1980s. For a discussion of 'theory' in British photography see John Roberts, *The Art of Interruption: Photography, Realism and the Everyday* (Manchester, 2001).

7 Until the mid-1990s photographic education in Ireland was limited to apprenticeships, City and Guilds or certificate courses largely directed towards commercial photography. The development of degree courses coincided with an expansion in art education, the influence of European photography, the building of a purpose-built gallery of photography in Dublin and the establishment of the arts organization Photo Works North in Belfast. Many of these developments were led or influenced by the experience of photographers, educators and curators in Britain and Europe.

8 This point was made by Luke Gibbons in a book review of Magnum's *A Day in the Life* series on Ireland and has been a theme that has regularly been discussed in relation to photographic representations of Ireland. See Luke Gibbons, 'Alien Eye: Photography and Ireland', *Circa*, 12 (1984), p. 10.

9 'Sightseeing' has been an aspect of Irish tourism since the eighteenth century and stereoscopic images of sights such as Killarney, Wicklow and the Giant's Causeway were being produced and circulated globally from the 1850s. In the 1950s the Irish government began to aggressively market Ireland as a tourist destination using photography and picture postcards similar to Hinde's. An account of the commercial development of tourism in Ireland can be found in Irene Furlong, *Irish Tourism, 1880–1980* (Dublin, 2008).

10 For an overview of Hinde's colour photography stretching from before the Second World War through to the 1970s see Declan McGonagle and David Lee, *Hindesight: John Hinde Photographs and Postcards by John Hinde Ltd., 1935–1971*, exh. cat., Irish Museum of Modern Art (Dublin, 1993).

11 See Liam Blake, *Real Ireland: People and Landscapes* (Dublin, 1984).

12 Fintan O'Toole, 'Introducing Irelantis', in Seán Hillen, *Irelantis* (Dublin, 1999), p. 5.

13 Ibid., pp. 5–6.

14 Such an account in a very narrow institutional context has, in a sense, already been published by Magnum in its expansive survey

of its collection of Irish photographs. See *Magnum Ireland* (London, 2008).

15 Even these descriptive terms of the two parts of the island are open to contestation. I only employ them here as a convenient shortcut to emphasize the complexities of politics, religion and culture that circulate within and beyond Ireland's geography. For some within the largely Protestant unionist community, Northern Ireland, despite being geographically separated from the British mainland by the Irish Sea, is politically and culturally a fully integrated part of the United Kingdom. For others within this same community there are aspirations for an Ulster nation that is politically and culturally autonomous to varying degrees from both the Republic of Ireland and the UK mainland. Within the predominantly Catholic nationalist community there remain strong contentions that Northern Ireland is an occupied territory, with many expressing political and cultural aspirations for the unification of Northern Ireland with the Republic. The broad strokes outlined here do not adequately cover the various perspectives from within the unionist or nationalist communities, nor indeed in the Republic of Ireland. For a more detailed account of how Ireland has been politically and culturally conceived by the different communities see Stephen Howe, *Ireland and Empire: Colonial Legacies in Irish History and Culture* (Oxford, 2000).

16 There has been a tendency to treat photography in Ireland as polarized by the border with photography in the Republic of Ireland largely being perceived to address issues of cultural loss and the romanticism of Ireland as a pre-modern rural idyll, while photography from Northern Ireland, particularly over the last thirty years, has almost solely been approached in the context of the Troubles. The differences are much more nuanced and two of the more sophisticated approaches that have brought contemporary photography from both North and South together have been the exhibitions *The Lie of the Land* held at the Gallery of Photography, Dublin in 1995 and *Revealing Views: Images from Ireland* at the Royal Festival Hall, London in 1999. See the catalogues *The Lie of the Land* (Dublin, 1995) and *Revealing Views*.

17 Edward Chandler, *Photography in Ireland: The Nineteenth Century* (Dublin, 2001); W. A. Maguire, *A Century in Focus: Photography and Photographers in the North of Ireland, 1839–1939* (Belfast, 2000).

18 Local history has played a significant part in the scholarship of Irish photography. Indeed the only source book on Irish photographic collections has emerged out of local history studies. See Liam Kelly, *Photographs and Photography in Irish Local History, Maynooth Research Guides for Irish Local History: Number 13* (Dublin, 2008).

one: A Short History of Irish Photography

1 Ireland's experience of English imperialism does not fit the established model of a colonized territory; indeed some historical accounts have questioned whether Ireland was a colony at all. The debate surrounding Ireland's status as a colony is too complex to cover here; as one historian has noted of the previous century, it was precisely the ambiguous status of Ireland as a colony which became its key characteristic: 'too physically close and too similar to Britain to be treated as a colony, but too separate and too different to be a region of the metropolitan centre; inheriting an undoubted division between settler and native, yet without the racial distinctions that could make these absolute'. See S. J. Connolly, 'Eighteenth-century Ireland: Colony or *Ancien Régime?*', in *The Making of Modern Irish History: Revisionism and the Revisionist Controversy*, ed. George D. Boyce and Alan O'Day (London, 1996), p. 26. Despite this ambiguity the development of photography in nineteenth-century Ireland displays several characteristics that demonstrate the impact of colonialism on both the types of photographic imagery taken of the country and its social uses.

2 The historical argument that Ireland was not a colony in the form of recognized models of European colonialism fails to acknowledge that even among those countries universally identified as having a colonial history, there is no universal or corresponding set of colonial experiences. As much as the colonial project may have dreamed of an Empire uniformly arranged as a series of analogous territories, cultures and races, each country within it had its own individual experience of the colonial process. What characterizes colonial experience is thus not uniformity but heterogeneity. For an overview of these debates in relation to Irish historiography see Stephen Howe, *Ireland and Empire: Colonial Legacies in Irish History and Culture* (Oxford, 2000).

3 This aspect of Ireland's photographic history has yet to be fully explored. There are a number of examples where Irish photographers were clearly influenced by colonial photography from Asia and the Middle East in their choice of subject-matter, while others used the photographic form to emphasize Ireland's cultural distinctiveness as a colony on the edge of Europe. In the discussion that follows only a limited number of examples have been identified.

4 See for example Christopher Pinney, *Camera Indica: The Social Life of Indian Photographs* (London, 1997).

5 The Anglo-Irish landlords who dominated amateur photography throughout much of the mid-nineteenth century cannot be classified as being colonized or indeed of being colonial subjects in Bhabha's sense of the term. What is significant about these photographers however is that they were culturally situated within an in-between space of colonial photography. Not fully English in

terms of geographic location and not quite Irish culturally, photography provided many of the Anglo-Irish with the opportunity to project their individual sense of cultural identity. Homi K. Bhabha, *The Location of Culture* (London, 1994), pp. 121–31.

6 The complexities of Ireland's colonial experiences in Irish historiography and cultural studies are covered in Howe, *Ireland and Empire*.

7 Edward Chandler and Peter Walsh, *Through the Brass Lidded Eye: Ireland and the Irish, 1839–1859, The Earliest Images*, exh. cat., Guinness Museum, Dublin (1989).

8 Ibid., pp. 11–12, 52. The Dublin Photographic Society, founded in 1854, changed its name to become The Photographic Society of Ireland in 1858. See Edward Chandler, *Photography in Ireland: The Nineteenth Century* (Dublin, 2001), pp. 65–70.

9 For details of the few photographers to appear in Belfast in the 1840s see W. A. Maguire, *A Century in Focus: Photography and Photographers in the North of Ireland, 1839–1939* (Belfast, 2000), pp. 7–11. There are several reasons why commercial portraiture was not as successful in Ireland's main cities: one is as a consequence of the Act of Union of 1801, which resulted in the political classes decamping to London from Dublin, while in Belfast a relatively small industrial middle class who would have been the potential market for early commercial portrait photographers could not sustain the long-term viability of studios. The cost of a framed daguerreotype was advertised as £1, 1 shilling, and this may have been too expensive to generate a growing clientele for commercial studios.

10 The origins of photography in Ireland are on the margins of the dominant historiography of European photography. They are to be found, quite literally, in the footnotes of a number of standard history books and journal articles. As citations they are not even discussed in the context of Irish photography but as empirical accounts of the London coal merchant Richard Beard's commercial studio that opened at the Royal Polytechnic Institution in London in 1841. I am referring here specifically to Helmut and Alison Gernsheim, *The Origins of Photography* (London, 1988); H. J. Arnold, *William Henry Fox Talbot: Pioneer of Photography and Man of Science* (London, 1977); and R. Derek Wood's, 'Daguerreotype Case Backs: Wharton's Design of 1841', *History of Photography*, IV/3 (July 1980), pp. 251–2.

11 Francis S. Beatty, 'Some Historical Recollections of Photography', *The Photographic News* (8 August 1879), pp. 382–3.

12 'The Daguerreotype', *The Belfast Newsletter* (19 February 1839), p. 1.

13 Established histories of photography citing Beatty's account of working as an operator for Richard Beard have ignored his claims to have been one of the first practitioners to have successfully produced a daguerreotype in the United Kingdom. Beatty later noted that this was merely three months after the publication of Daguerre's process on 15 June and several months before John

William Draper produced the first daguerreotype portraits in March 1840. Beatty, 'Some Historical Recollections of Photography', pp. 382–3.

14 Anon., 'Daguerreotype, or Nature Reproducing its Own Image. Old Long Bridge Belfast', *The Belfast Newsletter* (6 August 1840), p. 2.

15 Self-professed modesty was a feature of Beatty's writings and in an early article he included an elaborate illustration of a camera and ribbon to form the letter *P* which placed his name amongst early inventors such as Davy, Talbot, Niepce and Herschel. Beatty, 'Some Historical Recollections', p. 382.

16 Geoffrey Batchen, *Each Wild Idea: Writing, Photography, History* (Cambridge, MA, 2001), p. 5.

17 Beatty returned to Belfast despite being offered management of the Dublin studio opened by Beard at the Rotunda in Dublin in October 1841, a move designed by Beard to protect his patent for Ireland. The proprietor of this studio has never been fully established but the advertisement included the phrase 'under Her Majesty's Royal Letters and Patents' and Beard simultaneously opened studios in several cities across the United Kingdom at that time. The advertisement appeared in *The Freeman's Journal* (16 October 1842).

18 Beatty, 'Some Historical Recollections', p. 383.

19 Frequently referring to himself as 'Herr Glukman' or Professor Glukman in advertisements, his nationality was possibly German or East European. In addition to operating as a daguerreotypist, Glukman also ran a Grand Continental Museum in the early 1860s, and produced an illuminated electric light exhibition during Queen Victoria's visit to Ireland in 1849. During the same year he publically spoke out against the inclusion of English manufacturers as exhibitors at the Royal Dublin Society exhibitions. See Chandler, *Photography in Ireland*, pp. 19–27.

20 Robert Sloan, *William Smith O'Brien and the Young Ireland Rebellion of 1848* (Dublin, 2000).

21 Chandler, *Photography in Ireland*, p. 22.

22 On the emergence of a discourse of Irish nationalism and photography see Sarah Jane Edge, 'Photographic History and the Visual Appearance of an Irish Nationalist Discourse, 1840–1870', *Victorian Literature and Culture*, XXXII/1 (2004), pp. 17–39.

23 For an overview of the popularity of prints depicting Irish political life see the essays collected in Lawrence W. McBride, ed., *Images, Icons and the Irish Nationalist Imagination* (Dublin, 1999).

24 Although Dublin and Belfast remained centres of commercial studio portraiture in the 1840s, many other large towns and cities across the country also had daguerreotypists including Edward Harding in Cork, Robert McGee in Derry and the self-proclaimed Professor of Daguerreotypey, D. David Lewis, in the large provincial town of Athlone. In Belfast, as in Dublin, daguerreotype studios seldom remained in business for more than a few years.

The *carte-de-visite* brought about a renewed vigour to commercial portraiture in Belfast as well as in the larger regional towns of Enniskillen, Armagh and Monaghan. For more detail on the expansion of commercial portraiture in the north of Ireland during this period see Maguire, *A Century in Focus*, pp. 15–40. On the history of Disdéri's invention see Elizabeth Anne McCauley, *A.A.E. Disdéri and the Carte de Visite Portrait Photograph* (New Haven, CT, 1985).

25 The compact geography of the studios was such that various firms engaged in a price war to lure customers from each other, and the interconnection of streets from the north to the south of the city became known colloquially as the 'Photographer's Mile' (see Chandler, *Photography in Ireland*, p. 97). In addition to *cartes-de-visite*, many studios attracted customers with topical popular imagery. James Robinson, a prominent photographer in Dublin from 1850–1900, published stereoscopic images memorializing the poet Thomas Chatterton, which he advertised in the Dublin newspapers in 1859. Chatterton had been the subject of a painting by the Pre-Raphaelite artist Henry Wallis, titled *The Death of Chatterton*. The painting was bought by the artist Augustus Egg, who then licensed it to the publisher Robert Turner, who exhibited the painting in Dublin in 1859 to market the subscription for engravings of the work. Turner, who had warned against the infringement of copyright by photographers of the work in press advertisements, believed that although Robinson's stereoview was not a direct reproduction of the painting, the compositional similarities were such that his photograph amounted to piracy. Legal proceedings were issued to restrict his production and sale of the stereoscopic photographs of *The Death of Chatterton*, and despite Robinson's appeal to the courts, it was determined that he had breached Turner's rights as the copyright holder of Wallis's painting. Robinson's case was thus one of the first legal cases of photographic piracy in the British Isles. For an account of the case see G. B. Greenhill, '*The Death of Chatterton*, or Photography and the Law', *History of Photography*, V/3 (1981), pp. 199–205.

26 John Werge, *The Evolution of Photography* (London, 1890; repr. New York, 1973), p. 217.

27 For an account of the exhibition see Nellie O'Cleirigh, 'Dublin International Exhibition, 1865', *Dublin Historical Record*, XLVII/2 (Autumn 1994), pp. 169–82.

28 For a detailed discussion of the debates emerging out of the classification of photography within machinery see the chapter 'The Solitary Exception', in Steve Edwards, *The Making of English Photography: Allegories* (University Park, PA, 2006), pp. 165–203.

29 A member of the Amateur Photographic Association in London, and founding member and first secretary of the Dublin Photographic Society, established in 1854, Coghill was an aesthete who publically petitioned for photography to be treated as an art form. See Joscelyn Coghill, 'Notes on the Photographic Department', in *The Illustrated Record and Descriptive Catalogue of the Dublin International Exhibition 1865* (Dublin, 1865). Coghill's claims would appear to contradict Steve Edwards's assertion that it wasn't until the International Exhibition of 1872 that photographs were first accepted into the Fine Art section. Given his focus is on England and not her colonies this is hardly an oversight. What is noteworthy, however, is that due to Ireland's position as a social laboratory for a range of administrative, legal and cultural colonizing practices that were later to be implemented back in England and elsewhere, photography's inclusion in the Fine Arts section may have just been yet another experiment to gauge public reaction before implementing such re-classification back in England.

30 Oscar W. Merne, *The History of the Photographic Society of Ireland* (Dublin, 1954).

31 Coghill, 'Notes on the Photographic Department', unpaginated.

32 *The Irish Times and Daily Advertiser* (28 March 1865).

33 On the Lawrence Collection see Kieran Hickey, *The Light of Other Days: Irish Life at the Turn of the Century in the Photographs of Robert French* (Boston, MA, 1973).

34 In the 1870s Lawrence employed a former policeman, Robert French, as an 'Operator' who would tour almost every town and city in Ireland to produce topographical tourist views, which Lawrence produced as albumen prints and sold individually or in bound albums. Lawrence's picturesque views for an emerging tourist market appeared both in his own name and under licence for stereoscopic companies in North America and Europe. Simultaneously producing tens of thousands of photographic images through his own company and purchasing the stock of tourist photographs of his rivals, Lawrence became the proprietor of the largest photographic enterprise in the country. See Justin Carville, 'Mr Lawrence's Great Photographic Bazaar: Photography, History and the Imperial Streetscape', *Early Popular Visual Culture*, V/3 (November 2007), pp. 263–83.

35 Originally established as a daguerreotype studio in 1853, Lafayette's dominated high-street portraiture in Dublin from the 1880s until 1922, with four separate studios across the city. Appointed Her Majesty's Photographers in Dublin in 1887, Lafayette's was floated on the London Stock Exchange in 1898 as an incorporated company with studios in Dublin, Glasgow, Manchester and London. Lafayette's royal commissions contributed to its international profile, and the commercial enterprise's flotation came in the aftermath of its commission to produce portraits of guests dressed in historical and allegorical costume at the Duchess of Devonshire's Diamond Jubilee Ball in 1897. James Stack Lauder received international success as a photographer outside of the family business, winning awards at numerous international exhibitions. For a detailed biography, see Russell Harris, 'James Lafayette (James Stack Lauder) 1853–1923', in *Encyclopaedia of*

Nineteenth-century Photography, vol. 1, ed. John Hannavy (London, 2007), pp. 813–15.

36 It should be noted that the militaristic links with photography were not confined to the travel of soldiers and officers between England and Ireland. Soldiers in Irish regiments travelled to England's colonies in Africa and Asia, bringing photographic equipment with them, or in several instances taking up photography in these colonies as part of their militaristic duties. Burke's participation in the colonial practices of photography, much like his military career, evidences the complexities of photography and Ireland in the nineteenth century and its relations with British imperialism. Similar aesthetic strategies were used in the production of Irish landscape photographs for commercial tourism and by the Anglo-Irish ascendency classes, who owned many of the landed estates across the country. Throughout the nineteenth century Ireland was both colonized and participated in the colonizing of other territories under the control of British imperial rule. This complexity is not simply a technical one; it is also cultural. Nineteenth-century Irish photography has numerous instances of photographers contributing to the colonial vision of Western imperialism. See Omar Khan, 'John Burke, Photo-Artist of the Raj', *History of Photography*, xxi/3 (Autumn 1997), p. 236.

37 Larry J. Schaaf, ed., *Selected Correspondence of William Henry Fox Talbot, 1823–1874* (Bradford, 1993), pp. 35, 36, 44.

38 In 1845 a member of the Royal Irish Academy, Thomas Woods, even invented the 'catalystype', which he unsuccessfully argued was a separate invention to Talbot's patented calotype process. See Chandler, *Photography in Ireland*, p. 12.

39 In 1858 Shaw Smith delivered a paper to the Photographic Society of Ireland detailing the changes he made to Talbot's process during his journey on the Grand Tour. See Merne, *The History of the Photographic Society*, p. 47.

40 François Arago quoted in Josef Maria Eder, *History of Photography*, trans., Edward Epstean (New York, 1978), p. 234.

41 In 'A Small History of Photography' Walter Benjamin noted how much easier it is to get hold of a 'picture, more particularly a piece of sculpture, not to mention architecture, in a photograph than in reality'. For Benjamin photography's particular technological form of miniaturization helped 'men achieve control over works of art without whose aid they could longer be used'. This combination of the portability of art through its technological miniaturization by photography and its possession as image was embedded within discourses of colonial photography. See Walter Benjamin, 'A Small History of Photography', in *One Way Street and Other Writings*, trans. Edmund Jephcott and Kingsley Shorter (London, 1979), p. 253.

42 I am drawing on Edward Said's coupling of power and vision in *Orientalism* (New York, 1978).

43 Hemphill quoted in Pat Holland, *Tipperary Images: The Photography of Dr. William Despard Hemphill* (Cahir, 2003), p. 3.

44 William Despard Hemphill, *The Abbeys, Castles, And Scenery of Clonmel and The Surrounding Country* (Dublin, 1860).

45 Sir Joscelyn Coghill, 'On the Mutual Relations of Photography and Art', *Royal Dublin Society Journal* (January 1860), pp. 380–88.

46 For an overview of Rosse and Birr Castle see David H. Davidson, *Impressions of an Irish Countess: The Photography of Mary, Countess of Rosse* (Birr, 1989).

47 Charles Carson, *Technology and the Big House in Ireland, c. 1880–c. 1930* (New York, 2009).

48 Edwin Richard Wyndham Quin, Third Earl of Dunraven, was a keen antiquarian. He spent several years undertaking surveys of Irish ecclesiastical sites along with Mercer in preparation for the book but died in 1871 before it was completed. The book appeared in two volumes as Margaret Stokes, *Notes on Irish Architecture* (London, 1875–7).

49 Many of these photographers, especially those from Northern Ireland, operated commercial studios or produced picturesque tourist imagery, but they also pursued photography in conjunction with amateur leisure activities linked to the study of artefacts, antiquities, flora and fauna.

50 Maguire, *A Century in Focus*, p. 52.

51 William Swanston, 'Photography as an Aid to the Club Work', *Proceedings of the Belfast Naturalists' Field Club*, series ii, vol. iii (1888/89), pp. 131–2.

52 See Justin Carville, 'Photography, Tourism and Natural History: Cultural Identity and the Visualization of the Natural World', in *Irish Tourism: Image, Culture and Identity*, ed. Barbara O'Connor and Michael Cronin (Clevedon, 2003), pp. 215–38.

53 Mairéd Ashe FitzGerald, *Thomas Johnson Westropp (1860–1922): An Irish Antiquary*, *Seandálaíocht: Mon. 1* (Dublin, 2000, p. 92.

54 Welch was appointed official photographer of the Harland & Wolff shipyards in 1894 and photographed the construction of the RMS *Titanic*. See Maguire, *A Century in Focus*, pp. 93–106. The description of their interests in ethnology and commercial photography does not adequately cover the breadth of photography by both men, who undertook a vast array of commissioned work for administrative bodies and commercial enterprise throughout the late nineteenth century through to the 1930s. Welch in particular is possibly the most significant photographer of this period of Ireland's photographic culture. For an overview of Welch's work see E. Estyn Evans and Brian S. Turner, *Ireland's Eye: The Photographs of Robert John Welch* (Belfast, 1977).

55 Throughout the nineteenth century numerous Irish and Anglo-Irish figures travelled to the colonies in administrative or consular roles, many of whom took ethnographic and antiquarian photographs that contributed to the visual imaginary of European colonialism. Not all used photography to highlight the ills of

colonialism. There are too many to list here, but for a specific example see Éadaoin Agnew and Leon Litvack, 'The Subcontinent as Spectator Sport: The Photographs of Hariot Lady Dufferin, Vicereine of India', *History of Photography*, III/4 (2006), pp. 348–58.

56 Included in Casement's report on the Congo were several photographs of children whose hands had been hacked off with machetes. This was a requirement of the Belgian military as evidence of native deaths. Among these reports were photographs of the torture and mutilation of Congolese natives, including the harrowing case of a young child whose verbal testimony was included with a photograph taken of his mutilated arms. Casement used photography as visual testimony of the mutilation and torture of natives in the Congo by colonialists and their native agents, one of the first examples of the use of atrocity photography to document human rights abuses. Casement was executed in 1916 by British authorities for high treason. For an overview of Casement's role in human rights abuse investigations see Roger Casement, *The Eyes of Another Race: Roger Casement's Congo Report and 1903 Diary*, ed. Séamus O'Síocháin and Michael O'Sullivan (Dublin, 2003), pp. 167–71; and Séamus O'Síocháin, *Roger Casement: Imperialist, Rebel, Revolutionary* (Dublin, 2008). For a discussion of Casement's atrocity photography see Sharon Sliwinski, 'The Childhood of Human Rights: The Kodak on the Congo', *Journal of Visual Culture*, V/3 (2006), pp. 333–63.

57 Touring lantern slideshows were common throughout provincial Ireland and included subject-matter relating to nationalist struggles and the British monarchy. The Boer War, in which many Irish soldiers fought, was a prominent topic featured in magic lantern shows. See Niamh McCole, 'The Magic Lantern in Provincial Ireland, 1896–1906', *Early Popular Visual Culture*, V/1 (2007), pp. 247–62.

58 For a brief overview of the legal and political dimensions of the partition of Ireland see J. J. Lee, *Ireland 1912–1985: Politics and Society* (Cambridge, 1989), pp. 47–55.

59 The Black and Tans were an auxiliary group of demobbed First World War soldiers drafted into Ireland to support the Royal Irish Constabulary against rising guerrilla tactics employed by the Irish Republican Army. The violence of the Black and Tans against the civilian population became the focus of much press photography during this period. Commonly referred to as the Anglo-Irish War of 1921, the historian Michael Hopkinson has argued that the conflict actually had its sporadic origins in 1919. See Michael Hopkinson, *The Irish War of Independence* (Dublin, 2002), pp. 25–9.

60 The *Freeman's Journal* ceased publication in 1923, and after a brief period as a freelance photographer Cashman was invited by the future Taoiseach and President of Ireland, Éamon de Valera, to establish the photographic department of a new newspaper, *The*

Irish Press. See Louis Redmond, ed., *Ireland: The Revolutionary Years, Photographs from the Cashman Collection, Ireland 1910–1930* (Dublin, 1992).

61 Sometimes referred to as the Ulster Solemn Covenant and League, the document was established to protest against the third Home Rule Bill introduced by the Westminster government. Carson was the first signatory on 28 September 1912.

62 Gary A. Boyd, 'Supernatural Catholicity: Dublin and the 1932 Eucharistic Congress', *Early Popular Visual Culture*, V/3 (November 2007), p. 317.

63 Anon., 'Eucharistic Congress Souvenir Supplement', *The Irish Press* (20 June 1932), p. 41.

64 Anon., *31st International Eucharistic Congress, 1932: Pictorial Record* (Dublin, 1932).

65 Donal Ó Drisceoil, *Censorship in Ireland, 1839–1945: Neutrality, Politics and Society* (Cork, 1996), p. 6.

66 Ibid., p. 102.

67 Ibid., pp. 189, 195.

68 Numerous books have been published of Father Browne's photography, all edited by E. E. O'Donnell. See *Father Browne: A Life in Pictures* (Dublin, 1994); *Father Browne's Australia* (Dublin, 1995); *Father Browne's Cork: Photographs, 1912–54* (Dublin, 1995); *Father Browne's Dublin Photographs, 1925–50* (Dublin, 1993); *Father Browne's England* (Dublin, 1995); *Father Browne's Ireland: Remarkable Images of People and Places* (Dublin, 1990); *Father Browne's 'Titanic' Album: A Passenger's Photographs and Personal Memoir* (Dublin, 1997); *Forest Images: Father Browne's Woodland Photographs* (Dublin, 1992); *Images of Aran: Photographs by Father Browne, 1925 and 1938* (Dublin, 1993); and *The Genius of Father Browne: Ireland's Photographic Discovery* (Dublin, 1990).

69 For an overview of Doyle's career see Colman Doyle, *All Changed: Fifty Years of Photographing Ireland* (Dublin, 2004).

70 Although Browne's photographs had been displayed in public as part of his magic lantern shows on the *Titanic*, the bulk of his photographs remained stored in a suitcase until they were discovered by Jesuit colleagues in 1985.

71 See for example the chronologically arranged book *Ireland: 40 Years of Photo-Journalism* (Dublin, 1994).

72 Henri Cartier-Bresson, 'Introduction to *The Decisive Moment*', in *The Camera Viewed: Writings on Twentieth-Century Photography*, vol. II: *Photography After World War II*, ed. Peninah R. Petruck (New York, 1979), pp. 17–18.

73 The original gallery was opened by John Osman on the Quays in Dublin before the directorship was taken over by Christine Redmond, who oversaw its relocation to a purpose-built space in Temple Bar in 2000.

74 Organized by an independent group of photographers, Contemporary Irish Photography, the exhibitions in 1987 and 1989 were initially conceived as tentative steps towards a biennale

of Irish photography. The three exhibitions were significant because of the extraordinary range of photographic genres and styles exhibited in them. I am grateful to David Farrell, who has kindly provided me with information about these exhibitions and his role in their organization. Responsibility for any gaps or incorrect details are entirely my own.

75 In the catalogue's essay on *Out of the Shadows*, the point was made that to argue the case for a particular style in Irish photography was pointless given the diversity of its practitioners. See Patrick T. Murphy, *Out of the Shadows* (Dublin, 1981), p. 3.

76 Ibid., p. 6.

77 *Source* has developed into a quarterly journal with an international perspective and readership, yet still retains a strong sense of its origins within the grass roots of Northern Ireland's photographic culture. See the website at www.source.ie, last accessed 16 March 2011.

78 Seawright's work on Northern Ireland will be discussed in more detail in chapter Four. For a catalogue of this project see Paul Seawright, *Inside Information: Photographs, 1988–1995* (London, 1995).

79 See Tony O'Shea, *Dubliners* (Dublin, 1990). I discuss this book in more detail in chapter Five, 'The City in Ruins'.

80 Andrew Kincaid, *Postcolonial Dublin: Imperial Legacies and the Built Environment* (Minneapolis, MN, 2006), pp. 117–19.

81 Christine Redmond, 'Foreword', in *The Lie of the Land* (Dublin, 1995).

82 See for example *Trees from Germany* (Belfast, 2003) and *Bonfires* (Belfast, 2008).

83 Neither Morrissey nor Starkey produces work that addresses Irish society specifically. Indeed Starkey's work lacks any cultural or geographic specificity outside of the architectural references to enclosed urban spaces. Both artists live and work outside Ireland and have exhibited more extensively in Europe and North America than in Irish galleries or museums.

two: That Vast and Absorbing Subject

1 Michael Floyd, *The Face of Ireland* (London, 1937). The original Constitution was perceived in many quarters to be too closely aligned to the Treaty establishing the Irish Free State in 1922, which maintained a strong sphere of influence across Irish political life. The 1937 constitution sought to dictate specific definitions on national territory and citizenship embedded within political aspirations of a united Ireland and complete political, economic and religious autonomy from England.

2 Ibid., p. v.

3 Ibid., p. 87.

4 Ibid., dust-jacket.

5 John Urry, *The Tourist Gaze: Leisure and Travel in Contemporary Societies* (London, 1990).

6 Until the seventeenth and eighteenth centuries tourism was largely a scholarly activity in which people travelled to learn about the history and culture of other countries through reading or discoursing with learned colleagues, rather than to look at architecture or landscapes. See Judith Adler, 'Origins of Sightseeing', *Annals of Tourism Research*, 16 (1989), pp. 7–29.

7 Floyd, *The Face of Ireland*, p. vi.

8 See Lynn Doyle, *The Spirit of Ireland* (London, 1935), and T. H. Mason, *The Islands of Ireland* (London, 1936).

9 Floyd, *The Face of Ireland*, dust-jacket.

10 Oliver Wendell Holmes, 'The Stereoscope and the Stereograph', *The Atlantic Monthly*, 3 (1859), p. 747.

11 Literature on the history of the Irish Famine is voluminous but the texts drawn on here are Cecil Woodham-Smith, *The Great Hunger* (Dublin, 1962); Cormac Ó Gráda, *The Great Irish Famine* (Dublin, 1989); and Christine Kinealy, *This Great Calamity: The Irish Famine 1845–52* (Dublin, 1994).

12 Most of the abandoned cottages had been the homes of tenant farmers who had either died or emigrated. The scale of the Famine was such that rents were no longer being paid to landlords and many landed estates became bankrupt. This resulted in the introduction of the Encumbered Estates Act of 1849, initiating mass evictions and land clearance to allow for the sale of landed estates to new colonial investors who could seize the opportunity to modernize the depopulated, empty spaces of Ireland's agricultural landscape. See David Gray, *Famine, Land and Politics: British Government and Irish Society, 1843–1850* (Dublin, 1999).

13 Although Ireland was clearly a popular tourist destination for Victorian travellers before the Famine, the 1840s and '50s ushered in a new phase of the tourist industry, evident from the vast amounts of travelogues and guidebooks that were published. Mr and Mrs Samuel Carter Hall's various volumes of *Handbooks to Ireland* became some of the most popular tourist guides for English travellers to Ireland, but only began to be mass-published in the 1850s.

14 In his essays 'The Photographic Message' and the 'Rhetoric of the Image', Barthes makes the point that the photograph's existence is so exhausted by its perceived 'denotative status' that the description of the photograph is literally impossible; that is to say, we tend to look through the photograph and describe merely what it represents. In effect we could say that it is the denotative status of the photograph that paradoxically connotes its objectivity. See *Image, Music, Text*, trans. Stephen Heath (London, 1977).

15 Malcolm Andrews has pointed out that 'At the heart of picturesque tourism is a set of paradoxes . . . Firstly, the tourist wants to discover Nature untouched by man; and yet, when he finds it, he cannot resist the impulse, if only in the imagination, to "improve" it. Secondly, the tourist . . . will loudly acclaim the native beauties

of the British landscape by invoking *foreign* models'. *The Search for the Picturesque: Landscape Aesthetics and Tourism in Britain, 1760–1800* (Aldershot, 1989), p. 3. The 'foreignness' of the picturesque is accentuated in the history of Irish landscape representation through its broader associations with colonial discourse. A general thesis has emerged that the picturesque was such a dominant aesthetic force in pictorial representations of Ireland, particularly those associated with tourism, that it was internalized into postcolonial Irish visual culture. In the sociology of tourism this has been described as the 'Myths and Mirrors' thesis, in which the sheer abundance of tourist imagery of Ireland has provided a stock of visual codes through which an indigenous self-image has been fashioned that mirrors existing, largely photographic representations by outsiders. An extension of this thesis might suggest that not only is there colonial photography of Ireland, but that the photographic form in Irish visual culture has itself been colonized, so there would appear to be no other way to imagine Ireland photographically than through existing aesthetics of photography. See Barbara O'Connor, 'Myths and Mirrors: Tourist Images and National Identity', in *Tourism in Ireland: A Critical Analysis*, ed. Barbara O'Connor and Michael Cronin (Cork, 1993), pp. 68–85, and David Brett, *The Construction of Heritage* (Cork, 1996), pp. 38–60.

16 On pre- and post-Famine Ireland see Cormac Ó Gráda, *Black 47 and Beyond: The Great Irish Famine in History, Economy and Memory* (Princeton, NJ, 1999).

17 The process and effects of the Famine can be identified across a range of photographic practices that are not always necessarily associated with landscape and not always confined to Ireland. The continuous migration of Ireland's largely unskilled peasant class to America throughout the nineteenth century, for example, is in some very small ways part of the history of the emergence of early socially concerned photography on the threat and plight of European immigrants within urban slums by Jacob Riis and Lewis Hine. The chapter titles of Riis's *How the Other Half Lives* – 'The Italian in New York', 'Chinatown', 'Jewtown', 'The Sweaters of Jewtown' – provide an insight into the prominence given to specific ethnic groups, and Riis's photographs of 'Italian Rag pickers' and 'A Black-and-Tan Dive in "Africa"' demonstrate his emphasis of the visibility of race within New York's tenements. The Irish, however, have a different role within Riis's discussion of the races of the urban poor. Irish political history frequently emerges as an analogy to explain the slum problem as when Riis comments that the poor maintenance of tenements 'has come near to making the name landlord as odious in New York as it has become in Ireland', and his criticism of the sensationalism that proclaims there are 'more evictions in the tenements of New York . . . than in all of Ireland' (Jacob Riis, *How the Other Half Lives: Studies Among the Tenements of New York* [1980], London, 1970), pp. 53, 132. Landlordism and

Ireland surface a number of times throughout *How the Other Half Lives*, indeed in a strange reversal Riis characterizes the Celt himself as perhaps the most odious of New York's landlords: 'picturesquely autocratic', he is however 'merely showing forth the result of the schooling he had received, re-enacting, in his own way, the scheme of the tenements'. See Riis, *How the Other Half Lives*, pp. 22, 53, 132.

18 The sociologist Eamonn Slater has demonstrated that within the colonial model of the picturesque, the peasant cottage was subjected to aesthetic discipline and removed from established points of view that located the picturesque landscape geographically and symbolically as the landlord's private demesne. See Eamonn Slater, 'Contested Terrain: Differing Interpretations of Co. Wicklow's Landscape', *Journal of Irish Sociology*, III (1993), pp. 23–55.

19 The rapid economic recovery of Irish agriculture in the post-Famine period was not a seamless process; the tensions between tradition and modernity were complex and fractured across different classes. As Terry Eagleton has noted, Ireland had 'not leapt at a bound from tradition to modernity. Instead it presented an exemplary case of what Marxism has dubbed combined and uneven development'. See *Heathcliff and the Great Hunger: Studies in Irish Culture* (London, 1995), p. 274.

20 Helmut Gernsheim, *The Origins of Photography* (London, 1982), p. 6.

21 Mary Daly, 'Revisionism and Irish History: The Great Famine', in *The Making of Modern Irish History: Revisionism and the Revisionist Controversy*, ed. D. George Boyce and Alan O'Day (London, 1996), p. 71.

22 On the illustrated press and the Famine see Margaret Crawford, 'The Great Irish Famine 1845–9: Image Versus Reality', in *Ireland: Art into History*, ed. Brian P. Kennedy and Raymond Gillespie (Dublin, 1994), pp. 75–88.

23 Talbot issued various licences for the calotype including specific arrangements for amateurs. The majority of these were issued from the late 1840s to late 1850s. See H.J.P. Arnold, *William Henry Fox Talbot: Pioneer of Photography and Man of Science* (London, 1977), pp. 173–216.

24 Louisa Tenison, *Sketches of the East Drawn on Stone* (London, 1846) and *Castile and Andalusia* (London, 1853). The Tenisons also produced an album of photographs from their visit to Spain in 1851. I am grateful to Helena Pérez Gallardo for sharing her knowledge of this collection with me and for providing a copy of her unpublished paper 'The Image of Spanish Architecture by Nineteenth-century Foreign Photographers', delivered at the conference *Documenting History, Charting Progress, Exploring the World: Nineteenth Century Photographs of Architecture*, Indiana University South Bend and University of Notre Dame, 3–4 October 2010.

25 On the Land Wars see Samuel Clark, *Social Origins of the Land War* (Princeton, NJ, 1979) and Paul Bew, *Land and the National Question*

in Ireland, 1858–82 (Dublin, 1978). For a discussion of Land War imagery in the popular illustrated press see Gerard Moran, 'The Imagery of the Irish Land War, 1880–1890', in *Images, Icons and the Nationalist Imagination*, ed. Lawrence W. McBride (Dublin, 1999), pp. 37–52.

26 Gail Baylis, 'Imagined Narratives: Photography and the Construction of Diasporic Cultural Memory', in *Rethinking Diasporas: Hidden Narratives and Imagined Borders*, ed. Aoileann Ní Éigeartaigh, Kevin Howard and David Getty (Cambridge, 2007), pp. 20–30.

27 Ibid., pp. 21.

28 See Laurence M. Geary, *The Plan of Campaign, 1881–1891* (Cork, 1986).

29 Violently opposed by those small peasant farmers threatened with eviction, the Royal Irish Constabulary used battering rams to demolish the homes of tenants who had barricaded themselves inside. See L. Perry Curtis Jr, 'The Battering Ram and Irish Evictions, 1887–90', *Éire-Ireland*, XLII/3 (2007), pp. 207–48.

30 These lantern slides were projected alongside statistics of deaths from starvation throughout Victoria's reign over Ireland, leading Gonne to proclaim her the Famine Queen. See Fintan Cullen, 'Marketing National Sentiment: Lantern Slides of Evictions in Late Nineteenth-century Ireland', *History Workshop Journal*, 54 (2002), pp. 162–79.

31 The celebrations were held on 20 June 1897. The lantern slideshow followed an anti-imperialism demonstration led by the socialist James Connolly. Carrying a black coffin painted with the words 'British Empire', demonstrators followed the Socialist Workers' Band playing the 'Dead March' through the streets of Dublin and threw the coffin into the river Liffey at O'Connell Bridge to shouts of 'To Hell with the British Empire' after the procession had been baton-charged by police. See Siobhán Kilfeather, *Dublin: A Cultural and Literary History* (Dublin, 2005), pp. 158–60.

32 Sara Smyth, 'Tuke's Connemara Album' in *Framing the West: Images of Rural Ireland, 1891–1920*, ed. Ciara Breathnach (Dublin, 2007).

33 Ciara Breathnach, *The Congested Districts Board of Ireland, 1891–1923: Poverty and Development in the West of Ireland* (Dublin, 2005), p. 11.

34 F. S. Sheridan, '"The Congested Districts" and the Work of the Congested Districts Board', reproduced in James Morrissey, *On the Verge of Want* (Dublin, 2001), p. 4.

35 J. Harris Stone, *Connemara and the Neighbouring Spots of Beauty* (London, 1906), p. 56.

36 H. Doran, 'Kiltimagh Base-Line Report', reproduced in Morrissey, *On the Verge of Want*, p. 4.

37 See Justin Carville, 'Picturing Poverty: Colonial Photography and the Congested Districts Board' in *Framing the West*, ed. Breathnach, pp. 97–114.

38 Terry Smith identifies this as the combination of calibration, obliteration and symbolization within colonial practices of visual representation of the landscape. See 'The Visual Regimes of Colonization: Aboriginal Seeing and European Vision in Australia',

in *The Visual Culture Reader*, ed. Nicholas Mirzoeff, 2nd edn (London, 2002), pp. 484–94.

39 Welch's photographs for the Congested Districts Board were exhibited at the Viceregal Lodge in 1900 during the Queen's visit to Ireland to publicize the British effort to ameliorate rural Irish poverty. See 'The Queen's Irish Visit – Interesting Exhibit of West of Ireland Photographs', *The Northern Whig* (11 June 1900), p. 2. In 1898 the Lord Mayor of Dublin had also produced a report that included photographs of 'distress' in the west of Ireland, the aim of which was to generate political and financial support from politicians and philanthropists in England, especially Manchester. The photographs depicted rural peasants employed in the Work Relief Schemes of the Congested Districts Board to publicize the need for the continued paternalistic intervention of England in Ireland's affairs. See Daniel Tallon, *Distress in the West and South of Ireland, 1898: Report on the Work of the Mansion House Committee* (Dublin, 1898). A number of local politicians from Manchester visited the Congested Districts and in 1905 the *Manchester Guardian* commissioned the playwright John Millington Synge to write a series of articles on the west of Ireland accompanied by illustrations by the artist Jack B. Yeats. The articles and illustrations were published collectively as John Millington Synge, *In Wicklow, In West Kerry, In the Congested Districts and Under Ether* (Dublin, 1910).

40 For an overview of picturesque aesthetics see Andrews, *The Search for the Picturesque*.

41 It also had its three-dimensional form in the land surrounding the landlord's demesne. In their *Handbooks for Ireland*, the travel writers Mr and Mrs Samuel Carter Hall identified the private property of the colonial landlord as opposed to that of the native peasant, as the visual spaces across which the tourist's gaze could arrest the picturesque view with their tutored eye. As the sociologist Eamonn Slater notes, their textual description of picturesque tourism identified Wicklow as 'the garden of Ireland', not because of its natural beauty but because those parts of it most worthy of the tourists gaze had been landscaped by the colonial landlord. See Eamonn Slater, 'Reconstructing Nature as a Picturesque Theme Park: The Colonial Case of Ireland', *Early Popular Visual Culture*, V/3 (2007), pp. 213–45.

42 See ibid., pp. 235–7.

43 On the ideological aspects of this schism within picturesque tourism in Ireland see Slater, 'Contested Terrain', p. 45.

44 Frederick Holland Mares, *Photographs of Wicklow with Descriptive Letterpress* (Glasgow, 1867).

45 Anon., *Souvenir of the South of Ireland Illustrated and Described* (London, 1900).

46 Lee's Photographic Studio, *Photographic View Album of the Giant's Causeway, Portrush, Londonderry, Portstewart, Ballycastle, Larne and Antrim Coast Tour* (Portrush, 1900).

199

47 John L. Stoddard, *John L. Stoddard's Lectures, Ireland (two Lectures), Denmark, Sweden* (Boston, MA, 1901).

48 Smith's photographs were published in book form in 1966. See Michael Mac Liammoir and Edwin Smith, *Ireland* (London, 1966).

49 A similar example to Smith is Paul Caponigro's formalist photographs of monastic architecture, *Stone Churches of Ireland* (Revere, PA, 2007), while the subjective voyage through the Irish landscape by photographers has been given a more conceptual twist by Chris Killip, *Here Comes Everybody: Chris Killip's Irish Photographs* (London, 2009), a photographic travelogue metaphorically narrating his own introspective pilgrimage of travelling through Ireland on his journey from North America to the Isle of Man to see his mother.

50 The photographs were published in the same year as *A Fair Day: Photographs from the West of Ireland* (Derry, 1984).

51 Martin Parr, *Bad Weather* (London, 1982).

52 Val Williams, *Martin Parr* (London, 2002), pp. 78–80.

53 Fintan O'Toole, 'Land Across the Waves: Ireland and America', in Parr, *A Fair Day*, p. 9.

54 David Farrell, *Innocent Landscapes* (London, 2001).

55 On the intersection of memory, violence and landscape in Farrell's work see Mark Phelan, 'Not so Innocent Landscapes: Remembrance, Representation and the Disappeared', in *Violence Performed: Local Roots and Global Routes of Conflict*, ed. Patrick Anderson and Jisha Menon (London, 2009), pp. 285–316.

56 See Eamonn Slater, 'Dialectical Moments', in Martin Cregg, *Midlands* (Dublin, 2009).

57 Alex Boesten, *Traffic Island* (Dublin, 2000).

58 Dara McGrath, *By the Way* (Dublin, 2003).

59 Jackie Nickerson, *Ten Miles Round* (Dublin, 2009).

60 Simon Burch, *Under a Grey Sky* (Dublin, 2009).

three: **One of the World's Puzzles**

1 Arago was a central figure in the publicity of the daguerreotype and an astute strategist in its facilitation of the combination of science, national progress and international relations. For an excellent analysis of the political background to the French state's role in the promotion of Daguerre's invention see Anne McCauley, 'François Arago and the Politics of the French Invention of Photography', in *Multiple Views: Logan Grant Essays on Photography, 1983–89*, ed. Daniel P. Younger (Alburquerque, NM, 1991), pp. 43–69.

2 Arago announced Daguerre's invention to the Académie on Monday, 7 January 1839. His report, presented to the Chamber on 3 July, was in support of a Bill drafted by Minister for the Interior Comte Tannegui Duchâtel to award a state pension to Daguerre in return for making the details of the process available to the public without patent. The government bill is reproduced in Vicki Goldberg, ed., *Photography in Print: Writings from 1816 to the Present* (Albuquerque, NM, 1981), pp. 31–5.

3 Details of the background to Arago's report are discussed in Helmut and Alison Gernsheim, *L.J.M. Daguerre: The History of the Diorama and the Daguerreotype* (New York, 1968), pp. 79–97.

4 The history of the invention of photography has often been traced through the genre of portraiture. Gisèle Freund's early history of photography, for example, charts the invention of photography through the increased mechanization and industrialization of middle-class portraiture. See Gisèle Freund, *Photography and Society* (London, 1980).

5 Walter Benjamin, 'A Small History of Photography', in *One Way Street and Other Writings*, trans. Edmund Jephcott and Kingsley Shorter (London, 1979), p. 252.

6 Ibid., p. 252.

7 Robert Lynd, *Home Life in Ireland* (London, 1910), pp. 6–7.

8 Ibid., p. 1.

9 See Patrizia Di Bello, *Women's Albums and Photography in Victorian Britain* (Aldershot, 2007), pp. 35–7.

10 See Anne Higonnet, 'Secluded Vision', *Radical History Review*, 38 (1987), pp. 16–36.

11 Benjamin, 'A Small History', p. 245.

12 Ibid., p. 247.

13 Ibid., p. 248.

14 Charles Kingsley quoted in L. Perry Curtis, *Anglo-Saxons and Celts: A Study of Anti-Irish Prejudice in Victorian England* (Bridgeport, CT, 1968), p. 84.

15 Despite his religious profession, Kingsley was an advocate of evolutionary theory and had read Charles Darwin's *On the Origin of the Species* in the months before his arrival in Ireland. Darwin's *On the Origin of the Species* was originally published in 1859. Charles Darwin, *On the Origin of the Species by the Means of Natural Selection, or the Preservation of Favoured Races in the Struggle for Life* [1860] (London, 2009).

16 James Anthony Froude quoted in Curtis, *Anglo-Saxons*, p. 85. The de-humanizing discourse of the 'simian' Irishman in fact cut across the sciences, arts and popular culture throughout much of the mid-nineteenth century. See L. Perry Curtis Jr, *Apes and Angels: The Irishman in Victorian Caricature*, revd edn (Washington, DC, 1997).

17 Robert Knox, *The Races of Men* (London, 1850), p. 218, p. 253.

18 On the anxiety surrounding the lack of racial markers to distinguish the Irish from Anglo-Saxon identity see Luke Gibbons, 'Race Against Time: Racial Discourse and Irish History', in *Transformations in Irish Culture* (Cork, 1996), pp. 149–63.

19 The phrase is drawn from Jacques Derrida, *Of Grammatology*, trans. Gayatri Chakravorty Spivak (Baltimore, MD, 1997), p. 149.

20 See for example Elizabeth Edwards, 'Photographic "Types": The Pursuit of Method', *Visual Anthropology*, III/2–3 (1990), pp. 235–58.

21 John Beddoe, *The Races of Britain: A Contribution to the Anthropology of Western Europe* (London, 1885).

22 For an extensive discussion of this imagery see Curtis, *Apes and Angels*.

23 The enforced and self-exile of members of the Young Irelanders to Australia, France and North America resulted in Fenianism becoming an international movement. For a comprehensive overview of the Fenian movement see the essays collected in Fearghal McGarry and James McConnell, eds, *The Black Hand of Republicanism: Fenianism in Modern Ireland* (Dublin, 2009) and R. V. Comerford, *The Fenians in Context: Irish Politics and Society, 1848–82* (Dublin, 1998).

24 Denis Holland quoted in Brendán Mac Suibhne and Amy Martin, 'Fenians in the Frame: Photographing Irish Political Prisoners', *Field Day Review*, 1 (2005), p. 118. The representation of the Fenian face emerged as a site of political conflict over the identity formation of the Irish as barbarous Celts or virtuous nationalists. The popular imagery of the illustrated press and mass-produced prints where much of this conflict was waged also had its counterpoint in the instrumental uses of photography by the police and the prisons.

25 This early use of photography in the Irish penal system, and particularly the systematic photographing of Fenian prisoners from the mid-1860s, became the model for criminological photography rolled out across Britain throughout the following decade. See Peadar Slattery, 'Uses of Photography in Ireland, 1839–1900', unpublished PhD dissertation, 1 (1992), pp. 232–8.

26 Larcom was an ardent supporter of the accumulation of statistics, scientific methods of calibration and the positivist methods of acquiring knowledge as part of the efficient colonial administration of Ireland, becoming a leading figure in the Ordnance Survey of Ireland initiated in the mid-1820s. The instrumental uses of photography in criminology no doubt appealed to his fascination in mapping and calibrating the colonial subject. See Thomas E. Jordan, *An Imaginative Empiricist: Thomas Aiskew Larcom and Victorian Ireland* (New York, 2002).

27 I would like acknowledge the staff at New York Public Library for their assistance with obtaining information on this collection. An overview of the albums can be viewed at: http://digitalgallery.nypl.org/nypldigital/explore/dgexplore.cfm?col_id+180.

28 Portraits of Fenians in American military uniforms confiscated by the Irish Constabulary were also included with official photographs taken for prison records. See Mac Suibhne and Martin, 'Fenians in the Frame', p. 104.

29 Jeremiah O'Donovan Rossa, *O'Donovan Rossa's Prison Life: Six Years in English Prisons* (New York, 1874), p. 73. Rescinded in 1869, the Habeas Corpus Suspension Act allowed for internment without trial of suspected Fenian conspirators.

30 Similar photographs were attached to criminological files a copy of which was forwarded together with a photograph to the Inspector General of the Royal Irish Constabulary. See Mac Suibhne and Martin, 'Fenians in the Frame', pp. 104–5.

31 Photography was to become an important if somewhat problematic tool in the surveillance operations and intelligence work of the Special Branch of the Royal Irish Constabulary during the Plan of Campaign in the closing decade of the nineteenth century. For an excellent discussion of the problems associated with photography and surveillance see Gail Baylis, 'Metropolitan Surveillance and Rural Opacity: Secret Photography in Nineteenth-Century Ireland', *History of Photography*, XXXIII/1 (2009), pp. 26–38.

32 The inscription is in the inside pages of the album held with the Samuel Lee Anderson Papers in the National Library of Ireland.

33 There is not the space here to discuss the theoretical and historical debates around the social power model of photographic historiography. The standard text is John Tagg, *The Burden of Representation: Essays on Photographies and Histories* (London, 1998).

34 O'Donovan Rossa, *O'Donovan Rossa's Prison Life*, pp. 262–3.

35 Ibid., p. 262.

36 The Gap Girls was also the title of a popular series of stereoviews produced by the photographic company, Lawrence & Co.

37 J. Harris Stone, *Connemara and the Neighbouring Spots of Beauty and Interest* (London, 1906), p. 87.

38 Spurgeon Thompson has observed how this passage conforms to the conventions of colonial photography in its construction of 'authentic' Irish identity as the primitive peasant. Spurgeon Thompson, 'The Politics of Photography: Travel Writing and the Irish Countryside, 1900–1914', in *Images, Icons and the Irish Nationalist Imagination*, ed. Lawrence W. McBride (Dublin, 1999), pp. 119–20.

39 Bruce Gilden, *After the Off: Photographs by Bruce Gilden* (Stockport, 1999). There are few photographs of women in Gilden's series and only three photographs in which women appear on their own. The gendering of the horse-racing crowd says as much about Gilden's approach to the subject as it does about the public spectacle of horse racing itself. The focus on middle-aged men in the series contributes significantly to the particular photographic form of the Irish face.

40 For an overview of the ethnological survey of Great Britain of which the Dublin Laboratory was part see James Urry, *Before Social Anthropology: Essays on the History of British Anthropology* (Chur, Switzerland, 1993), pp. 83–101.

41 Photography was not an adjunct to other ethnographic strategies but was integrated by Haddon and Browne into the methods of physical anthropology including craniotomy and John Beddoe's Index of Nigrescence. Beddoe's description of the Irish as 'Africanoid', another example of the racialism of Irish identity

that expressed Victorian anxieties over the whiteness of the Irish Celt, was a motivating factor in the survey's use of visual technologies to document the Irish face. Beddoe's search for the 'black Irish', and his belief that the Index of Nigrescence could prove that the Irish were darker than Anglo-Saxons, led Haddon and Browne to the remote outlying islands along the western seaboard in the belief that the persistence of a truly Gaelic identity could be visibly mapped. The Index of Nigrescence involved a mathematical conundrum of human skin, hair and eyes to calculate the level of melanin in a race. The formula and method was outlined in Beddoe's *The Races of Britain*.

42 Unlike the photographs of Fenians in the criminological files and albums of colonial administrators that sought to bring the photographed body closer to the viewer, Haddon and Browne's type photographs had the opposite intent. Distancing and rationalizing the body through the rigorous methods of photographic anthropometry, the type photograph transformed the subject into a pictorial object to be dispassionately scrutinized and observed. In the terminology of Haddon and Browne they were visible 'specimens' of racial types. For a discussion of this aspect of the Laboratory see Justin Carville, 'Resisting Vision: Photography, Anthropology and the Production of Race in Ireland', in *Visual, Material and Print Culture in Nineteenth Century Ireland*, ed. Ciara Breathnach and Catherine Lawless (Dublin, 2010).

43 This was as much a failure of subjects to conform to the anthropological methods of photography as it was the inability of visual technologies to adequately provide definitive evidence of the persistence of a distinctive Irish identity. The belief that the mechanical objectivity of the camera would erase any sense of social encounter between the ethnographers and the people they photographed quickly collapsed. Browne commented on the refusal of 'specimens' to conform to being photographed. Even their various ruses to trick people into having their portrait taken demonstrate that the act of photography became what Mary Louise Pratt has termed the 'contact zone' between the different cultures of the photographer and 'primitive' Irish peasant. See Mary Louis Pratt, *Imperial Eyes: Travel Writing and Transculturation* (London, 1992), p. 6.

44 The original publication of *The Aran Islands* in 1907 included twelve drawings by the artist Jack B. Yeats, brother of the cultural Revivalist William Butler Yeats, some of which are based on Synge's photographs.

45 Synge has described Aran as 'These few acres at the Edge of Europe' in his ethnographic travelogue *The Aran Islands* (London, 1992), p. 93. For Revivalists such as Synge the geographic distance of Aran provided the opportunity to develop a pastoral image of Ireland that drew on existing Orientalist modes of representation that fed through into photographic representations of the island

and its inhabitants. See Declan Kiberd, *Inventing Ireland: The Literature of the Modern Nation* (London, 1996), p. 287. On the concept of Irish Orientalism see Joseph Lennon, 'Irish Orientalism: An Overview', in *Ireland and Postcolonial Theory*, ed. Clare Carroll and Patricia King (Cork, 2003), p. 129.

46 Synge, *The Aran Islands*, p. 34.

47 Ibid., p. 61.

48 On the pastoral in Synge's writings on the Aran Islands see Oona Frawley, *Irish Pastoral: Nostalgia and Twentieth-Century Literature* (Dublin, 2005), pp. 81–103.

49 Synge, Notebook 19. Reproduced in Alan Price, ed., *J. M. Synge, Collected Works*, vol. II: *Prose* (London, 1966), p. 54.

50 Bill Doyle, *The Aran Islands: Another World* (Dublin, 1996).

51 Brian Mercer Walker, *Shadows on Glass: A Portfolio of Early Ulster Photography* (Belfast, 1976), pp. 20–29.

52 On McKinney's family farm and local area see Brian M. Walker, *Sentry Hill: An Ulster Farm and Family* (Belfast, 1991).

53 Liam Kelly, *The Face of Time: Leland Lewis Duncan, 1862–1923: Photographs of Co. Leitrim* (Dublin, 1995). I am grateful to Father Liam Kelly for sharing his knowledge of Duncan with me.

54 The most comprehensive overview of this archive is David Okuefuna, *The Wonderful World of Albert Kahn: Colour Photographs from a Lost Age* (London, 2008).

55 Rose Shaw, *Carleton's Country* (Dublin, 1930).

56 Ibid., p. 83.

57 See Fintan Cullen, *Conquering England: Ireland in Victorian London* (London, 2005), pp. 62–4.

58 Ibid., pp. 62–3.

59 Dorothea Lange, 'Irish Country People', *Life*, 21 March 1955.

60 Dorothea Lange quoted in Daniel Dixon, 'Ireland's Dorothea Lange', in Gerry Mullin, *Dorothea Lange's Ireland* (London, 1996), p. 17.

61 See Justin Carville, 'A "Sympathetic Look": Documentary Humanism and Irish Identity in Dorothea Lange's "Irish Country People"', in *Affecting Irishness: Negotiating Cultural Identity Within and Beyond the Nation*, ed. James P. Byrne, Padraig Kirwan and Michael O'Sullivan (Frankfurt, 2009), pp. 197–217.

62 Clare Lynch's Documentary *Photos to Send* traces this circulation of Lange's photo-essay as part of her narrative exploration of diasporic identity.

63 See the exhibition catalogue *The Edge of Europe* (Dublin, 1996).

64 Timothy O'Grady and Steve Pyke, *I Could Read the Sky* (London, 1997). The novel was adapted into a film directed by Nicola Bruce, *I Could Read the Sky*, Irish Film Board/Channel Four Films, 1999.

65 O'Callaghan's series was produced as a book and awarded Photographic Book of the Year by the International Centre for Photography, New York and Rencontres d'Arles de la Photographie, France in 2003. See *Hide that Can: A Photographic Diary of the Men of Arlington House* (London, 2002).

66 Alen MacWeeney, *Irish Travellers* (New Haven, CT, 2007), Sharon Gmelch, Pat Langan and George Gmelch, *Tinkers and Travellers: Ireland's Nomads* (Dublin, 1975). In addition to this work on Irish Travellers Derek Speirs's work with Pavee Point is an important contribution to documenting the social plight of the travelling community; see Derek Speirs, *Pavee Pictures* (Dublin, 1991). See also Mathias T. Oppersdorff, *People of the Road* (Syracuse, NY, 1997).

67 John Minihan and Eugene McCabe, *Shadows from the Pale: Portrait of an Irish Town* (London, 1996).

68 Krass Clement, *Drum: Et Sted I Irland* (Copenhagen, 1996).

69 Anthony Haughey in the series *Between* worked with the detainees in an asylum centre established in the former Butlin's Mosney holiday camp once depicted in John Hinde's colour postcards of Ireland. Haughey photographed residents in a direct style that sought to bestow the dignity upon the subject which the Irish state's policy of refusing citizenship to asylum seekers had denied them. During an exhibition of the work, the residents posted messages on old John Hinde postcards to the gallery demanding the right to be heard and granted their wish to become Irish citizens. On one postcard was written 'even if you call me an Asylum Seeker. I am a Human anyway . . . I must be told something positive. The dying man from the Congo'. Just over a century after Roger Casement had used photography to campaign against the abuse of the Congolese under British Imperialism, photography once more was pressed into service to document the human rights of a Congolese national.

70 Bowler's series was commissioned by Dún Laoghaire Rathdown County Council's Place and Identity Scheme under the Per Cent for Art Programme.

four: Conflicting Images

1 The Good Friday Agreement was signed by the British and Irish governments and the north's main political parties on 10 April 1998. A referendum was held to adopt the Agreement by the people of Northern Ireland on 23 May 1998 and on the same date a referendum was held in the south to amend the Irish Constitution removing the State's territorial claim to the six counties of the north.

2 See Richard West, 'It's Your Decision', *Source*, 15 (1998), unpaginated.

3 The origins of the conflict are a point of historical contention and there is not the space here to explore the nuances of these historical disputes. Some historians have identified the declaration of war against the Irish Republican Army by the Ulster Volunteer Force in 1966 as the origins of the Troubles while others have cited the rise of the Civil Rights movement in Northern Ireland in 1968 as the genesis of the conflict. What is significant about these positions is that the former locates the Troubles as linked to sectarian conflict, the latter civil rights campaigning for greater equality of Northern Ireland's Catholic community. The discussion of photography in this chapter takes as its framework the latter thesis. See David McKittrick, *Making Sense of the Troubles* (Belfast, 2000) and Tim Pat Coogan, *The Troubles: Ireland's Ordeal, 1966–1996* (Dublin, 1996).

4 The findings of the first investigation conducted by Lord Chief Justice Widgery in 1972, referred to as the *Widgery Tribunal*, has long been contested and a new inquiry initiated after campaigning by the Bloody Sunday Justice Campaign was established in 1997 and led by Lord Saville. At the time of writing, this inquiry has yet to publish its report but the testimony of Grimaldi, the photojournalist Gilles Peress and their photographs have been included in the proceedings of the inquiry. Fulvio Grimaldi's testimony to both tribunals can be found online at www.bloody-sunday-inquiry.org.uk/reports/kstatments/Archive/M34.pdf, last accessed 18 March 2011.

5 Baudrillard's standard text on this is *The Gulf War Did Not Take Place* (Bloomington, IN, 1995) but see also *The Evil Demon of Images* (Sydney, 1988).

6 Grimaldi has recounted how radio interceptions of the British Army by local people in the Bogside suggest that he was a potential target. See Fulvio Grimaldi and Susan North, *Blood in the Street* (Dublin, Rome, London, 1972).

7 See for example the photo-story accompanied with an essay by Loudon Wainwright, 'A People Lost in Hate', *Life* (20 August 1971), pp. 20–25.

8 See Justin Carville, 'Re-Negotiated Territory: The Politics of Place, Space and Landscape in Irish Photography', *Afterimage*, XXIX/1 (2001), pp. 5–9.

9 See Norman B. Moyes and David Kennerly, eds, *Battle Eye: A History of American Combat Photography* (New York, 1996).

10 'A Classic Scene of Irish Violence', *Life* (4 September 1970), pp. 48–48B.

11 See John Taylor, *War Photography: Realism and the British Press* (London, 1991), pp. 10–12. Taylor writes of the official perspective of the tabloid media's portrayal of Irish terrorism but the concept is also useful in the context of the American print media's concern with the representation of conflict after the Vietnam war.

12 'The Beat of Life', *Life* (11 February 1972), pp. 2–3. On Peress's ongoing relationship with photojournalism and Bloody Sunday in the aftermath of the Troubles see Trisha Ziff, ed., *Hidden Truths: Bloody Sunday 1972* (Santa Monica, CA, 2002).

13 Grimaldi and North, *Blood in the Street*, p. 1.

14 Ibid., p. 32.

15 See chapter 175, 'Missing Photograph and Other Materials', Bloody Sunday Inquiry, vol. IX (2010).

16 Clive Limpkin, *The Battle of Bogside* (London, 1972). Another similar publication is Colman Doyle, *People at War* (Dublin, 1975).

17 Editorial, 'Reporting on Northern Ireland', *Camerawork*, 14 (1979), unpaginated.

18 See Jessica Evans, 'Introduction', in *The Camerawork Essays: Context and Meaning in Photography*, ed. Jessica Evans (London, 1997), pp. 11–35.

19 'Editorial', *Camerawork*.

20 Kashi has noted that 'As an outsider, I encountered tremendous hostility and suspicion at times. As an American sticking my nose into the Loyalist community, I was also met with outright accusations of IRA loyalty or, as I constantly heard muttered towards me, "Mr Noraid".' See Ed Kashi, 'Foreword', in *No Surrender: The Protestants, Photographs of Northern Ireland* (San Francisco, CA, 1991), p. 4.

21 Trisha Ziff, ed., *Still War: Photographs from the North of Ireland by Mike Abrahams and Laurie Sparham* (New York, 1990).

22 On the history and cultural significance of political wall murals see Bill Rolston, *Drawing Support: Murals in the North of Ireland* (Belfast, 1992) and Neil Jarman, 'Painting Landscapes: The Place of Murals in the Symbolic Construction of Urban Space', in *Symbols in Northern Ireland*, ed. Anthony Buckley (Belfast, 1998).

23 Vilém Flusser, *Towards a Philosophy of Photography*, trans. Anthony Mathews (London, 2000), p. 65

24 Graham Dawson, 'Trauma, Place and the Politics of Memory: Bloody Sunday, Derry, 1972–2004', *History Workshop Journal*, 59 (2005), p. 165.

25 Grimaldi, Peress and several other photojournalists have had their photographs of that day submitted as visual testimony into the record of the Saville Inquiry hearings. The British Army, who reportedly had 25 photographers and camera operators on duty, have 'mislaid' all photographic material taken during that day, which has added to the legal and cultural significance of photojournalism's documentation of Bloody Sunday.

26 The collections of photographs such as that by Belfast Exposed has made an important contribution to reworking collective histories of Northern Ireland through the archive. The Belfast Exposed archive has become a repository for photographic images produced for community projects and for photography that has emerged from within various communities themselves. As discussed later the archive is an important theme within post-conflict visual culture in Northern Ireland.

27 It is only in the last few years that a comprehensive appraisal has been undertaken of press photography in Northern Ireland with the exhibition *Out of the Darkness*, held in 2007 at the Golden Thread Gallery, Belfast. See Roisín McDonough and John Harrison, *Out of the Darkness: 40 Years of Northern Ireland Press Photography* (Belfast, 2007).

28 For an overview of Sloan's work see Aidan Dunne, 'A Broken Surface: Victor Sloan's Photographic Work', in *Victor Sloan: Selected Works 1980–2000* (Belfast, 2001), pp. 23–147.

29 See Brian McAvera, *Marking the North: The Work of Victor Sloan*, exh. cat. (Dublin and York, 1990), pp. 9–15.

30 This point is made by McAvera who states: 'The manipulated image is the method by which he bypasses the soiled coinage of photographic "honesty", "truth" and "authenticity"', *Marking the North*, p. 13.

31 See *Willie Doherty: Unknown Depths*, exh. cat., Ffotogallery (Cardiff, 1991) and *Willie Doherty: Partial View*, exh. cat., Douglas Hyde Gallery (Dublin, 1993).

32 This point is expanded upon by Jean Fisher, 'Seeing Beyond the Pale: The Photographic Works of Willie Doherty', in *Unknown Depths*, unpaginated.

33 For a detailed overview through specific case studies see the essays collected in Bill Rolston and David Miller, eds, *War and Words: The Northern Ireland Media Reader* (London, 1996).

34 William Stott, *Documentary Expression and Thirties America* (Chicago, IL, 1973), pp. 12–17.

35 Paul Graham, *Troubled Land* (Manchester, 1987).

36 'Gillian Wearing in Conversation with Paul Graham', in *Paul Graham* (London, 1996), p. 16.

37 The series was published as *In Umbra Res: Sixteen Photographs of Northern Ireland* (Manchester, 1991).

38 For a review of this work see Nicholas Allen, 'The People's Taxis', *Source*, 16 (1998), unpaginated.

39 Paul Quinn's series *Maguire's Barber's Belfast* was also produced in 1996. Gareth McConnell's *Portraits and Interiors from the Albert Bar*, 1999 are reproduced in Gareth McConnell, *Gareth McConnell: Photoworks* (Göttingen, 2004).

40 Hal Foster, 'Postmodernism: A Preface', in *Postmodern Culture*, ed. Hal Foster (London, 1985), p. x.

41 See Carville, 'Re-Negotiated Territory', pp. 5–9.

42 Haughey's series which includes the disputed territories of European ethnic conflicts in Bosnia and Herzegovina and Kosovo, represents the traces and afterimages of conflict where a supposedly post-conflict situation is *in situ*. Through the combination of photographs of the discarded detritus of human conflict, the infrastructure of military surveillance and arbitrary landscapes that have no visible signs of violence, Haughey's series interrogates the continual conflict over memory, identity and territory in the aftermath of the Troubles. See Anthony Haughey, *Disputed Territory* (Dublin, 2006).

43 Seawright quoted in 'Northern Star', *The Irish Times* (28 May 1997), p. 12.

44 André Bazin, 'The Ontology of the Photographic Image' in *Classic Essays on Photography*, ed. Alan Trachtenberg (New Haven, CT, 1980), p. 242.

45 See Jacques Derrida, *Archive Fever: A Freudian Impression*, trans. Eric Prenowitz (Chicago, IL, 1996).

46 See Hal Foster, 'An Archival Impulse', *October*, 110 (2004), pp. 1–32.

47 See Pierre Nora, 'Between Memory and History: Les Lieux de Mémoire', *Representations*, 26 (1989), pp. 7–25.

48　See the various projects commissioned by Belfast Exposed such as John Duncan, *Trees From Germany* (Belfast, 2003); Kai Olaf Hesse, *Topography of the Titanic* (Belfast, 2003); Ursala Burke and Daniel Jewesbury, *Archive: Lisburn Road* (Belfast, 2004); Donovan Wylie, *The Maze* (Göttingen, 2004); G. Hatje Cantz, ed., *Claudio Hills – Archive Belfast* (Belfast, 2004); Peter Richards and Ruth Graham, *Portraits from a 50s Archive* (Belfast, 2005). The Belfast Exposed archive can be accessed at www.belfastexposed.org, last accessed 18 March 2011.

49　Archival practices have been a characteristic of post-conflict visual arts and is not just a phenomenon within photography. See catalogue of the exhibition by Fionna Barber, *Archiving Space and Time* (Portadown and Manchester, 2009).

50　See Colin Graham, 'Every Passer-by a Culprit?: Archive Fever, Photography and the Peace in Northern Ireland', *Third Text*, XIX/5 (2005), pp. 567–80.

51　See Eoghan McTigue, *All Over Again* (Belfast, 2004).

52　On the politics of memory and space in Northern Ireland see Graham Dawson, *Making Peace with the Past: Memory, Trauma and the Troubles* (Manchester, 2007).

five: The City in Ruins

1　Anon. 'Daguerreotype, or Nature Reproducing its Own Image: Old Long Bridge Belfast', *The Belfast Newsletter* (6 August 1840), p. 2.

2　The bridge took eight years to complete and was opened in 1849 by Queen Victoria.

3　Charles Baudelaire, 'The Modern Public and Photography' [1859], in *Art in Theory, 1815–1900: An Anthology of Changing Ideas*, ed. Charles Harrison, Paul Wood and Jason Graiger (Oxford, 1998), p. 668.

4　For a brief overview of the differing interpretations of ruins see Malcolm Andrews, *The Search for the Picturesque: Landscape Aesthetics and Tourism in Britain, 1760–1800* (Aldershot, 1989), pp. 41–50.

5　Many of these ideas are addressed in James Donald, 'Metropolis: The City as Text', in *Social and Cultural Aspects of Modernity*, ed. Robert Bocock and Kenneth Thompson (Cambridge, 1992) and James Donald, *Imaging the Modern City* (London, 1999).

6　For a discussion of the concept of 'ruins' see Christopher Woodward, *In Ruins* (New York, 2001).

7　Robert Pool and John Cash, *View of the Most Remarkable Public Buildings, Monuments and other Edifices in the city of Dublin* (Dublin, 1780), pp. ix–x.

8　James Malton, *A Picturesque and Descriptive View of the City of Dublin* (Dublin, 1799), p. li.

9　This phrase was used in several reports on photography including the one that appeared in *The Belfast Newsletter* in 1839. It was also used by William Henry Fox Talbot in his description of the calotype. See William Henry Fox Talbot, 'Some Account of the Art of Photogenic Drawing, or, The Process by Which Natural Objects May Be Made to Delineate Themselves without the Aid of Artists Pencil' [1839], in *Photography: Essays and Images*, ed. Beaumont Newhall (London, 1981), pp. 23–31.

10　For a background on the development of Dublin during this time see Edel Sheridan, 'Designing the Capital City: Dublin, *c. 1660–1810*', in Joseph Brady and Anngret Simms, eds, *Dublin Through Space and Time (c. 900–1900)* (Dublin, 2001), pp. 66–135.

11　See Edward McParland, 'The Wide Street Commissioners: Their Importance for Dublin Architecture in the Late Eighteenth – Early Nineteenth Century', *Bulletin of the Irish Georgian Society*, XV/1 (1972), pp. 1–32.

12　See Justin Carville, 'Mr Lawrence's Great Photographic Bazaar: Photography, History and the Imperial Streetscape', *Early Popular Visual Culture*, V/3 (November 2007), pp. 263–83.

13　Frederick Holland Mares, *Photographs of Dublin with Descriptive Letterpress* (Glasgow, 1867).

14　Ibid., unpaginated.

15　For an account of the rebellion see Max Caulfield, *The Easter Rebellion* (Dublin, 1995).

16　On the concept of late photography see David Campany, 'Safety in Numbness: Some Remarks on Problems of Late Photography', in *Where is the Photograph?*, ed. David Green (Brighton, 2003), pp. 123–32.

17　James Stephens, *The Insurrection in Dublin* (Buckinghamshire, 1992), p. 73.

18　*The Freeman's Journal*, 26 April 1916, p. 1.

19　See Justin Carville, 'Visualizing the Rising: Photography, Memory and the Visual Economy of the 1916 Easter Rising', in *Photographs, Histories and Meanings*, ed. Marlene Kadar, Jeanne Perreault and Linda Warley (New York, 2010), pp. 91–109.

20　For a brief discussion of this aspect of ruins in an Irish context see Luke Gibbons, *Transformations in Irish Culture* (Cork, 1996), p. 159.

21　On the War of Independence see Michael Hopkinson, *The Irish War of Independence* (Dublin, 2002) and on the Civil War see Brendan Clifford, *The Irish Civil War: The Conflict that Formed the State* (Cork, 1993).

22　See Anon., *Pictures of Dublin After the Fighting* (Dublin, 1922).

23　This description is used in a pamphlet which includes photographs by Robert Cashman. See Anon., *Old Ireland in Pictures: Two Dublin Risings and their Consequences* (Dublin, 1923), unpaginated.

24　Dublin was accidentally bombed in May of that year as well despite its neutrality. For an account of Ireland during the period acknowledged by the Irish state only as the Emergency see Tony Gray, *The Lost Years: The Emergency in Ireland, 1939–45* (New York, 1988).

25　*Belfast Telegraph*, 'Bombs on Belfast: A Camera Record' (Belfast, 1941).

26 Ibid., unpaginated.

27 Ibid.

28 Charles Dickens quoted in Jim Cooke, 'Charles Dickens: A Dublin Chronicler', *Dublin Historical Record*, XLII/3 (1989), pp. 97–8.

29 What has been titled the *Darkest Belfast Collection* of photographs was produced in 1911 of an area identified for slum clearance in the aftermath of a government inquiry in 1906. See Brian Mercer Walker, *Shadows on Glass: A Portfolio of Early Ulster Photography* (Belfast, 1976), pp. 108–13. The *Darkest Dublin Collection* was produced for a government inquiry in 1913 into the condition of working-class housing. See Christian Corlett, *Darkest Dublin: The Story of the Church Street Disaster and a Pictorial Account of the Slums in Dublin in 1913* (Dublin, 2008).

30 *Report of the Departmental Committee into the Housing Conditions of the Working Classes* (Dublin, 1914).

31 Nevill Johnson, *Dublin: The People's City* (Dublin, 1981).

32 James Plunkett, 'Foreword', pp. 7–8.

33 See Bill Doyle, *Images of Dublin: A Time Remembered* (Dublin, 2001).

34 See Edna O'Brien, *Mother Ireland* (London, 1976).

35 Robert McLiam Wilson and Donovan Wylie, *The Dispossessed* (London, 1992).

36 Ibid., p. 131.

37 Tony O'Shea, *Dubliners* (Dublin, 1990).

38 The erosion of the distinctiveness of Dublin as place has been most clearly symbolized in the construction of *The Spire*, a massive stainless-steel monument in the centre of the city's main thoroughfare. Stretching into the Dublin skyline, *The Spire* is effectively a monument to 'nothingness'. The softening of Dublin's architectural character, however, predates its more recent global manifestations. For the beginnings of this process see Frank McDonald, *The Destruction of Dublin* (Dublin, 1985).

39 Marc Augé, *Non-Places: Introduction to An Anthropology of Supermodernity* (New York, 1995).

40 For a more detailed account of Duncan's work in the context of recent photographic representations of Belfast see Colin Graham, 'Belfast in Photographs', in *The Cities of Belfast*, ed. Nicholas Allen and Aaron Kelly (Dublin, 2003), pp. 152–67.

41 John Duncan, *Trees From Germany* (Belfast, 2003).

42 See John Duncan, *Bonfires* (Göttingen, 2008).

Epilogue

1 Allan Sekula, 'The Traffic in Photographs', in *Photography Against the Grain: Essays and Photoworks, 1973–1983* (Halifax, Nova Scotia, 1984), pp. 77–101.

2 Ibid., p. 100.

3 Ibid., p. 95.

4 Ibid., p. 100.

5 On the significance of such imagery within Irish-American popular culture see Stephanie Rains, *The Irish American in Popular Culture, 1945–2000* (Dublin, 2007).

6 David Noble quoted in Declan McGonagle and David Lee, *Hindesight* (Dublin, 1993), p. 38.

7 Claire Connolly makes this point when she comments that '[t]his last anecdote perfectly captures the proto-postmodern sensibility present within Hinde's images, a further explanation, perhaps, of the enduring cultural interest in these postcards'. See Claire Connolly, 'Introduction: Ireland in Theory', in *Theorizing Ireland*, ed. Claire Connolly (London, 2003), p. 8.

8 Jean Baudrillard, *Simulacra and Simulation*, trans. Shelia Faria Glaser (Ann Arbor, MI, 1994), p. 2.

9 Sekula, 'The Traffic in Photographs', p. 100.

10 The body of work was commissioned by Mayo County Council. See the accompanying publication: *Clare Island: This Time, This Place* (Castlebar, 2006).

11 The island was the subject of a multi-disciplinary survey in the late Edwardian era known as the Clare Island Surveys, which contributed much to the construction of the island as a remote, primitive society.

12 Mark Curran, *The Breathing Factory* (Heidelberg, 2006).

Select Bibliography

Abrahams, Mike, and Laurie Sparham, *Still War: Photographs from the North of Ireland* (London, 1989)

Anderson, Benedict, *Imagined Communities: Reflections on the Origin and Spread of Nationalism* (London, 1991)

Baylis, Gail, 'Imagined Narratives: Photography and the Construction of Diasporic Cultural Memory', in *Rethinking Diasporas: Hidden Narratives and Imagined Borders*, ed. Aoileann Ní Éigeartaigh, Kevin Howard and David Getty (Cambridge, 2007)

——, 'Metropolitan Surveillance and Rural Opacity: Secret Photography in Nineteenth-Century Ireland', *History of Photography*, XXXIII/1 (2009)

Belfast Exposed, *Claudio Hils: Archive Belfast* (New York, 2004)

Blake, Liam, *Real Ireland: People and Landscapes* (Dublin, 1984)

Boesten, Alex, *Traffic Island* (Dublin, 2000)

Boyce, D., and Alan O'Day, eds, *The Making of Modern Irish History: Revisionism and the Revisionist Controversy* (London, 1996)

Breathnach, Ciara, ed., *Framing the West: Images of Rural Ireland, 1891–1920* (Dublin, 2007)

Burch, Simon, *Under a Grey Sky* (Dublin, 2009)

Carville, Justin, 'Visualizing the Rising: Photography, Memory and the Visual Economy of the 1916 Easter Rising', in *Photographs, Histories and Meanings*, ed. Marlene Kadar, Jeanne Perreault and Linda Warley (New York, 2010)

——, 'A "Sympathetic Look": Documentary Humanism and Irish Identity in Dorothea Lange's "Irish Country People"', in *Affecting Irishness: Negotiating Cultural Identity Within and Beyond the Nation*, ed. James P. Byrne, Padraig Kirwan and Michael O'Sullivan (Frankfurt, 2009)

——, 'Re-Negotiated Territory: The Politics of Place, Space and Landscape in Irish Photography', *Afterimage*, XXIX/1 (2001)

Chandler, Edward, *Photography in Ireland: The Nineteenth Century* (Dublin, 2001)

——, and Peter Walsh, *Through the Brass Lidded Eye: Ireland and the Irish, 1839–1859, The Earliest Images*, exh. cat., Guinness Museum, Dublin (1989)

——, *Photographs in Dublin during the Victorian Era* (Dublin, 1982)

Clement, Krass, *Drum: Et Sted I Irland* (Copenhagen, 1996)

Cregg, Martin, *Midlands* (Dublin, 2009)

Cullen, Fintan, 'Marketing National Sentiment: Lantern Slides of Evictions in Late Nineteenth-century Ireland', *History Workshop Journal*, 54 (2002)

Curran, Mark, *The Breathing Factory* (Heidelberg, 2006)

Dalsimer, Adele M., and Vera Krielkamp, eds, *Visualizing Ireland: National Identity and the Pictorial Tradition* (London, 1993)

Davidson, David H., *Impressions of an Irish Countess: The Photography of Mary, Countess of Rosse* (Birr, 1989)

Doherty, Willie, *No Smoke Without Fire* (London, 1996)

Doyle, Bill, *The Aran Islands: Another World* (Dublin, 1996)

Doyle, Colman, and Terry O'Sullivan, *The People of Ireland* (Cork, 1971)

Edge, Sarah Jane, 'Photographic History and the Visual Appearance of an Irish Nationalist Discourse, 1840–1870', *Victorian Literature and Culture*, XXXII/1 (2004)

Evans, E. Estyn, and Brian S. Turner, *Ireland's Eye: The Photographs of Robert John Welch* (Belfast, 1997)

Farrell, David, ed., *Contemporary Irish Photography: Captured Light Exhibition*, exh. cat. (Dublin, 1989)

——, *Innocent Landscapes* (London, 2001)

Gibbons, Luke, *Transformations in Irish Culture* (Cork, 1996)

Gilden, Bruce, *After the Off: Photographs by Bruce Gilden* (Stockport, 1999)

Gorham, Maurice, *Dublin from Old Photographs* (London, 1972)

Graham, Colin, *Deconstructing Ireland: Identity, Theory, Culture* (Edinburgh, 2001)

——, '"Every Passer-by a Culprit?": Archive Fever, Photography and the Peace in Belfast', *Third Text*, 19.5 (2005)

——, 'Belfast in Photographs', in *The Cities of Belfast*, ed. Nicholas Allen and Aaron Kelly (Dublin, 2003)

Graham, Paul, *In Umbra Res: Sixteen Photographs of Northern Ireland*, exh. cat., National Museum of Photography, Film and Television, Bradford (Manchester, 1991)

——, *Troubled Land* (Manchester, 1987)

Grimaldi, Fulvio, and Susan North, *Blood in the Street* (Dublin, Rome, London, 1972)

Haughey, Anthony, *Disputed Territory* (Dublin, 2006)

——, and Fintan O'Toole, *Imeall na hEorpa (The Edge of Europe)*, exh. cat., Gallery of Photography, Dublin (1996)

Hickey, Kieran, *The Light of Other Days: Irish Life at the Turn of the Century in the Photographs of Robert French* (Boston, MA, 1973)

Hill, Myrtle, and Vivienne Pollock, *Image and Experience: Photographs of Irishwomen, c. 1880–1920* (Belfast, 1993)

Hillen, Seán, *Irelantis* (Dublin, 1999)

Howe, Stephen, *Ireland and Empire: Colonial Legacies in Irish History and Culture* (Oxford, 2000)

Johnson, Nevill, *Dublin: The People's City* (Dublin, 1981)

Kiang, Tanya, 'Playing the green card: contemporary photography in Ireland', *Aperture*, 134 (Winter 1994)

Kiberd, Declan, *Inventing Ireland: The Literature of the Modern Nation* (London, 1996)

Kissane, Noel, ed., *Ex Camera, 1860–1960: Photographs from the Collections of the National Library of Ireland* (Dublin, 1990)

——, ed., *The Irish Face* (Dublin, 1986)

MacWeeney, Alen, *Irish Travellers* (New Haven, CT, 2008)

Maguire, W. A., *A Century in Focus: Photography and Photographers in the North of Ireland, 1839–1939* (Belfast, 2000)

——, *Caught in Time: The Photographs of Alex Hogg of Belfast, 1870–1930* (Belfast, 1991)

McBride, Lawrence W., ed., *Images, Icons and the Irish Nationalist Imagination* (Dublin, 1999)

McGonagle, Declan, and David Lee, *Hindesight: John Hinde Photographs and Postcards by John Hinde Ltd., 1935–1971*, exh. cat., Irish Museum of Modern Art, Dublin (1993)

McGrath, Dara, *By the Way* (Dublin, 2003)

McRedmond, Louis, ed., *Ireland: The Revolutionary Years: Photographs from the Cashman Collection, Ireland, 1910–1930* (Dublin, 1992)

McTigue, Eoghan, *All Over Again* (Belfast, 2004)

Merne, Oscar W., *The History of the Photographic Society of Ireland* (Dublin, 1954)

Minihan, John, and Eugene McCabe, *Shadows from the Pale: Portrait of an Irish Town* (London, 1996)

Morrison, George, *An Irish Camera* (London, 1979)

Mullins, Gerry, ed., *Dorothea Lange's Ireland* (London, 1996)

O'Shea, Tony, *Dubliners* (Dublin, 1990)

Osman, John, ed., *Out of the Shadows: Contemporary Irish Photography*, exh. cat., Douglas Hyde Gallery, Dublin (1981)

Parr, Martin, *A Fair Day: Photographs from the West of Ireland* (Derry, 1984)

——, *Bad Weather* (London, 1982)

Redmond, Christine, ed., *The Lie of the Land* (Dublin, 1995)

Regan, Leo, *Taken Down in Evidence: Ireland from the Back Seat of a Patrol Car* (Dublin, 1995)

Rouse, Sarah, *Into the Light: An Illustrated Guide to the Photographic Collections in the National Library of Ireland* (Dublin, 1998)

Seawright, Paul, *Paul Seawright* (Salamanca, 2000)

——, *Inside Information: Photographs, 1988–1995* (London, 1995)

Sexton, Sean, *The Irish: A Photohistory* (London, 2002)

——, ed., *Ireland in Old Photographs* (New York, 1989)

Sloan, Victor, *Victor Sloan: Selected Works, 1980–2000* (Belfast, 2001)

Stephens, Lilo, ed., *My Wallet of Photographs: The Collected Photographs of J. M. Synge* (Dublin, 1971)

Walker, Brian M., *Shadows on Glass: A Portfolio of Early Ulster Photography* (Belfast, 1976)

——, Art Ó Brion and Sean McMahon, *Faces of Ireland, 1875–1925* (Belfast, 1980)

Willie Doherty: Partial View, exh. cat., Douglas Hyde Gallery, Dublin (1993)

Donovan Wylie, *The Maze* (London, 2004)

——, *Ireland: Singular Images* (London, 1994)

——, *32 Counties: Photographs of Ireland* (London, 1989)

Foucault, Michel 22
Four Courts 168
France 31, 166
Free Derry Corner 139
Freeman's Journal 42
French, Robert 71
Furlong, William Holland 28
 Irish Evictions series 71

Gallery of Photography 51, 56, 81
Galton, Francis 105
Galway 67, 72
gender 58, 91–2, 101, 126
geographical imaginings 7–16, 41, 55, 76, 109, 118
Gernsheim, Helmut 65
Giant's Causeway 77, 101
Gilden, Bruce 105
 After the Off 105
Gilpin, Reverend William 75
Glasgow 174
globalization 16, 56, 59, 84–5, 138, 140, 181–2, 184, 189–90
Glukman, Leone 23
Gonne, Maud 71
Good Friday Agreement 127, 141, 157
Graham, Paul 147–8
 Troubled Land 147
 New Europe 147
 In Umbra Res 147
Grand Central Station, New York 184
Great Britain 22, 47
Green, Wilfred Alfred 40
Grimaldi, Fulvio 128–9, 133–4, 140
 Blood in the Street 133–4

Haddon, Alfred Cort 105
Halfmoon Photography Workshop 136
Haughey, Anthony 54–5, 121, 151
 Disputed Territory 151
 Home 54
 The Edge of Europe 121
Hawarden, Lady Clementina 36
Hemphill, William Despard 32–3
 The Abbeys, Castles, and Scenery of Clonmel and the Surrounding Country 32
Hewlett-Packard 189
Hillen, Séan 10–12
 Irelantis 10
Hinde, John 9–10, 12, 185, 187
Hogan, W. D. 168

Hogg, Alexander 47
Holmes, Oliver Wendell 62–3
Home Rule 23

I Could Read the Sky 121
identity 16, 54, 90–91, 94–5, 112, 117–18, 126, 137
 communal 41
 cultural 9, 15–16, 39
 diasporic 121
 see also religious affiliation
Illustrated London News 65–6
imaginary, the 9–13
imperialism 18, 20, 31–2, 64, 71, 75, 99, 162–7
 anti- 69
 European 32
India 27–8, 116
indigenous 9, 12, 16, 41, 105, 109
International Exhibition (London) 25–6
International Exhibition of Arts and Manufactures (Dublin) 24, 26
International Health Exposition 105
Irish cultural studies 8
Irish Famine 33, 36, 62–9, 72
Irish Free State 10, 14, 41–3, 45, 47
Irish Independent, The 78
Irish Press, The 49
Irish Times, The 134
Irish Volunteers (Óglaigh na hÉireann) 166
Irish War of Independence 42, 167–8
Islamic Cultural Centre of Ireland 126

Johnson, Nevill 173–4
 The People's City 173
Joly, John 8

Kahn, Albert 112
 Archives of the Planet 112
Kashi, Ed 137
 No Surrender: The Protestants 137
Kashmir 27
Killarney 62–3, 77, 101
Kilronan Castle 67
Kingsley, Charles 93–4
Knox, Robert 93–4
 The Races of Men 94
Korean War 131
Koudelka, Josef 51, 54

Lafayette Studio 27
Lagan 170

Lakes of Killarney 77
Land League 71
landscape 7–8, 16, 25, 42, 60–64, 79–80
 anti-tourist 186–8
 post-conflict 153–4
 post-Famine 64–75
 sectarian 147
 simulated 184–5, 187
 social 80–89
 tourist 9–10, 75–8, 179
 urban 164, 166
Land Wars 68–9
Langan, Pat 121
Lange, Dorothea 117–18
 'Irish Country People' 117
language 128, 141–5, 184, 188, 190
Larcom, Thomas Aiskew 97
Lauder Brothers 27
 Lauder, Edmund Stanley 27
 Lauder, James Stack 27
Lawrence's Great Bazaar and Photographic Galleries 27, 71
 Lawrence, John Fortune 26
 Lawrence, William Mervin 26–7
Lee Photographic Studios 77
Leitrim 112
Lewisham Antiquarian Society 112
Life magazine 117–18, 131, 133
Limerick 115, 171
Limpkin, Clive 134–5, 139
 The Battle of Bogside 134
Linked Ring Group 8
London 22, 26, 36, 121, 174
Long Bridge, Belfast 22, 160
Louth 89
Loyalist community 137, 151
Lynd, Robert 99, 126

MacWeeney, Alen 121, 125
Magnum Agency 174
Maguire, W. A. 14–15
 A Century in Focus: Photography and Photographers in the North of Ireland, 1839–1939 14
Mallacy, Father T. 71
Malton, James 163
Man of Aran 185
Mares, Frederick Holland 75, 163–4
 Photographs of Dublin 163–5
 Photographs of Wicklow 75
mass production 10, 16, 23, 77, 91, 97

Mayo 67–8
Maze prison 155
McCoy, Patrick 148
 The People's Taxis 148
McGrath, Dara 85
 By the Way 85
McIntyre, Mary 153
McKinney, William Fee 111
McTigue, Eoghan 157
 All Over Again 157
medallions 27, 61
memory 58, 141, 154–9
 collective 40–41, 43, 65, 68, 71, 120, 141, 159, 167
 cultural 68, 121
 diasporic 68
Mercer, William 37
Mespoulet, Marguerite 112
Metropolitan Photo Co. 99
Middle East 9, 30–32, 126
Mignon-Alba, Madeline 112
Millbank prison 99
Minihan, John 125
 Shadows from the Pale 125
Morrissey, Trish 57–9
 Seven Years 58
Mountjoy prison 97
Moyne Abbey 68
Muckross Lake 102
Mulcahy, Richard 43
Murray, Tony 52
Murree 27

Nation, The 23
National Club 71
nationalists 23, 41, 43, 69, 106, 131–2, 134, 137, 139, 151
National Museum of Photography, Film and Television, Bradford 147
Natural Philosophy Committee 21
Nelson, Horatio (Nelson's Column) 163–5
Newry 40
Nickerson, Jackie 89
 Ten Miles Round 89
Noble, David 185
Northern Ireland 13–15, 47, 126, 169, 174
 conflict and post-conflict 127–59

O'Brien, Edna 174
 Mother Ireland 174
O'Brien, William Smith 23
O'Callaghan, Deirdre 121

O'Connell, Daniel 23
O'Connor, Eily 101–2
O'Donovan Rossa, Jeremiah 97, 99
O'Grady, Timothy 121
O'Neill, Henry 23
Orchard Gallery, Derry 80
Orient 32
O'Shea, Tony 52, 54–5, 177–8
 Dubliners 54, 177
O'Toole, Fintan 10, 81–2
Overseas Press Club of America Robert Capa Gold Medal 134

Palestine 67
Parr, Martin 51, 54, 80–82
 A Fair Day 81–2
 Bad Weather 81
Peace Process 126, 129, 141
Pearse, Patrick 166
Peress, Gilles 133–4
Peru 41
Peshawar 27
photo-book 54, 125
photo-essay 117, 131, 137
Photographic News, The 22
photojournalism 7–8, 16, 42, 49, 54, 105, 128–41, 147–8, 177–8
photo-novel 121
photo-reportage 121, 126
photoscape 139
phototelegraphy 41
Photo-Works North 54
pictorial space 111
Picture Post 47
picturesque 7–8, 10, 27, 33, 37, 60–64, 66, 68, 72, 75–7, 80–81, 85, 89, 99,
 109, 161, 171, 185, 188
Plan of Campaign 71
Plunkett, James 173–4
Poland 188
portraiture
 criminological 16, 97–9
 critical documentary 89, 148, 188–9
 early domestic 91–3
 fine art 25
 identity 90–91
 of nationalist heroes 23, 71
 studio 8, 16, 20–24, 27, 91
 see also race, Irish face and Irish types
Portrush 77
post-colonialism 8, 16, 185
Powerscourt Estate 75

press photography 41–3, 78–9
Price, William Lake 33, 67
Punch 95
Pyke, Steve 121

Queen's Bridge, Belfast 160
Queenstown 48
Queen Victoria's Jubilee 27, 69, 71
Quinn, Paul 148

race 91, 94–5, 97
 Irish face 93–5, 112, 117
 Irish types 99–106, 112
 see also portraiture, criminological
racism, anti-Irish 93–4
Reagan, Ronald 185
real, the 9, 12, 142
Redmond, Christine 56
Rejlander, Oscar 25
religious affiliation 137
 Catholic 81, 120, 131, 133, 147, 171
 Protestant 28, 131, 137, 147
 Muslim 126
Revivalists 40, 109
Richmond gaol 23
Robinson, Henry Peach 25
Rodwell, Crispin 141
Roscommon 67
Rosse, Countess (Mary) of 33
Royal Daguerreotype Rooms, Belfast 22
Royal Dublin Society 21
Royal Irish Academy 21, 28
Royal Polytechnic Institution, London 22
Royal Ulster Constabulary 134
ruins 32–3, 67–8, 82, 160–70
Rutland Square 71
Ruttledge-Fair, Major Robert 71–3
Ryan, Mary (Lady Cotton) 115–17

Sackville Street (O'Connell Street) 163, 165–6
Sander, August 91
Saville Inquiry 141
Seawright, Paul 54–5, 145–7, 151, 157
 Belfast 151
 Conflicting Account 157
 Fires 151
 Police Force 151
 Sectarian Murder 54, 145–7
Second World War 173

Sekula, Allan 184–5, 187, 190
Shaw, George Bernard 8
Shaw, Rose 112
 Carleton's Country 112
Shaw-Smith, John 30–32
 prints 68
single-plate colour photographic process 8
Sligo 93
Sloan, Victor 142–3
Smith, Edwin 80
Society of Friends 72
Source magazine 54, 127
South Africa 127
Southampton 48
Souvenir of the South of Ireland 77
souvenirs 8
Spain 67
Spectator, The 22
Speirs, Derek 52
Starkey, Hannah 57–9
State of Emergency 47
Steele-Perkins, Chris 137
Stephens, James 166
stereographic images 16, 25, 61–2
stereoscopic cards 8, 27, 165
stereotype 7, 50–51, 95, 132, 148
stereoviews 77, 101
Sterling, Joe 188–89
 Working Distance 188
Stoddard, John L. 77
Stone, J. Harris 102–4
Stott, William 147
street photography 52, 173
streetscape 161, 163, 165–6
 see also cityscape
Sun, The 134
Swanston, William 38–9
Synge, John Millington 106–9
Syria 67

Talbot, William Henry Fox 28, 30, 33, 65
Tenison, Edward King 67
Tenison, Lady Louisa 67, 91–2
Tiger's Bay, Belfast 137
Tipperary 33, 36
Titanic 48
tourist photography 7, 9–10, 60–63, 72, 77, 187
 books 27, 61–2, 75, 77
 colonial 72, 105

ethnographic 99–103
gaze 12, 61, 76
Grand Tour 30, 67
Postcards 8, 10
see also landscape
Traveller community 121, 125
Troubles, the 8, 54, 127–37, 141–3, 147–8, 159
Tuach, Rod 52
Tuke, James Hack 72
Tyrone 112

Ulster 40–41, 111
Ulster Amateur Photographic Society 21, 38
Ulster Covenant 43
unionism 15, 32, 41, 43, 56, 131
United Kingdom 9, 47, 174
University of St Andrew's 28

Vandeleur family 92
Vaughan, Jim 187
 This Time, This Place 187–8
Vietnam War 129, 131

wall murals 128, 139–41, 153, 157
War of Independence 167–8
Welch, Robert John 40, 73
Werge, John 25
Westmeath 98
Westropp, Thomas J. 39
Wexford 71
whole-plate camera 103
Widgery Inquiry 134
Wilson, Robert McLiam 174
Wiltshire, Elinor 174
Woods, Steve 65
 Ireland 1848 65–6
Wylie, Donovan 153–4, 174, 177, 179, 183
 Dispossessed 183

Yorkshire 72
Young Irelanders 23, 95
Ypres 166